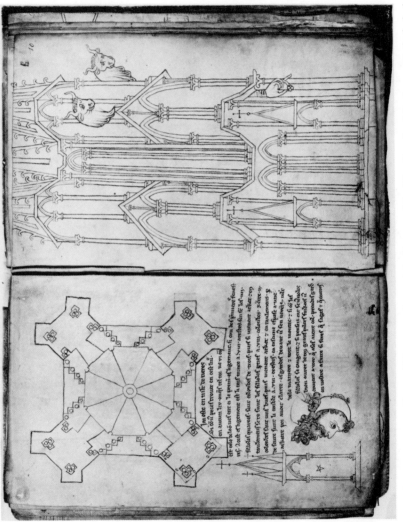

Villard De Honnecourt: Plan and Elevation of one of the Towers of the West Facade of the former Cathedral of Notre-Dame of Laon (Aisne), France, 1220s–1230s. [Paris, Bibliothèque nationale, MS. fr. 19.093, Fols. 9v and 10; photograph courtesy of the Bibliothèque nationale.]

# Villard de Honnecourt
# The Artist and His Drawings

*a critical bibliography*

*A*
*Reference*
*Publication*
*in*
*Art History*

Herbert L. Kessler
*Editor*

# Villard de Honnecourt
# The Artist and His Drawings

*a critical bibliography*

CARL F. BARNES, JR.

G.K. HALL &CO.

70 LINCOLN STREET, BOSTON, MASS.

Copyright © 1982 by Carl F. Barnes, Jr.

**Library of Congress Cataloging in Publication Data**

Barnes, Carl F.
  Villard de Honnecourt—the artist and his
drawings.

  (Reference publication in art history)
  Includes index.
  1.  Villard, de Honnecourt, 13th cent.—
Bibliography.  I.  Title.  II.  Series.
Z8942.426.B37  1982    016.741'092'4    82-11900
[NC248.V52]
ISBN 0-8161-8481-X

*This publication is printed on permanent/durable acid-free paper*
MANUFACTURED IN THE UNITED STATES OF AMERICA

In Memory of My Brother
WARD VIRDIN BARNES
1948-1976

# Contents

# The Author

Carl F. Barnes, Jr., is professor of art history and
archaeology at Oakland University in Rochester, Michigan.
He was educated at Washington and Lee University (BA,
1957) and Columbia University (MA, 1959; PhD, 1967)
where he was a student of the late Robert Branner.  Be-
fore coming to Michigan, Barnes taught at Pennsylvania
State University and the University of Wisconsin at
Milwaukee.  Barnes served as president of The Inter-
national Center of Medieval Art (1978-1981) and is cur-
rently treasurer of that organization.  He has published
on medieval art and architecture in Art Bulletin, Gesta,
Journal of the Society of Architectural Historians, and
Speculum.  Barnes is preparing, in collaboration with
Lon R. Shelby of Southern Illinois University at
Carbondale, a new critical edition of the Villard de
Honnecourt manuscript.

# Preface
# and Bibliographical Note

The manuscript of drawings by Villard de Honnecourt now in Paris (Bibliothèque nationale, MS. fr. 19.093) is a unique survival of thirteenth-century Europe. This uniqueness has had two unfortunate consequences. It has made the drawings and their artist famous beyond all justification. And it has engendered endless speculation as to their purpose and his career.

Villard provides very little information about himself or his activities. Most of what medievalists teach and write about Villard is not based on the dual contents of his manuscript--his drawings and his addended inscriptions to certain of these--but on what interpreters have had to say. Always suspect, this practice is utterly unacceptable in the case of Villard because so many commentators have been manifestly incorrect in their interpretations. Even worse, many of these interpretations have become accepted as fact and perpetuated as such. If a bibliography can be said to have a thesis, that of this, the first critical Villard bibliography, is to identify the sources of the many errors concerning Villard and his manuscript and to demonstrate how, and by whom, these errors have been repeated down through the years. Yet, lest this effort deteriorate into a merely negative critique, I have also attempted to show the origin of those theories on Villard which are today both current and valid.

The bibliography on any subject is much like a shotgun blast: dispersion increases as it moves in time away from its source. In the past half century since publication of the Hahnloser facsimile edition of the Villard manuscript in 1935, Villard has become a standard fixture in the general literature on medieval art. To cite every bibliographic reference to Villard and his drawings which has been published since 1935 is, therefore, not possible. I have attempted to include those references devoted specifically to one or another problem presented by the manuscript, as well as those more general items which, while frequently concerned with Villard but indirectly or in passing, nonetheless make some significant observation. Conversely, it is necessary for anyone seriously interested in Villard to be familiar with <u>all</u> writings concerning him and his drawings, since these writings are the sources of our current state of

understanding (or misunderstanding) of Villard and his manuscript.
I believe I have included virtually every bibliographic reference to
Villard published before 1900, as well as the great majority of those
published between 1900 and 1935.

All entries are listed in chronological order of appearance by
year and, within each year, alphabetically by the last name of the
author.  In the cross-references, entries are specified by author-
year-item, for example, Branner, 1958.1.  The seven facsimile edi-
tions of the manuscript are listed and analyzed separately and are
referred to simply by the last name of the author.  Entries from
multivolume dictionaries and encyclopaedias are all contained under
the year of publication of the first volume of the series.  Unless
otherwise indicated by an asterisk (*), I have examined all sources
on which entries are based.  In every case I have gone to the first
edition of any given work if at all possible.  When this has not been
possible, I have clearly indicated by double asterisks (**) which
edition was employed, although the entry itself appears under the
year of publication of the first edition of the work in question.

In all bibliographic citations of articles, inclusive pagination
is given, for example, in Quicherat, 1876.2; Samaran, 1973.4.  In
bibliographic citations of books, inclusive pagination is given if
there is a specific section or chapter devoted to Villard (e.g.,
Lance, 1872.1; Gimpel, 1976.2).  However, in many books Villard is
discussed in a number of places with no main "entry" (e.g., Cerf,
1861.1; Focillon, 1938.1).  In these instances it has not been pos-
sible to give inclusive pagination in the bibliographic citation.  In
all annotations specific page numbers of the edition employed are
provided with principal points summarized or quotations included:
Lefrançois Pillion (1949.3) "Stresses the unique significance of the
manuscript, suggesting (p. 62) that it has lost twenty to twenty-five
leaves and noting (p. 65) that its pêle-mêle character and cluttered
drawings are attributable to the high cost of parchment."  In addi-
tion, the Villard drawings employed in each entry are listed, to-
gether with their source if this can be determined.  Where no source
is listed, the illustration is made from the Bibliothèque nationale
negative.

A note of caution is in order concerning references on which I
relied.  I have assumed that the official indexes to various journals
are accurate and, if they contain no listing for Villard, that the
journal in question has no material on him.  However, in actual
practice this is not always so, the Bulletin monumental being a
notable case of incomplete indexing.  Of course, published indexes
always appear after (sometimes long after) the materials on which
they are based.  More recent issues of many journals have not yet
been indexed.  In these cases I went to the journals themselves.  A
list of indexes consulted follows this note.

After some vacillation, I decided to include all obtainable re-
views of the various facsimile editions of the Villard manuscript.
Certain of these are perfunctory and more announcements than critical
analyses. Others, however, contain major essays on Villard and his
manuscript in addition to posing significant questions yet to be
answered. It proved impossible to secure a number of late 1930s
German newspaper reviews of the first edition of the Hahnloser fac-
simile. The second edition of Hahnloser lists most of these.

In preparing this or any study of Villard de Honnecourt, a mini-
mum of four editorial decisions have to be made. The first is what
name to employ for Villard himself. The second is what to call his
manuscript. The third is what to term the writing which appears in
the manuscript. And the fourth is how to designate the leaves of the
manuscript.

Villard gives his name twice in his manuscript, spelled two dif-
ferent ways: "Wilars dehonecort" (fol. 1v) and "Vilars de honcort"
(fol. 15). Later additions to the manuscript give his last name as
"De Honnecor" (fol. 3, fifteenth century) and as "De Honnecourts"
(fol. 23v, fifteenth century or later). A thirteenth-century addi-
tion to the manuscript (fol. 15) gives his name in Latin as "Ulardus
d[e] Hunecort." Various writers since 1858 have employed "Vilars,"
"Vilart," "Villars," "Villart," "Villardt," "Villard," and "Wilars."
My personal inclination, based on a comment by my colleague Meredith
P. Lillich, is that if a man answered to "Wilars dehonecort," he
should not be called "Villard de [or of] Honnecourt." But I have,
with some misgiving, followed the most common practice and have used
simply "Villard" or "Villard de Honnecourt." However, all citations
indicate the name used by the author of the study cited.

Villard in three places (fols. 1v, 9v, and 14v) terms his manu-
script a "book" (livre) but nowhere gives it a title. Various au-
thors have employed a great variety of designations, including "book,"
"encyclopaedia," "lodge book," "model book," "notebook," "sketchbook,"
"shop manual," "textbook," and "treatise," to cite but the most com-
monly employed terms. The designation employed by any given author
is his or her personal choice, as is the way Villard's name is
spelled; but this choice has a different effect on the reader. These
designations are neither neutral nor synonymous. The title employed
usually indicates the purpose the author assigns to the manuscript.
For Hahnloser the manuscript was a "lodge book" (Bauhüttenbuch). For
Frankl, on the basis of Hahnloser's interpretation, it was a "text-
book" (Lehrbuch). The French most commonly refer to the manuscript
as an album ("carnet des notes de voyage") or as an album de croquis,
which translates into English as "sketchbook." This latter is the
designation most frequently employed by American and British writers,
although the word "sketchbook" appears to be interchangeable with the
designation "notebook." A number of writers refer to the manuscript
as a "model book," meaning that it provided or was intended to pro-
vide iconographic and/or stylistic models. Yet others employ

"notebook," "sketchbook," and "model book" as synonyms. I adopt the literal and noninferential designation "manuscript."

How one terms the writing Villard (and others) added to certain of the drawings in the manuscript is likewise a decision based on one's interpretation of the purpose of the manuscript and its drawings. Among the designations used by various authors are "addenda," "captions," "comments," "descriptions," "instructions," "legends," "notes," and "text." These are no more interchangeable than the various titles employed, since each has a specific connotation if not a precise definition. The fact is that Villard's writings in the manuscript are all addenda in the sense that they were added after the drawings were made (see Introduction). They also are variously comments, explanations, or instructions, depending on what they say. When Villard notes (fol. 6) "Of such manner was the sepulchre of a Saracen I saw one time," he is simply identifying the subject of the drawing. When he says the same thing of a horologe (fol. 6v), he adds a written description of its various parts. When he draws a catapult (fol. 30), his text is different. He gives specific dimensions--the only drawing in the manuscript for which he provides measurements--and he says, "If you wish to make the strong engine which is called a trebucet, pay attention [to these instructions]." Thus Villard's addenda had, as did his drawings, various purposes. Since the purpose of this bibliography is not primarily to explain either Villard's drawings or his written addenda to them, I have employed the term "inscriptions" for his written comments in the literal sense of something "written in," without attempting to suggest specific reasons for his having done so.

The final "judgment call" one has to make is what to call the surfaces containing the drawings and inscriptions. Villard himself refers to them as "leaves," as one would expect of a medieval writer, although in one place he employs "leaf" in the modern sense to indicate not a single piece of parchment but "pages" in the sense of the front and back of a single leaf. Since the greater number of commentators on Villard knew the manuscript only through one or more of its facsimile editions, not having seen the original, they generally refer to "plates" as numbered in whatever edition(s) they employed. This is confusing since the different facsimile editions employ different numbering schemes, using both arabic and roman numerals and applying different numerical designations to the same original leaf because the authors omitted one or more leaves or, in the case of Bowie, rearranged the sequence of the leaves. Certain of the earlier commentators correctly, I believe, designated the leaves as "folios." This is the system I have adopted. It is the standard means of designating leaves in medieval manuscripts and was the medieval method of doing so. There are now thirty-three individual leaves in the Villard manuscript, hence sixty-six different surfaces. Each leaf is given one number (fol. 1, 2, 3, etc.). The right or front (Lat: recto) surface of each folio is indicated simply by "fol." plus a number (e.g., fol. 14); the rear face of the same leaf is

designated by the same number plus the addition of the letter "v" (Lat. verso = back, rear; e.g., fol. 14v).

Adopting this scheme for designating the different leaves of the manuscript has the advantage of historical precedent. It has the disadvantage of introducing yet another scheme of numbering for the leaves. However, the individualistic designations employed by various authors have resulted in chaotic cross-references. One cannot know from a given study if the author is employing "plate" to indicate his or her illustration, one of the facsimile plates, or a specific drawing by Villard. Moreover, the term "plate" has a misleading contemporary connotation which suggests to most people a full-page illustration. I use the term "figure" to indicate a given drawing by Villard on a specific folio. It is to be hoped that future commentators on the Villard manuscript will abjure all personal numbering schemes and employ the historic medieval scheme which is both simple and explicit.

In the Introduction and in the "Writings about Villard and His Drawings, 1666-1981" I have given the site name only of churches commonly associated with Villard, for example, "Reims," not "Cathedral of Notre-Dame at Reims." For identification of the churches in question, see the "Appendix: Churches Attributed to Villard."

Many colleagues have called my attention to references I might otherwise have overlooked, and I am especially grateful to the following for having provided materials otherwise inaccessible to me: László Gerevich (Hungarian Academy of Sciences, Budapest), Gloria Gilmore-House (International Center of Medieval Art, The Cloisters), Jean Gimpel (Gimpel Fils, London), Peter Kurmann (Free University, Berlin), Walter C. Leedy (Cleveland State University), Stephen Murray (Indiana University), Lon R. Shelby (Southern Illinois University, Carbondale), Thomas Thieme (Chalmers School of Architecture, Göteborg), Harry B. Titus (Wake Forest University), and Jan van der Meulen (Cleveland State University). Professor Thieme rendered a special service by surveying Scandinavian literature on medieval art for references to Villard. Dean Laszlo J. Hetenyi of Oakland University translated Hungarian items for me, and I was assisted with translations from German by Ms. Susan Piotrowski of the University of Oklahoma and by Dean Robert E. Simmons of Oakland University.

The great majority of bibliographic items concerning Villard had to be secured through interlibrary loan from various institutions. Without the expertise and efforts of Ms. Linda Guyotte and Ms. Mary Wright of the Kresge Library at Oakland University, who tracked down and secured for me so many items, this bibliography could not have been prepared.

## Preface and Bibliographical Note

This work has been edited by Professor Herbert L. Kessler of The Johns Hopkins University, to whom I am most grateful.

Finally, I would be most grateful to any reader who would indicate to me any omissions he or she considers serious.

# Dictionaries, Encyclopaedias and Indexes Consulted

Allgemeines Lexikon der Bildenden Künstler (Thieme-Becker)
Art Bulletin
Art Index
Avery Index to Architectural Periodicals
Cahiers de la Civilisation Mediévalé
Catalog of the Avery Memorial Architectural Library
Catalog of the Harvard University Fine Arts Library
Encyclopaedia of World Art
Journal of the Society of Architectural Historians
Katalog des Kunsthistorischen Instituts in Florenz
Metropolitan Museum of Art Catalog
New York Public Library Dictionary Catalog of the Art and Architecture Division
Répertoire d'Art et d'Archéologie
RILA (Répertoire international de la littérature de l'art)
Ryerson Library of the Chicago Art Institute
Société Française d'Archéologie (Bulletin monumental and Congrès archéologique)
Technology and Culture

# Introduction: The Manuscript and Its Artist

Villard de Honnecourt and his manuscript are in reality one and the same, for Villard himself is unrecorded in history save in his manuscript. Any attempt to understand Villard, to recreate his life, depends on a thorough familiarity with his one legacy to history and, especially, an ability and willingness to distinguish between its contents and what has been written about those contents. Thus one must begin any investigation with the manuscript itself.

## 1. THE MANUSCRIPT

There are three essentially inseparable interrelated questions concerning the Villard manuscript. What was its original extent? What is its history? What was its purpose? As the entries in this bibliography so amply demonstrate, there is little agreement on answers to any of these questions, especially the third.

As it exists today in the grande réserve of the Bibliothèque nationale in Paris, the Villard manuscript is an unpretentious item rather easily described. It consists of thirty-three parchment leaves composed of thirteen bifolios and seven folios sewn along one vertical edge. These leaves are contained in seven gatherings or quires as follows: Quire I, 3 bifolios and 1 folio; Quire II, 2 bifolios and 3 folios; Quire III, 1 bifolio and 1 folio; Quire IV, 2 bifolios and no folios; Quire V, no bifolios and 2 folios; Quire VI, 4 bifolios and no folios; Quire VII, 1 bifolio and no folios.

These quires are themselves contained in a dark brown pigskin binding forming a portfolio which, seen from above, looks like this in schematic form:

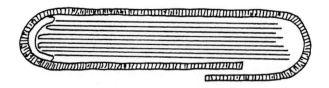

There is general agreement that this portfolio dates from the thir-
teenth century, but some commentators (Lassus; Burges, 1858.1) pro-
pose that it may not be the original binding of the manuscript.

The parchment leaves of the manuscript vary widely in color,
quality, and texture, suggesting they were acquired by Villard at
different places and at different times. The leaves average ±235 mm
(9.25 in.) in height by ±155 mm (6.10 in.) in width and are sewn and
bound so as to be more or less even along their upper edges (see
Frontispiece). Bucher claims that the folios were originally larger
(255 mm × 180 mm) than they are at present, and some trimming may
have taken place at an unknown date. However, there is a thirteenth-
century numbering scheme along the top edge of some leaves (see
below), including one (fol. 8) with an irregular upper edge, suggest-
ing this leaf was always its current size which, in turn, may indi-
cate that no alteration or trimming occurred after the leaves were
assembled as a manuscript.

The manuscript was last unbound in 1926, to permit study by
Hahnloser, who claims it was rebound differently from the way it had
been prior to 1926. My own examination of the manuscript does not
confirm this, nor does it reveal anything about the original contents
or sequence of folios because the manuscript had been unbound and re-
bound at least once previously, and probably more than once. Folio 13
contains an inscription by someone other than Villard, a so-called
Master II (see below), in the fold or gutter of what originally was a
bifolio. This inscription could not have been made had the manuscript
not then been unbound. On the inside of the front flap of the port-
folio there is a glued paper carrying the date 1533 which <u>may</u> indi-
cate that the manuscript was rebound at that time. On the inside
lower third of the front flap is the notation "Volume de 33 feuillets/
31 janvier 1893." This certainly represents an inventory made at that
time; it may reflect a rebinding at that time.

The question is not how many times the manuscript has been rebound,
but what effect(s) this may have had on the arrabgement of the folios.
And a yet more important question is how many leaves have been lost
from the manuscript since the thirteenth century. There are at least
three proofs that losses have occurred: Villard refers (fols. 14v
and 30) to drawings no longer in the manuscript; in the fifteenth
century the leaves were counted and at that time numbered forty-one
(see below); and there remain sewn into the gutter fragments of
leaves which have been removed from the manuscript. These several

indications of loss do not, however, confirm the extent of loss. On this there is quite a difference of opinion, from a low of thirteen leaves (Omont) to a high of thirty-one (Hahnloser), with the middle ground ranging from twenty-one (Lassus and Willis) to twenty-five (Lefrançois Pillion, 1949.3) lost leaves. My conclusion, after examination of the manuscript, is that Omont's estimate is closest to fact. As can be seen from the composition of the quires given above, losses from Quires V and VII appear to have been the most extensive, provided that all quires originally were of the same or approximately the same extent, but this is by no means certain.

Beginning with Quicherat (1849.1), various authors have tried to catalog the contents of the Villard manuscript, either within broad categories such as (and usually based on) those of Quicherat, or in great detail by counting individual drawings. This latter is an interesting but futile exercise because no two individuals see the distinctions in the figures the same way. As Bucher notes, Hahnloser came up with one hundred seventy-three "human and sculptural representations" whereas he found ninety-four "human figures." My own classification of the materials in the Villard manuscript, based on a scheme suggested by Stephen Murray of Indiana University, is: (i) animals, (ii) architecture, (iii) carpentry, (iv) church furnishings, (v) geometry, (vi) humans, (vii) masonry, (viii) mechanical devices, (ix) recipes or formulas, and (x) surveying. This list is inclusive without suggesting anything about the profession or purpose of the artist, the principal shortcoming of Quicherat's scheme.

The history of the Villard manuscript is quite imperfectly known. Gaps of centuries exist between clues, and these clues are hints in a complex puzzle rather than data providing its solution. To begin at the beginning, it is unknown when the manuscript came into being. As discussed below under "The Artist," the best estimate is that Villard made his drawings over a period of years, most likely in the 1220s and 1230s, although this might be extended somewhat in either direction.

Whatever the real dates of the drawings, there are more significant considerations. First, Villard made his drawings in different places and at different times. Second, Villard did not make these drawings in what would today be called a sketchbook. This is proved by the fact that in one instance a drawing begun on one leaf of a bifolio (the spears of the riders on fol. 8v) runs through the gutter onto the opposed leaf of the bifolio (emerging above the heads of the seated couple on fol. 14). In addition, the head of a standing male nude and a leaf-head on fol. 22 run into the gutter. These drawings could not have been executed in a bound manuscript. Third, Villard added his inscriptions sometime after he made his drawings and after the folios were bound. As Willis observed in 1859, Villard apparently had not anticipated the use of inscriptions when the drawings were executed, for he had to fit certain inscriptions awkwardly

around the drawings. Folio 9 provides an especially effective illustrative example of this. Also, Villard's use of sequential past tenses proves that the inscriptions came after the drawings. When he drew (fol. 10v) a window at Reims he noted, "I had been sent into the land of Hungary when I drew it because I liked it best." This inscription was clearly added after the drawing was made to explain, however imprecisely, why the drawing had been executed.

Villard's inscriptions are more consistent than his drawings. They were made with a crow-quill pen (Burges, 1858.1) and one ink in a steady, precise lettering throughout. This suggests they were made over a short period of time, probably days at most, as distinct from the years required for the drawings. Villard wrote a rather fluent French, allowing for medieval spelling variations, and he wrote in the dialect of his native Picardie. The only indication that he knew Latin is his use of the word leo on fols. 24 and 24v. Certain wordings in the inscriptions prove they were written after the folios had been assembled, if not actually bound. In three places (fols. 1v, 9v, and 14v) Villard refers to a book (livre) and in one place (fol. 19v) he says, "in these four leaves (fuelles) are figures of/from the art of geometry." He elsewhere (fol. 21v) says, "see there two leaf faces," referring to the facing leaf (fol. 22). Folios 21v and 22 are separate leaves of separate quires, thus this inscription could not predate assembly of the leaves into manuscript format.

At some point in his life Villard got the idea of "going public" with his drawings, to paraphrase Lon Shelby's (1975.2) felicitous expression. What prompted Villard to do so, other than ordinary human vanity, and whether he was self-motivated or had the idea suggested to him, are unknown. It was at this time that Villard bound or had bound his drawings and added inscriptions to certain of them. To judge from his inscriptions, especially his "preface" on fol. 1v, Villard believed or hoped that his inscribed drawings would be useful. But it is unclear to whom he thought they might be useful. As Shelby first (1975.2) observed, Villard addressed what he was by then calling a livre to no one in particular, which is a different way of admitting that it was addressed merely to posterity (Willis).

This notwithstanding, it has long been believed (Garling, 1858.2) that Villard created his manuscript for the lodge in which he worked or which he headed. Not everyone has accepted this view (Mérimée, 1858.5), but it is still the prevailing interpretation.

Whenever the manuscript left Villard's possession, and wherever it went, its subsequent alteration has provided a source for contentious speculation. Until Schneegans discovered (1901.1) that three different individuals had entered inscriptions in the manuscript, it was assumed that all of its drawings and inscriptions were by Villard only; most people do not realize that all nineteenth-century commentary was based on this misunderstanding. Schneegans designated the three hands as "masters," of whom the first was Villard. He was

thinking in epigraphical and/or philological, not architectural, terms when he employed the expression "master."

For a generation Schneegans's discovery remained unknown or ignored, then in 1935 its virtually inevitable consequence occurred. Hahnloser in his facsimile and Überwasser (1935.4) simultaneously and independently advanced the hypothesis that Schneegans's second and third masters were Villard's successors in his lodge (Bauhütte). There is not a modicum of evidence to support such a claim, but it has since developed into one of the standard "facts" in Villard studies (Harvey, 1945.2; Scheller, 1963.5). I employ the designations "Master II" and "Master III" because of the weight of tradition and to avoid confusion, but it would be more accurate and less suggestive to designate the two individuals who made addenda to the manuscript as "Hand I" and "Hand II."

When and under what conditions Master II gained access to the Villard manuscript is unknown. The commonly accepted date is ca. 1250 (Branner, 1960.5) to ca. 1260 (Frankl, 1960.6), but it must be understood that this dating is relative and depends on the supposition that Villard had concluded his activity with the manuscript somewhat earlier. Master II added Picard and Latin inscriptions to certain of Villard's drawings (see Schneegans, 1901.1 for details) and erased fol. 20 and the upper half of fol. 20v to add his own drawings and inscriptions. There is general agreement that Master II's additions are hints to masons about how to solve various technical problems, but there is disagreement as to the precision and usefulness of these hints. Moreover, there is a dispute as to their source. On fol. 20 Master II stated, "totes ces figures sunt estraites de geometrie." Some commentators (Mortet, 1910.1, without realizing the drawings in question were not by Villard; Branner, 1957.1) have taken this as proof that this material was copied from another manuscript, either a treatise on geometry or a manuscript similar to Villard's. Others (Shelby, 1972.6) emphatically deny the "manuscript model" theory, and the question is unresolved.

This particular puzzle may never be resolved, but Master II's addenda do not prove him to have been an architect. They demonstrate only that he was interested in masonry. He could have copied the formulas on fols. 20 and 20v, if one accepts the "manuscript model" theory, without understanding how they worked. Either way, his additions do not prove him to have been a direct successor to, let alone a pupil of, Villard. Bucher alone of all commentators suggests that Master II, while he inherited the manuscript from Villard, was a contemporary who worked with him on revising it to its present form. This novel proposal seems to be contradicted by the fact that Master II misidentified one of Villard's drawings (a plan of Meaux on fol. 15), something he is unlikely to have done were he and Villard collaborators.

Yet later in the thirteenth century (Schneegans, 1901.1; Branner,
1957.1) a third individual, Master III, added commentary to the manu-
script (see Schneegans, 1901.1 for details).  This individual wrote
in French, but not in the Picard dialect, and showed no interest in
architecture, save for a gratuitous paraphrase (fol. 31v) of a
Villard inscription (fol. 32) concerning a drawing of the elevations
of Reims.  Two possible inferences to be drawn from this are that
Master III was not an architect and that the manuscript was no longer
in Picardie by the end of the thirteenth century, having been brought
to an area where the Île-de-France or "royal" dialect was in common
use.  These are inferences only, although it is reasonable to con-
clude, on the slight evidence available, that Master III is less
likely to have been a follower/pupil of Master II than the latter is
to have been a follower/pupil of Villard.  Bucher makes the intrigu-
ing suggestion that Master III was a cleric interested in the manu-
script for its esoteric value as a curiosity rather than for any
practical usefulness it may have had as a lodge manual.  This idea
may have merit, although it requires considering why a cleric mis-
identified traditional Christian iconography (for example, a sleeping
apostle on fol. 17 as the fallen Christ) and why, if he had anti-
quarian inclinations, he wrote not in Latin but in French.

If Master III owned the manuscript ca. 1290/1300--again, a sup-
posed dating relative to the datings assigned to Villard and to
Master II--it must by this time have no longer been in or used in a
building lodge, if it ever had been so used.  As Bucher has proposed,
it may have been in one or more clerical libraries.  Sometime in the
fourteenth (?) century one "Jehanne Martain" autographed fol. 33v but
why, and who he was, are unknown.  The hypothesis advanced by Enlart
(1902.3) that the manuscript was owned, and added to, by the sculptor
Jean de Roupy (d. 1438), known as Jean de Cambrai, is altogether un-
convincing.

Only late in the fifteenth century, to judge from the paleography
involved, can the manuscript again be accounted for.  At that time a
"J. Mancel" counted the leaves then in the manuscript and noted on
fol. 33v that "en ce livre a quarente et i feillet."  Mancel also
attempted to complete a thirteenth-century non- (post-?) Villard
numbering of the folios but succeeded only in creating yet more con-
fusion.  While Mancel cannot be identified, his activity with the
manuscript suggests it was then part of a collection of manuscripts.

The next notation in the manuscript is the insertion of the date
1533 on fol. 8, with no indication as to what this refers or by whom
it was made.  The common view is that by this time the manuscript was
in Chartres in the possession of a family named, in the most common
spelling, Félibien.  However, the evidence for this is circumstantial
and based in part on a forgery on fol. 1 of the manuscript.  This
intriguing and not unamusing bit of chest-thumping is too complex to
detail here, but is explained fully in Hahnloser and in Bucher and
in two articles (1946.2 and 1973.4) on this specific subject by

# Introduction

Samaran. In summary, ca. 1600 someone erased an inscription by Villard to note that the manuscript contained the "machines" or "engines" of his engineer ancestor, one Alessio Fellibien, and added the date 1482. The absurdity of this claim must have embarrassed some later member of the family, who attempted to eradicate the inscription and did so sufficiently thoroughly that it can now be read only under ultraviolet light. The same is true of an inscription on fol. 23v between the legs of the horse, which identified its rider as a Félibien who was the "ancestor" (aiel) of Villard.

Who among many possible Félibiens erased these references to the family connection with Villard is unknown. It is possible that it was André Félibien, the first individual ever to mention the Villard manuscript in a published work, the first item (1666.1) of this bibliography. As pointed out there, it is not certain beyond all doubt that the reference is to the Villard manuscript, but it is difficult to conclude otherwise.

As the manuscript probably had "fallen into André's hands" through inheritance, so must he have willed it to one of his two sons, either the architect Jean-François (1658-1733) or the Maurist scholar Dom Michel (1666-1719). Both published extensively, in contexts which would seem to call for reference to the manuscript, yet neither makes any mention of it. Jean-François wrote a history of famous architects (Recueil historique de la vie et des ouvrages des plus célèbres architectes, Paris, 1687), including those of the Gothic period in France, but he either was unaware of Villard's manuscript or did not consider Villard sufficiently "celebrated" to mention. Dom Michel wrote on manuscripts but made no reference to that of Villard.

In the seventeenth or early eighteenth century the Villard manuscript came into possession of the Benedictine abbey of Saint-Germain-des-Prés in (but then outside) Paris. As Dom Michel died at Saint-Germain-des-Prés in 1719, having left his library to the abbey, it must be assumed that this is how the Villard manuscript entered the abbey collection. It was kept there throughout the remainder of the century without attracting the attention of any scholars, so far as can be determined from publications. One of the librarians at Saint-Germain-des-Prés catalogued (fol. 1) the Villard manuscript as s[anc]ti Germani a Pratis N[o] 1104, and it was there that the manuscript folios were given the arabic numbers 1-33 now on the rectos of its folios. This means that since the time of Mancel, in the late fifteenth century, seven leaves had been lost/removed from the manuscript. It likewise confirms that no losses have occurred since the eighteenth century.

During the French Revolution, late in 1795, the Saint-Germain-des-Prés collection was inventoried at the Bibliothèque nationale, where the Villard manuscript was designated (fol. 1) by its Saint-Germain-des-Prés number, 1104, and was classified as a "Latin" manuscript, suggesting that whoever did the cataloguing read few if any of the manuscript inscriptions.

Only in 1865, forty years after Willemin and Pottier had first published (1825.1) certain of its illustrations and eight years after Lassus had published his facsimile edition, was the Villard manuscript recatalogued as part of the <u>fonds français</u> in the Bibliothèque nationale and assigned the shelf number it has had since that time, MS. fr. 19.093.

Disagreement among scholars about the original extent of the Villard manuscript and its history are mild in contrast to the furious arguments raging over its purpose and, related to that, what to call it. This academic donnybrook does not depend, surprisingly enough, on how one views Villard's profession; even those who agree that Villard was an architect find themselves in disaccord concerning the nature and purpose of his manuscript. Four basic interpretations are commonly held, although these are not without some overlap.

First, the most common view, in early literature especially but still the most prevalent, is that the manuscript was simply a sketchbook of random drawings of various ideas and objects Villard found, or hoped to find, of use to him in his profession. While it is something of an oversimplification, this might be said to be the French and, more recently, the American view of the manuscript.

The second interpretation is that the manuscript was a model book or pattern book. This opinion has champions of all nationalities, among others Booz (1956.1), Evans (1969.1), Morey (1935.3), Scheller (1963.5), and Van Marle (1926.2), although there are those across the entire span of Villard studies who emphatically deny this view, from Mérimée (1858.5) to Sauerländer (1970.5). Those who accept the "yes, it was a model book" approach also accept the view, whether stated or not, that there is a certain logic to the contents of the manuscript. Those who deny the model book designation do so on the basis that its contents are too random, too haphazard, to have been of much use to an artist. Focillon (1931.1) takes this view, and Lefrançois Pillion (1949.3) refers to the subject matter of the manuscript as "<u>pêle-mêle</u>."

The third interpretation of the manuscript dates specifically from the publication of the Hahnloser facsimile in 1935. This is the view that it was a lodge book or shop manual (<u>Bauhüttenbuch</u>) prepared for use at a construction site. Hahnloser was by no means the first commentator to suggest that the Villard manuscript was used in a lodge (see Stein, 1929.3), but the intensity and explicitness of Hahnloser's interpretation forever reduced the options of others. Subsequent scholars have been forced to split into anti- and pro-<u>Bauhüttenbuch</u> camps. By and large French scholars have rejected this interpretation, a point of annoyance to Hahnloser who, in his second edition (and in 1971.4), chided the French for their stubbornness. Some French scholars were persuaded to Hahnloser's view, most notably Réau (1936.2) and Du Colombier (1953.2), although the latter took the

curious stand that the manuscript is a <u>Bauhüttenbuch</u> which must be called an <u>album</u>.

The fourth interpretation about the nature of the Villard manuscript is both the oldest and the newest and combines aspects of the other three. A number of nineteenth-century writers noted the variety of subject matter in the manuscript, some (Viollet-le-Duc, 1863.1) in admiring if perplexed terms, other (Renan, 1862.1) in critical terms. The idea was expressed early (Garling, 1858.2) that the manuscript was intended for the instruction of others, an obvious conclusion given Villard's inscriptions. This view of the manuscript maintains that it was a teaching manual. Over the years certain proponents of this interpretation, associating the notion of diversity of content and didactic purpose, have gotten carried away in their characterizations of the completeness or thoroughness of the manuscript: "thoroughly practical 'building encyclopaedia'" (Harvey, 1950.2); "notes on every aspect of the building crafts, technical procedures, and artistic composition" (Jantzen, 1957.4); "first organic treatise on medieval architecture" (<u>Encyclopaedia of World Art</u>, 1959.3); "<u>summa</u> <u>scientiae</u> <u>et</u> <u>artis</u>" (Binding and Nussbaum, 1978.2). The extreme view in this connection is that of Frankl (1960.6) who claimed that the manuscript was a textbook (<u>Lehrbuch</u>) "encompassing everything a Gothic architect needed to learn." This view has been soundly denounced (Shelby, 1970.7 and 1975.2), but the damage has been done. As might be expected of (or, indeed, as is required of) such an interpretation, its proponents (Bucher, following Frankl) maintain that the Villard manuscript is organized into chapters.

Which of these four interpretations of the Villard manuscript is correct? Most likely none is entirely correct or, rather, each is partly correct. It is easy to demonstrate that the Villard manuscript went through an evolutionary process during which it served or was intended to serve different purposes at different times (Barnes, 1960.1).

At some point in his life for now unknown reasons Villard began to make sketches or drawings of things that interested him. These he must have made in a random manner, on sheets of parchment acquired as he needed them. He seems originally to have had no specific purpose in mind, and he was quite casual about adding one drawing to a leaf with a preexistent and unrelated drawing, for example, gamblers (?) and animals plus a Tantalus cup and the mechanism for a handwarmer on fol. 9, wrestlers plus two church plans on fol. 14v. It has been maintained (Hahnloser; Frankl, 1960.6; and Bucher) that Villard took care to employ his better quality leaves for his better drawings, but this claim is suspect. Allowing room for disagreement as to which drawings are Villard's "best," two of his more finished drawings, a choirstall and a standing figure appear on fol. 29, an imperfectly shaped leaf and one of the darkest and most brittle in the manuscript. One should imagine (Wormald, 1936.3) that Villard preserved

his unbound parchment leaves in a portfolio not unlike that now
serving as the binding for the manuscript.

Just why Villard began making drawings is unknown.  He seems to
have had a wide variety of interests in things around him, and he was
especially attracted to the unusual and the exceptional (Sauerländer,
1970.5), for example, to a pagan (Roman?) tomb which he said was that
of a Saracen.  Villard was apparently captivated by mechanical de-
vices of all sorts, including those that were little more than triv-
ial gadgets (see Gimpel, 1971.1 and 1976.2).  He very clearly had
antiquarian interests so far as sculpture was concerned, but Roman
architecture apparently held no appeal for him.  He was impressed by
the geometry employed in standardized formal designs as well as in
genre scenes he chanced upon.

However, Villard's voracious imagination alone cannot explain his
drawings.  No corroborative sketches or collections of sketches exist
from the thirteenth century to suggest that anyone made or kept
visual records merely for the sake of keeping records.  Sketchbooks
did not exist and parchment, even the generally poor-quality parch-
ment employed by Villard, must have been reasonably costly.  One must
conclude that Villard set out to make his drawings, random as they
appear to be, with some purpose in mind.  This conclusion is inti-
mately related to the question of his career (see below, "The
Artist"), but for the present let it be noted only that his various
drawings must have been mnemonic (Mérimée, 1858.5; Bucher), serving
as aide-mémoires for things he found of interest.  At this stage he
probably made unrelated individual drawings, although occasionally
two leaves or the recto and verso of one leaf were required for a
single subject or theme.  However, some subjects required or were
given more extensive treatment, for example, Reims, which takes up
fols. 30v, 31, 31v, 32, and 32v, or his series of drawings of geom-
etry and of humans and animals, which occupy two leaves or four
surfaces (fols. 18, 18v, 19, and 19v).

This latter pattern may have been the crucial factor in the next
and decisive step in the evolution of the manuscript, in fact, that
of its evolution from a collection of drawings to a manuscript.
Villard must have eventually come to realize that he possessed in-
dividual drawings and/or sets of related drawings which, if assembled
properly, could produce a reasonably coherent yet impressively varied
ensemble.  Perhaps this idea was suggested to him, for it is incon-
ceivable that he did not show his drawings to others since it is
known that he collaborated with a certain Pierre de Corbie in devis-
ing the scheme for one drawing, a church plan on fol. 15 which he
claims that he and Pierre invented (trova).

Villard must by this stage have become hopeful, or even con-
vinced, that his assembled drawings would be useful to others.  And
this poses for us, as perhaps it did for Villard himself, a funda-
mental question:  was it necessary to make specific additional

drawings to complete the collection satisfactorily?  Those who see
the manuscript in <u>Bauhüttenbuch</u> or <u>Lehrbuch</u> terms (Hahnloser; Frankl,
1960.6) believe Villard did just this, creating entire sections or
"chapters," expecially the "chapter" involving animals.  I do not
believe this to have been the case, but it certainly cannot be proved
that Villard did not then make one or more drawings.

That Villard attempted, as best he could, to arrange his drawings
into related sets is clear.  And it is clear that this process re-
quired some editorial decisions concerning layout and sequence.  Be-
cause he had made unrelated drawings on given folios, occasionally in
opposed directions, he had to choose which individual drawing of the
two was the more important or in which "set" he wished to include it.
For example, he believed his choirstalls on fol. 27v were of greater
interest than the standing figure because the folio appears with the
choirstalls upright and the human figure upside down.  This particu-
lar folio may not be in its original position in terms of sequence,
but the inscription referring to choirstalls was to be read with the
choirstalls, indicating that the figure was considered less impor-
tant.  This explains why the two figures on fol. 28 are upside down,
this being the opposed leaf in bifolio 27-27v/28-28v.

A question no one appears to have considered is whether Villard
had a (much?) more extensive collection of drawings from which he
selected only those he considered to be his best or his most instruc-
tive.  There is no answer to this, given the absence of even a single
surviving Villard drawing other than those in his manuscript.  The
somewhat jumbled variety of drawings, the inconsistent leaf textures
and sizes, and the explanatory inscriptions Villard felt were re-
quired all suggest that he employed most of what he had on hand when
he decided to create a manuscript.

One must conclude that Villard did not execute an extensive se-
ries of drawings once he had determined to make his "book."  He may
have realized that there were some inconsistencies involved in his
arrangements, and he also must have realized that certain of his
drawings would be curious if not incomprehensible to future posses-
sors of his manuscript, thus certain of his inscriptions are simple
explanations of the subject matter of given drawings.  Others involve
instructions about how to do such and such.  A persistent tone is
that of his personal achievements, where he had been and what he had
seen:  "Of such manner was the sepulchre of a Saracen I saw one time"
(fol. 6); "whoever wishes to make a horologe, see here one that I saw
one time" (fol. 6v); "I have been in many lands, as you discover in
this book" (fol. 9v); "I was one time in Hungary, there where I
stayed for many a day" (fol. 15v); "Note well that it [the lion] was
drawn from life" (fol. 24v).

As indicated above, it is not known to whom Villard addressed his
manuscript.  It is accordingly not certain precisely how he expected
it to be used, but he leaves no doubt that he believed (fol. 1v) it

to be useful concerning carpentry, machines, and masonry.  He clearly believed that its geometry was a special feature.  In his "preface" he says, "you will find the principles of representation (portrai-ture), and the features as the discipline geometry commands and instructs it [to be done]."  On fol. 18v at the beginning of two folios of similar material, he says, "here begins the principles of the techniques of representation as the discipline of geometry in-structs [it to be done] for facilitating work."  At the end of these two folios, on fol. 19v, Villard states, "in these four leaves are some figures from the discipline of geometry; but to become familiar with it, it is necessary to pay careful attention."

The figures on these folios have engendered much attention and controversy.  They have been taken (Mortet, 1910.1) to prove that geometry, not arithmetic, was the basis of medieval design.  For Von Schlosser (1914.3) they proved that geometry dominated all medi-eval design.  Viollet-le-Duc (1854.1 and 1863.1) took them as proof that Villard was not a very gifted artist and had to rely on such aids.  Others (Burges, 1958.1; Wittkower, 1971.8, at least by impli-cation) have seen them as limiting Villard's artistic expression.

There is, to be sure, legitimate ground for questioning their usefulness because of their inconsistency or, in the words of Willis and others (Lorgues, 1968.5), their "arbitrariness."  It has also been proposed by a number of commentators (Du Colombier, 1953.2; Lefrançois Pillion, 1949.3; Lorgues, 1968.5; and Scheller, 1963.5) that Villard's geometric schemata did not generate or control his figures but were applied after the figures themselves were drawn.  Careful examination of the folios in question, in raking light with a magnifying glass, reveals that sometimes figures came first, some-times geometric schemata came first.  Neither can be taken as proof that geometry was the generating element of Villard's designs or, by extension, of Gothic designs in general.  Frankl (1945.1) and Pierce (1976.5) propose that the purpose of the geometric designs was to aid in transferring given figures from small to large size, as from a model book to a fresco or stained glass.

Whatever its function, perhaps less significant and less intel-lectual than is commonly thought, Villard's geometry has become embroiled in another long-standing controversy.  This is the question of whether Villard's geometry was a carefully guarded guild or trade secret not to be shared with those outside the profession.  Frankl (1945.1 and 1960.6) has been the foremost proponent of the "secret of the medieval masons" cult, and so far as Villard is concerned, Harvey (1950.2) and Kostof (1977.5) have accepted Frankl's view.  As might be expected, from the very beginning of Villard studies others (Garling, 1858.2) have not concurred.

This issue revolves not around Villard's geometric sketches in general, but around one specific geometric principle essential to medieval design.  This is the means of dividing in half or doubling

the area of a square, something which can be done geometrically but
not arithmetically. It has long been realized that this was a key to
medieval design, known to architects from Vitruvius through Mathes
Roriczer and, as Shelby has shown (1977.7), to designers who were not
principally architects, including Hanns Schmuttermayer. Known as
"rotation of squares" or "quadrature" (the term employed in the
bibliographic entries), the method is as follows: square are rotated
within or without one another so that the midpoint of each side of a
given square becomes the corner of the generated square (when reduc-
ing by half the area of the first square) or so that each corner of
the first square becomes the midpoint of each side of the generated
square (when doubling the area of the first square):

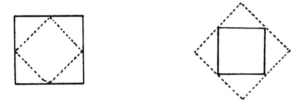

Master II added two examples of quadrature to the Villard manu-
script (fol. 20), one of which he says concerns the laying out of a
cloister and one of which he says concerns stonecutting. Whether or
not he understood how these worked, the many authors who cite these
two diagrams as proof of the use of quadrature in the thirteenth cen-
tury are correct.

It may not be correct to claim that Villard understood this fun-
damental design principle. He botched it very badly in his drawing
(fol. 16) of the Lausanne rose (Bucher, 1968.3 and 1972.2), suggest-
ing he could not recognize quadrature when he saw it. As pointed out
in the bibliographic entries, Überwasser (1949.4) and Velte (1951.3)
analyzed Villard's drawing (fol. 9v) of the Laon tower plan and came
up with "completely different interpretations" (Branner, 1955.2).
Villard may have vaguely understood the use of quadrature, at least
enough so as to employ it in a playful way in two of his drawings of
"pin-wheel" rotating masons on fol. 19v. What at first glance ap-
pears to be his most obvious use of quadrature, the "face in the
square" on that folio, may be something entirely different, as Frankl
(1945.1) pointed out. All this suggests that Villard may not have
had any professional secrets, certainly not any fundamental design
principles, to reveal.

It would appear that Master II found Villard's geometric schemata
incomplete if not useless, for he found it necessary to erase certain
of Villard's drawings and to employ the folios (20 and 20v) as pal-
impsests, adding his own more specific "how to do such and such"
diagrams and explanations. If Master II was a mason, and if the
manuscript entered some lodge, it is unproven that it "remained long

in a lodge" (Aubert, 1961.1). Just how useful the manuscript would
have been is questionable, and Bucher's proposal that its very lack
of practicality made it something of a curiosity to be preserved in
a clerical library is most attractive.

One cannot reasonably argue that the Villard manuscript, for all
its fascination, is an encyclopaedia, a manual, a treatise, or as-
sumes any form that connotes careful planning and completeness. In
the words of Viollet-le-Duc (1863.1), who knew something about com-
pleteness in encyclopaedias and treatises concerning architecture,
the Villard manuscript is, "ni un traité, ni un exposé de principes
classés avec méthode, ni un cours d'architecture théorique et pra-
tique, ni le fondation d'un ouvrage [sur l'architecture]."

## 2. THE ARTIST

If little is known of the history of the Villard manuscript, yet
less is known of its artist. Villard tells us virtually nothing
about himself, either who he was or what he did. He does not claim
a single professional work other than his book.

With two exceptions only, he says nothing about his travels. He
twice (fols. 10v and 15v) claims he went to Hungary or, rather, he
once claims (fol. 15v) to have gone there and once claims (fol. 10v)
to have been sent there. He elsewhere (fol. 9v) says that he had
been to many lands (m[u]lt de tieres), but it is by no means clear
that by this expression he intended to convey what today is under-
stood as geographical or political countries. For Villard, the
Laonnais (Laon) may have been one tiere, the Beauce (Chartres)
another.

It is by inference only that one assumes Villard to have been at
Cambrai, Chartres, Laon, Lausanne, Meaux, Reims, and Vaucelles, the
inference being based on the fact that he drew architectural, non-
portable features of churches at each of these sites. However, the
question has been raised (Branner, 1963.2) as to whether Villard drew
from drawings rather than from actual construction. If he drew from
drawings, as he surely did in the case of his plan of Cambrai (fol.
14v), the possibility exists that certain of his models came to
Villard rather than him going to them, that is, that he gained
access to drawings carried around by their creators in the same way
that he must have carried his sketches on his travels. Nonetheless,
it is probably reasonable to suppose that Villard visited those sites
recorded in one way or another in his manuscript.

The potential for two different interpretations of the nature of
Villard's architectural models raises a fundamental question about
the methodology of Villard studies. Depending on what they have
wished to prove, authors have accepted Villard's statements on a
selective basis. For example, Villard describes the object on

fol. 6 as "the sepulchre of a Saracen I saw one time." Adhémar
(1939.1) proposes that the model for this drawing was not a tomb
monument of some type but some sort of Byzantine or Late Roman con-
sular ivory. In doing this, apparently because no satisfactory
parallel now exists, Adhémar would have us believe that Villard was
either forgetful or a liar. Villard may in fact have been both; but
this approach to his inscriptions is unacceptable. Scholars may not
have it both ways, accepting Villard's statements when they fit their
theses, discrediting them when they do not.

It is only honest to take the view that Villard meant whatever he
said whenever he said it. It is true that his inscriptions were
added long after his drawing were made, and it is likely that time
had obscured specifics. It is also true that Villard found himself
attempting to bring order to a manifestly disorganized series of
drawings. Moreover, it seems obvious that Villard was not unduly
burdened by humilitas and that he made the most of any possibility,
for example, in bragging about his travels or boasting about the use-
fulness of his drawings. But this does not make him either dishonest
or deceitful.

Another real hindrance to interpreting correctly what Villard had
to say is that commentators have consistently misquoted his inscrip-
tions. Allowing that there is latitude in possible translations, no
purpose is served by misattribution. By way of demonstrating this, the
bibliographic entries include every instance encountered when Villard
has been miscredited with having made (fol. 9v) a personal aesthetic
judgment about the Laon tower. Beginning with Quicherat (1849.1),
dozens of authors report that Villard said the Laon tower was "the
most beautiful in the world" or "the most beautiful I have ever
seen." Were this correct, it might prove that Villard was a discern-
ing individual with developed aesthetic sensitivity. But he said no
such thing. He noted only that "in no place, ever, did I see such a
tower as is that of Laon," a strong but simple statement of fact.
Villard of course made aesthetic judgments. But without knowing what
he excluded from his drawings, it is impossible to determine the con-
verse significance of what he included therein. And it is absolutely
inexcusable to misquote him to support one's personal views.

The question of when Villard was active is more easily answered,
at least generally, than is the question of why he did what he did.
It is unsupportable that Villard was active into the 1260s (Viollet-
le-Duc, 1860.2; Chevalier, 1905.1), let alone that he lived as late
as 1270 or beyond (Henszlmann, 1858.3; Renan, 1862.1; Coulton,
1928.1). No author has yet identified for any Villard drawing a
model which came into being as late as 1250, although this fact does
not in itself provide a sure terminus post quem for Villard's activ-
ity since Bucher, especially, points out convincingly that Villard
appears either ignorant of or indifferent to structural and decora-
tive trends dating from the 1230s and later. Bucher notes that
Villard did not visit such progressive centers as Amiens and

Beauvais, although per se this proves nothing. It suggests, however, that Villard was conservative, and it is demonstrable that those architectural features which interested him sufficiently to be recorded all date in the 1230s at the latest and represent earlier developments.

The only architectural work drawn by Villard which is reasonably securely dated is one of the radiating chapels at Reims (fols. 30v and 31), begun in 1210/1211 and completed by 1221. The generally accepted dates for his other architectural models are the following: Cambrai plan (fol. 14v), 1230s; Chartres rose (fol. 15v), ca. 1220; Laon tower (fols. 9v and 10), 1230s; Lausanne rose (fol. 16), 1235 at the latest; Meaux plan (fol. 15), by 1220; and Vaucelles plan (fol. 17), 1235 at the latest. The Reims elevations (31v) and choir buttresses (fol. 32v) are subject to intense dating controversies, but are no later than 1241, probably a decade earlier. Thus the "ideal date" (Branner, 1958.1) for Villard's architectural drawings seems to be ca. 1230/1235.

This dating accords, it must be admitted, less than perfectly with Villard's style in his drapery renderings. For drapery he consistently adopted an interpretation of late antique folds and pleats, developed as a sort of classical revival in the Meuse Valley region in the 1180s, whose most famous practitioner was Nicholas of Verdun. This particular treatment of drapery has been termed Muldenfaltenstil ("trough-fold style") because of its sharply incised lines and is characterized by tightly curved loops which resemble hairpins or pothooks. Muldenfaltenstil, although found in manuscript and stained glass painting, metalwork, and stone sculpture, was largely limited to northeastern France, especially the area around Reims, and had almost disappeared by ca. 1230. Villard was virtually obsessed with Muldenfaltenstil, and there appears to be a parallel between his preferences in drapery treatment and those in architecture, namely, that he was most interested in what was no longer in vogue or, at least, was rapidly passing out of fashion.

If this speculation is correct, what is one to make of it? Does it indicate that Villard was something of an antiquarian? This seems possible, for he clearly was interested in antiquity. Yet he drew no ancient buildings. Conversely, those architectural features which he found worthy of recording have two things in common: either they were very unusual (Laon Tower, Lausanne rose), or were somewhat bizarre, perhaps unworkable solutions to problems (fol. 15, plan with alternating square and round radiating chapels, an example of which had been built at Vaucelles).

There is an alternative explanation possible for Villard's conservative, out-of-fashion drapery-rendering technique. If he was trained as a metalworker, particularly one who specialized in niello work, as has been proposed (Barnes, 1981.1), his drafting technique would have remained subconsciously constant throughout his career,

regardless of the length of time that career spanned. This does not, however, explain what appears to be a rather consistent selection of retardataire models.

Villard appears, in sum, to have been an individual of conservative tastes whose artistic activities date mainly in the 1220s and, especially, in the 1230s. There is no evidence to date his activity much later than this, and he cannot be proved to have been active much earlier. Bucher suggests he began sketching ca. 1216, and this seems possible, although it is unacceptable to associate him with the creation of a missal made for Noyon use possibly as early as 1200, as Vitzthum (1914.2) attempted to do. One probably would be safe in assuming that Villard was born in the last quarter of the twelfth century, closer to 1200 than to 1175.

Beyond these assumptions, to create a career for Villard is an entirely speculative exercise. It must be emphasized again that Villard himself, his vanity intact when he added inscriptions to his drawings, says nothing whatsoever of his professional career and claims authorship of no monument in any medium. Every building attributed to Villard (see Appendix) is attributed by modern authors on circumstantial evidence only, or on the basis of wishful thinking with no circumstantial evidence at all. In fact, the designation of Villard as an architect is a modern designation which dates from Quicherat's famous essay of 1849, the first truly scholarly study of the Villard manuscript.

Villard is now automatically termed an architect in literature both scholarly and popular. It is a seriously ingrained habit, difficult if not impossible to break. Certain recent studies (Branner, 1973.1; Shelby, 1975.2; Barnes, 1978.1; possibly Calkins, 1979.2; Barnes, 1981.1; Kidson, 1981.3; and Recht, 1981.4) at least demonstrate the courage to reconsider the question. But they have not yet had widespread impact. Perhaps the most one can expect is that the more blatant absurdities will not continue to be repeated. What is to be gained when, on the basis of so little information, Villard is termed "one of the leaders in the development of Gothic architecture in the thirteenth century" (Sturgis, 1901.2); "a great master, like Dürer" (Überwasser, 1935.4); "un prince du métier" (Lefrançois Pillion, 1949.3)? These were, it is true, characterizations of a time when art historical enthusiasm may have overshadowed common sense. But the pattern continues: "distinguished architect" (Von Simson, 1952.3); one belonging to the "aristocratie de son métier" (Daniel-Rops, 1954.1); "famous Gothic master"(Huyghe, 1958.4); "well-trained and successful thirteenth-century architect" (Fitchen, 1961.4); "a respected master architect" (Von Simson, 1972.7).

It is against such unjustified claims as these that one must attempt to plot Villard's life and career. Born in the small village of Honnecourt-sur-Escault, as a young man Villard must have been interested in whatever special was going on in the neighborhood. In

the second decade of the thirteenth century, when he may have begun
making his sketches, the most compelling activity nearby certainly
was construction of the choir of Vaucelles. This was the largest
Cistercian church ever built, so large that it created a serious
scandal for the order (Dimier, 1949.1). It is difficult to imagine
Villard not having visited the site to observe the activities there.
But this is not the same as, and does not permit, the assumption that
he was employed there, let alone that he received his architectural
training there (Enlart, 1895.1; Von Simson, 1952.3) or was "master of
the shop" (Baron, 1960.2).

The same view can be extended to Villard's interest in Cambrai
and Reims. Why would a local practitioner of whatever craft, or no
craft at all, not be fascinated by and make a point of visiting the
cathedral of his diocese and that of his archdiocese if at all pos-
sible? As it happens, these two churches were among the greatest
creations of the thirteenth century, and they doubtless attracted
visitors then as Reims does now.

However, one must not overdo the casualness of Villard's interest
in these construction sites. There is proof that he was more than a
mere tourist or pilgrim, for at Vaucelles and at Cambrai he gained
access to the workshop, as he also did at Reims. Villard's drawing
of the Cambrai choir plan (fol. 14v) is a copy of another plan, as
likely were his now-lost drawings of the Cambrai chapels, elevations,
and buttresses (Branner, 1963.2). The same is true of his plan
(fol. 17) of Vaucelles (Schöller, 1978.6). There is disagreement
about whether Villard made his Reims drawings from other drawings
(Garling, 1858.2; Jantzen, 1957.4) or from observing construction
(Reinhardt, 1963.3), although Villard himself tells us that some of
his drawings (fol. 32) were made from templates (molles).

His interest in these sites, then, was more than casual. But his
reaction to his visits raises a basic question that no one seems to
have asked. If Villard was the architect of any one or all of these
buildings, why did he have to copy its (their) plan(s)? It makes no
sense to claim that he would have traced his own plan(s). Of course,
no one credits Villard with the design for Reims. Although this has
been suggested (Cerf, 1861.1), it has long been discredited
(Demaison, 1894.1), and no recent author except Bucher attributes
any aspect of Reims to Villard.

To one of his Reims drawings, that of an aisle window on fol.
10v, Villard added a short inscription which may well be his most
enigmatic: "I had been sent into the land of Hungary when I drew it
[the window], because I liked it best." This seemingly simple state-
ment is the catalyst of all speculation about Villard in Hungary, the
most intriguing and unknown aspect of his life. In the first place,
it is unclear whether the expression j'estoie mandes should be trans-
lated as "I was sent," which is the general reading given to it, or
as "I was summoned." And were the reading certain, one would not

know its implications. By whom was he summoned or sent? For what purpose(s)?

The traditional view (Viollet-le-Duc, 1859.2) is that Villard drew the Reims window to serve as a model for work(s) in Hungary. But this cannot be proved because no Hungarian buildings can be associated with him. Many have of course been attributed to him, most notably and most persistently Kassa; but recent literature dismisses this idea (for a thorough summary, see Gál, 1929.2 and Horváth, 1936.1). As it happens, only as recently as 1971 was clear evidence discovered for any aspect of Villard's Hungarian venture. Excavations by Gerevich at Pilis exposed a very unusual pavement design which Villard drew on Fol. 15v, noting that it was one he had seen in Hungary. Gerevich maintained in a series of studies (1971.2, 1971.3, 1974.1, and 1977.1) that Villard may have designed and/or constructed the tomb of queen Gertrude de Meran (d. 1213) at Pilis. While this is possible, the evidence is circumstantial and inconclusive.

It is possible, indeed it is likely, that Villard did not remain in Hungary for an extended period. Several Hungarian authors suggest as much (Szabó, 1913.1; Divald, 1927.2), and when Villard referred to his trip, he stated that he remained "many a day" (maint jor). The inscription was written long after the visit itself, but one has to assume Villard had some reason for referring to his trip in terms of "days."

The fact remains that the date, duration, and purpose of Villard's visit to Hungary are unknown. In the words of Gál (1929.2), "En fin de compte, on doit avouer que le dernier problème, soulevé par le séjour de Villard de Honnecourt en Hongrie et qui concerne son activité dans ce pays, est actuellement indéterminable."

On his way to or from Hungary, Villard must have passed through Lausanne where the rose window of the south terminal of the transept caught his attention (fol. 16), perhaps because of its unusual design, perhaps because it was in all probability designed by a fellow Picard artist, one Pierre d'Arras. By all admissions (Bruges, 1858.1; Garling, 1858.2) Villard did a very poor job indeed of reproducing the design of the window, assuming that his drawing is of the actual window and was not made after a preliminary drawing never executed in stone and glass. In connection with his trip to Hungary, going or coming, Villard may have been in the upper Rhineland where he made some drawings based on a Byzantine-German model book. Bober (1963.1) makes a persuasive argument for parallels between certain of Villard's drawings and figures in a Psalter executed ca. 1230/1235 for the Benedictine monastery of Saint-Blasien in the diocese of Constance.

If this dating is correct, as it seems to be, and if the Lausanne rose was erected no later than 1235, Villard's trip to Hungary would appear to have been no later than ca. 1240, which date coincides

reasonably with a <u>terminus</u> <u>post</u> <u>quem</u> for the Reims nave aisle window which he reports he drew before his journey. While nothing in Hungary can be unequivocably attributed to Villard, this dating assumes significance for those who believe that Villard was an architect but who can find no trace of his presumed architectural activity in Hungary. The Tartar invasion of Hungary in 1240-1242 destroyed much architecture and certainly halted construction projects. When architectural activity was resumed, the influence of France had given way to that of Germany (Horváth, 1936.1).

Villard probably returned to France no later than 1235/1240 and what he did during the remainder of his life is quite as unknown as what he did during the period before his trip to Hungary. The most recent theory (Bucher) is that he worked for a time as a subcontractor at Reims, but this is a singular, undocumented view. The oldest theory (Bénard, 1864.1) is that Villard was hired to work or to direct work at Saint-Quentin, near his hometown. This is a persistent claim, supported by Hahnloser, Bucher, and others. The evidence for associating Villard with Saint-Quentin is contained partly in his sketches of the Hungarian pavement drawing and the Chartres rose window, both of which designs with variants are found at Saint-Quentin. However, the date and authenticity of the window engraved in plaster at Saint-Quentin is quite controversial (Bucher, 1977.2; Barnes, 1978.1; Bucher, 1978.3). It is at best inconsistent for Bucher to consider Villard a minor architect who rose to mastership of one of the more significant building projects of France.

What, then, did Villard do professionally? He cannot be proved to have been an architect. Was he a practitioner of some other art? As noted above, his drapery-rendering technique is that of a metalworker, thus he was possibly a sculptor, although not exclusively in metalwork objects, although a number of his drawings are of <u>ars</u> <u>sacra</u> products (Adhémar, 1939.1; Wixom, 1972.8). A number of writers propose that Villard may have been a sculptor (Evans, 1948.1; Kidson, 1958.5; and Gerevich in his several studies). For more than a century, since Burges (1858.1), there has been speculation that he may have designed choirstalls, as shown in two of his drawings (fols. 27v and 29). The choirstalls at Lausanne have been at least tentatively attributed to him (Burges, 1858.1; Bucher) because they show seminude wrestlers similar to those in a scene on Villard's fol. 14v, but this design has elsewhere (Jusselin, 1911.1) been traced not to Lausanne but to Chartres.

Just as there is no clear professional career demonstrated in his drawings, so there is no discernible life-pattern to be found in Villard's manuscript. He appears to have been especially devoted to the Virgin, an unsurprising thirteenth-century phenomenon. Most of the churches he drew were dedicated to the Virgin, as were all Cistercian churches. It is tempting to try to associate him with the Cistercians in some way, although not as specifically as attempted by Enlart (1895.1) and Von Simson (1952.3 and 1956.3). It is possible

that he attended a church school, possibly a Cistercian school, for he was literate. But it is very unlikely that he was a monk-priest, for his knowledge of Latin as revealed in his manuscript (fols. 24 and 24v) was limited to the word leo. Branner's "clerk with a flair for drawing" theory is most attractive, although incomplete, for Villard undoubtedly was a skilled artist save when he attempted architectural renderings.

In conclusion, the fact remains that it is unknown and likely to remain unknown just who Villard was and just what he did professionally. His manuscript poses many more questions than it answers (Gall, 1925.1) and Focillon's claim (1931.1) that "nous savons rien, ou presque rien, de Villard de Honnecourt" is, alas!, pessimistically accurate.

Villard's manuscript does provide, in its variety as in its uniqueness, an extraordinary look into a thirteenth-century personality. Focillon elsewhere (1938.1) so astutely observed that "no one was ever more vigorously of his own time." From Quicherat (1849.1) through Frankl (1960.6) there have been those who think of Villard as a "Gothic Vitruvius" in his versatility of interests; but others (Samaran, 1973.3) disagree. Writers from Mérimée (1858.5) through Gimpel (1976.2) have championed Villard as a sort of thirteenth-century Leonardo da Vinci.

One should not go to that extreme. But it is undeniable that Villard enjoyed and was fascinated by the novelties of the world in which he lived. Perhaps the most accurate way to characterize him is to resurrect a now debased and distorted word, "dilettante." This word originally described "one who is delighted in the world around himself." Who better fits this definition than Villard de Honnecourt?

# The Facsimile Editions

To date seven facsimile editions of the Villard manuscript have been published. These vary in nature and in content, and none is a facsimile in the literal sense of an "exact replica." No editor has published the Villard folios in color, a key to understanding Villard's technique of drawing (see Barnes, 1981.1), and the Bibliothèque nationale refuses to authorize or undertake color photography of the manuscript, incorrectly insisting that the Villard "dessins sont en noir et blanc." Certain editors (Lassus, Willis, Bowie, and Bouvet) omit folios from their editions. All editors save Hahnloser and Bouvet intersperse their commentaries and reproductions of the folios. Because the various editors have employed different numbering schemes for the folios, a concordance between the seven editions and the manuscript itself is provided at the end of this section.

A new critical English edition of the Villard manuscript is now in preparation by this author in collaboration with Lon R. Shelby.

F.I
  LASSUS, J[EAN]-B[ATISTE]-A[NTOINE]. Album de Villard de Honnecourt: Architecte du XIIIe siècle, manuscrit publié en fac-simile. Paris: Imprimerie impériale, 1858. Photographic reprint. Paris: Léonce Laget, 1976, xviii + 189 pp., 72 pls. + text figs.

This was the first facsimile edition of the Villard drawings and remains the only extensive scholarly edition in French. It served as the basis for later editions, especially that of Willis. This edition was substantially completed in manuscript form by Lassus when he died on 15 July 1857. Final editing and actual publication was by Alfred Darcel, a pupil of Lassus who was charged with this responsibility by the Lassus family. According to Darcel in his "Notice sur Lassus" (pp. iii-ix), "j'y ai travaillé avec un pieux respect pour sa [Lassus's] mémoire . . . et conformément à ses manuscrits."

Lassus (1807-1857) is best known for his work as a restoration architect, sometimes in collaboration with Viollet-le-Duc, on such

Gothic monuments as the cathedrals of Chartres and Paris and the
Sainte-Chapelle in Paris. He published extensively on his restora-
tion work and shared with Viollet-le-Duc an unrestrained belief in
the "rationalism" of French Gothic architecture. He viewed Gothic as
"notre art national," and had an intense loathing for the neoclassi-
cal revival in the France of his day. It was in defense of this view
that he undertook publication of the Villard drawings, and in his
"Preface" (pp. xi–xviii) he explains his views in strong terms,
accusing the neoclassicists of being pygmées of ignorance concerning
the history of architecture and construction.

Lassus, in his preface (p. xvi), gives a more specific reason
for publishing the Villard drawings: "bien que cet ouvrage du célè-
bre architecte du XIIIe siècle ne soit qu'un simple album de voyage,
l'habileté des dessins et la variété des objets qu'il contient per-
mettent cependent d'apprécier l'étendue des connaissances théoriques
et pratiques de ces grands artistes qui ont élevé nos admirables
cathédrales." Lassus acknowledges (p. x) that it was Quicherat
(1849.1) who first brought the Villard drawings to public attention
and that he agrees with Quicherat's conclusions and explanations, his
purpose being to make the entire content of the manuscript available
to the public.

Following his preface is a long (pp. 1–41) essay entitled "Con-
sidérations sur la renaissance de l'art français au XIXe siècle,"
which defends the Gothic revival and his own views but does not even
mention Villard.

He then (pp. 43–52) offers a biography of Villard, based on the
contents of the manuscript. Lassus's main points are that Villard
was active between 1230 and 1250 at the outside, and he attributes
(p. 45) to Villard the design of the choir of Cambrai, which Lassus
dates 1227–1251. He proposes (pp. 50–51) that on the basis of his
fame at Cambrai, Villard was called to Hungary where, ca. 1250, he
designed Kassa and assisted in the restoration of other Hungarian
churches destroyed during the Tartar invasion of 1242. Lassus also
suggests (p. 51) that Villard may have been at least indirectly in-
volved in the design of Marburg. At the end of this brief summary
of Villard's career, Lassus terms (p. 52) the manuscript an encyclo-
pédie pratique and dates it in the second third of the thirteenth
century.

Lassus next gives (pp. 53–56) an analysis of the manuscript it-
self, before considering the folios one by one. He observes that
while its binding is thirteenth-century, the drawings were made be-
fore being installed in this binding because one drawing continues
through the gutter. Lassus's examination of the manuscript led him
to propose (p. 54) that twenty-one leaves (forty-two pages) are
missing. His "table of contents" of the Villard drawings is taken
from Quicherat, but he notes (p. 55) that the actual arrangement of
materials "résulterait pour nous une confusion fâcheuse."

Lassus's plates are lithographs, slightly larger than the origi-
nals, by an artist named Leroy who died just after completing his
work. Folios 3 and 33 are omitted and eight comparative supplemental
plates (LXV-LXXII) are included. All plates are numbered sequen-
tially in roman numerals and are separate from the text. Some plates
have been inverted, top-to-bottom, from their arrangement in the
manuscript.

The Lassus plates have frequently been reproduced elsewhere
without warning that they are lithographs after the originals. All
who study Villard should be aware of this.

As this bibliography is going to press, the Société française
d'archéologie has announced its intention to publish a study by Jean-
Michel Leinaud entitled Jean-Baptiste Lassus (1807-1857) ou les temps
retrouvé des cathédrales in its monograph series (Bibliothèque de la
Société française d'archéologie). This study presumably will include
discussion of the Lassus facsimile of the Villard manuscript.

F.II
    WILLIS, ROBERT. Fac-simile of the Sketch Book of Wilars
        de Honecort with Commentaries and Descriptions by
        M. J. B. A. Lassus and by M. J. Quicherat: Translated
        and Edited with Many Additional Articles and Notes by
        the Rev. R. Willis. London [Oxford]: John Henry and
        James Parker, 1859, ix + 243 pp., 73 pls. + text figs.

Willis (1800-1895) was an ordained minister who held the
Jacksonian Professorship of History at Cambridge University. An
individual of varied interests--he wrote on chess strategy, on the
relationship between the vowel sounds of the human voice and the
notes of pipe organs, and on mechanics for engineers--Willis is now
best known for his architectural histories of a number of important
English cathedral foundations, most notably Canterbury and
Winchester, and for his edition of the Villard manuscript. He also
wrote a dictionary of medieval architectural terms, and his interest
in medieval architectural practice probably explains his interest in
Villard.

Willis's edition of the Villard manuscript is essentially an
English translation of the Lassus edition with extensive additional
commentary by Willis, enough to justify his comment (p. vii) that,
"The text of the present volume differs in many respects from that of
the French edition. . . ." In his preface (pp. v-ix) Willis says
(p. vii) that the existence of the Villard manuscript came to his
attention through the article by Quicherat (1849.1), the first part
of which Willis included (pp. 1-7) in translation in his edition.
In 1851 Willis "obtained [from the Bibliothèque impériale in Paris]
the rare privilege of tracing those of its [the manuscript's] pages
which interested me as belonging to architecture and mechanism [i.e.,

mechanics]."  He was preparing his own, English edition of the manu-
script when he learned of Lassus's efforts and was thereby "induced
to postpone the publication of the results I have arrived at."

It is not clear from his edition whether or not Willis was per-
sonally acquainted with Lassus (whom he praises on p. ix of his
preface), although Lassus corresponded with James Henry Parker, the
antiquarian-archaeologist who published the Willis facsimile.

Willis's justification for his facsimile of the Villard manu-
script was twofold.  One was his belief in the importance of the
manuscript.  The second was his belief that the Lassus edition was
incomplete (p. viii): "But as his [Lassus's] labours have been un-
happily cut short and left imperfect, I have ventured to add to them
my own, and to attempt the formation of a commentary that should in-
clude the opinions of writers who have as yet interested themselves
in the question [of the manuscript]."  When this was written, only a
few writers had shown any interest, as the entries in this bibliog-
raphy show.

Willis's facsimile is organized as follows:  Preface (pp. v-ix),
in which he summarizes the importance of the drawings and recounts
his own involvement with the manuscript; Table of Contents (p. x);
List of Plates (pp. xi-xii); translation of the first part of the
Quicherat 1849 article (pp. 1-7), followed by a two-page (pp. 8-9)
commentary on Villard's activities in Hungary; "Description of the
Manuscript and Its Contents" (pp. 10-15) followed (p. 16) by a dia-
gram of the codicological reconstruction of the manuscript; and a
"Classified List of Subject Matter" (pp. 17-20) arranged as follows:
sacred or emblematical figures, secular human and animal figures,
architecture and construction plans and drawings, practical geometry,
masonry, carpentry, machines, and receipts [formulas].  Willis omits
"as foreign to the illustration of our artist" Lassus's long essay
defending the Gothic style.  The greater part of Willis's facsimile
(pp. 21-238) consists of his "Explanation of the Plates."

Willis's organization of these involves reproducing the Lassus
lithographs, each followed by commentary; thus the folios are sepa-
rated by text and difficult to compare.  He employs Lassus's number-
ing scheme.  Both in the text and footnotes, Willis carefully notes
whether the commentary is his own or whether it is translated from
Lassus or from Quicherat.  Willis provides with most plates, where
appropriate, transcriptions of the Picard inscriptions, the Lassus
French translations, and the best English translations to date, far
more accurate than those in the Bowie facsimile.  Willis's most ex-
tensive additions to or revisions of Lassus's commentary occur in
connection with the geometrical and stereometrical drawings found on
fols. 20 and 20v.  Willis did not realize that these drawings were
not by Villard.

For Willis, the significance of the Villard manuscript was in
what it revealed about thirteenth-century drawing (p. v): "The manu-
script which is the subject of the present volume is a most valuable
monument for the state of delineation in the thirteenth century." He
also claims that "The architectural drawings are especially interest-
ing for the light they throw upon mediaeval [architectural] practice."
In the first connection, Willis notes that Villard drew after the
antique and makes the claim that he also drew "from living models set
in attitudes for the purpose [of making academic studies]." Willis
praises Villard's architectural drawings for their interest as dis-
tinct from "the mechanical copying which is the reproach and mis-
fortune of our own [age]," but he appears to be suspicious of
Villard's powers of observation. It is Willis who first set up
(p. vi) the dubious proposition that "Villard appears even to have
altered parts of the buildings he was sketching, improving them as
he thought, and giving them a more fashionable air as he went along,
to save himself the trouble of doing so when he wished to engraft
them upon one of his own designs."

One of the most useful parts of the Willis facsimile is his
"Description of the Manuscript and Its Contents" (pp. 10-20) which,
although based on Burges (1858.1), Lassus, and Quicherat (1849.1),
remains one of the most precise English summaries of the codicologi-
cal state of the manuscript. His principal points are (p. 12) that
twenty-one leaves can be proved to be missing from the manuscript,
that (p. 14) the manuscript is a "veritable sketch-book" for which
"the sketches were made at separate times," and that the drawings are
not "a collection made up or rearranged in after-life by its posses-
sor." Willis also noted that the "inscriptions are subsequent addi-
tions [to the drawings] for the information of posterity, and [were]
not contemplated at the time the drawings were made, for no space had
been reserved for them." Save for the number of folios Willis esti-
mates to be missing, these observations or interpretations are gen-
erally accepted as correct even today.

For all his interest in Villard, Willis was not greatly concerned
with Villard's professional career. As his title indicates, he ac-
cepted without question Lassus's and Quicherat's view that Villard
was an architect, and Willis refers (p. v) to Villard's "practice
[of architecture]." But he was not interested in what buildings
Villard may have designed. In his preface (p. v) he attributes
Cambrai to Villard, but in discussing (pp. 86-90) Villard's drawing
of the plan of Cambrai (fol. 14v), Willis appears to deny or to
question this attribution. He reports (pp. 8-9) the "state of the
question" of Villard's association with Hungary based on Henszlmann
(1857.1) but takes no stand on the various attributions made.

The Willis facsimile has never been reissued and remained from
1859 to 1959, when the Bowie facsimile appeared, the only English
edition of the manuscript. These have subsequently (1979) been

joined by the Bucher facsimile. The Willis facsimile was, therefore, for a century the only source on the Villard manuscript for English-speaking scholars. Long out of print and what Robert Branner (1960.4) termed a "bibliographic rarity," the Willis edition was superseded in 1935 as the most critical edition of the Villard manuscript by the Hahnloser facsimile.

F.III
>    O[MONT], H[ENRI AUGUSTE]. Album de Villard de Honnecourt:
>    Architecte du XIIIe siècle. Paris: Berthaud Frères,
>    n.d. [1906]. Reprints. Paris, 1927 and 1931, 18 pp. +
>    68 pls.

Born the year that Lassus died, Omont (1857-1940) was Conserva-teur en Chef of manuscripts at the Bibliothèque nationale from 1903 until 1935 and is credited with much of the organization and prestige of that research facility. Omont published hundreds of catalogs and other works on the manuscripts in his care, and his edition of Villard, published three years after he became conservator, was but a minor effort in a long career.

Omont appears to have had no special interest in Villard per se, and it is unclear why he published a facsimile edition of the Villard manuscript unless it was to provide the public with an inexpensive edition of Villard by contrast to that of Lassus or whether by 1906 the Lassus edition was out of print. His motivation may have been to provide a more accurate edition, since his plates are glass negative prints of, rather than lithographs made after, the originals. The Omont edition is brief and uncritical, summarizing the earlier literature on the manuscript and tracing its history down to 1865 when it was assigned its current shelf number in the Bibliothèque nationale. He gives a transcription of the manuscript inscriptions and a brief description of the contents of each folio, together with a brief index arranged by subject.

A trained codicologist, Omont designated the manuscript folios as folios, but only as secondary to his plate numbers. He estimated that thirteen folios are missing from the manuscript. Omont reproduced each of the thirty-three extant folios and provided unnumbered illustrations of the binding of the manuscript itself. Since Omont illustrated folios omitted by Lassus and Willis, his numbering scheme (in roman numerals) is different from theirs (see "Concordance between the Manuscript and Facsimile Editions").

F.IV
>    HAHNLOSER, HANS R[OBERT]. Villard de Honnecourt:
>    Kritische Gesamtausgabe des Bauhüttenbuches ms. fr.
>    19093 der Pariser Nationalbibliothek. Vienna: Anton
>    Schroll & Co., 1935, xi + 342 pp., 66 pls. + text figs.

2d rev. and enlarged edition. Graz: Akademische Druck-
und Verlagsanstalt, 1972. xi + 404 pp., 66 pls. + text
figs. [All references below are to the second edition.]

This is the most scholarly edition of the Villard manuscript and,
while it has been and will continue to be supplemented, may never be
replaced as the principal study of the subject. Hahnloser considered
and studied virtually every aspect of the drawings and inscriptions.
There are, however, two difficulties with Hahnloser's edition which
must be faced by all who use it. One is that it is written in some
of the most abstract philosophical German ever put to paper and is,
therefore, very difficult to read. The other is that Hahnloser, as
his subtitle indicates, firmly believed that the Villard manuscript
was a lodge book (Bauhüttenbuch) and approached every question with
this predisposition. Most readers will find certain interpretations
and conclusions forced to satisfy this prejudice.

Hahnloser (1899-1974) was a Swiss art historian trained in Vienna
under Von Schlosser (1914.3) and was later Professor of Art History
at the University of Bern. Interested in modern as well as medieval
art, Hahnloser is known principally as a medievalist and mainly for
his facsimile of the Villard manuscript, the most frequently cited
source for any Villard question since 1935. Hahnloser also published
a facsimile of the Wolfenbüttel model book (Das Musterbuch von
Wolfenbüttel, Vienna, 1929) and a study of the stained glass and
altars in Bern Cathedral (Chorfenster und Altäre des Berner Munsters,
Bern, 1950).

The organization of Hahnloser's facsimile is the following:
"Vorwort zur Zweiten Auflage" (pp. ix-xi); "Einführung zur ersten
Auflage" (pp. 1-4); "Sprachkritischer und ikonographischer Kommentar"
(pp. 5-176); "Zur Literatur" [to 1935] (pp. 177-81); "Zur Technik des
Buches" (pp. 182-88); "Erhaltung und Unfang der Handschrift" (pp.
189-93); "Villards Nachfolger am Werk" (pp. 194-200); "Villards
Stilwandel und sein Verhältnis zum Vorbild" (pp. 201-15); "Der per-
sonliche Zeichenstil des Künstlers" [i.e., Villard] (pp. 216-24);
"Zur Biographie des Künstlers" (pp. 225-37); "Das Hüttenbuch
[Villard manuscript] als Ganzes" (pp. 238-46); "Wahl und Wert der
Exempel" (pp. 247-79); "Anhang," including Bibliography (pp. 280-81),
"Reconstruction of the Foliation of the Manuscript" (pp. 282-87),
Glossary (pp. 288-97), and Index (pp. 298-340); "Seit 1935 erschienene
Spezial-Literatur" (pp. 341-42); "Nachträge von 1971" (pp. 343-403);
66 Tafeln; and 213 Abbildungen.

The "Supplement of 1971" is in effect an insert into the photo-
graphically reproduced 1935 edition and is keyed to the original
page and plate numbers. For the most part, this supplement brings
together literature and commentary published between 1935 and 1971,
including models for and parallels to Villard's drawings published
during that period. In no case did Hahnloser modify or recant any
significant conclusion contained in the first edition (p. x). In the

"Foreword to the Second Edition" Hahnloser complained (p. ix) that his designation of the Villard manuscript as a <u>Bauhüttenbuch</u> had not been accepted by French scholarship which persisted in employing the "falschen Ausdruck '<u>Album</u>.'"

Hahnloser's reproductions of the manuscript folios are photographs of the originals reproduced at approximately the same size as the latter. His reproductions are the best in print and, together with those of Bouvet, are the easiest to study because they are reproduced without intervening text and commentary and without cropping or inversion. Hahnloser termed the folios <u>Tafeln</u> (plates) and thus has a total of sixty-six, counting each face of each folio as a <u>Tafel</u>. Along the outer edges of the reproductions appear small arabic letters referring to different details and inscriptions found on the folios themselves, to which the commentaries are keyed. These letters are visible yet sufficiently inconspicuous so as not to detract from the reproductions themselves. This scheme is preferable to that of adding handwritten letters to the reproductions themselves as it was employed by Bowie in his first edition.

There are many "firsts" in Hahnloser's facsimile, which is why it is an irreplaceable source. Hahnloser was able to obtain authorization from Omont in 1926 to have the manuscript unbound (pp. 4, 283) so it could be examined as never before or since. He was also able to employ ultraviolet light and ultraviolet photography in his examination and thereby discovered inscriptions (fols. 1 and 23v) not previously seen or deciphered. Finally, he was able to examine the remains of cut folios disengaged from the gutters of the extant bifolios when the manuscript was unbound. He complains in several places that these were lost, and that certain folio "tails" were reversed when the manuscript was rebound, falsifying the codicological (re)construction of the manuscript as it exists today. [This author's examination of the Villard manuscript in 1978 does not confirm this claim.]

On the basis of this examination, Hahnloser proposed (chart on p. 192) that the manuscript originally contained a minimum of fifty-six leaves plus a probable eight more, hence a total of sixty-four, of which thirty-three now remain. Thus only about half of the original is now extant.

Another very significant "first" of the Hahnloser facsimile is that he was the first art historian to recognize the different hands at work in the manuscript. On the basis of Schneegans's study (1901.1) of the inscriptions, Hahnloser identified two artists other than Villard, individuals whom he designated as Master II and Master III, using the Latin designation <u>magister</u> (pp. 194–200 and passim). Hahnloser reversed Schneegans's order, believing (p. 194) that the latter's "Ms. 3" "unmittelbar nach Villard am Buch gearbeitet hat." The key to Hahnloser's basic thesis is that Master II and Master III were followers of or successors to Villard in the same lodge

(p. 199), ". . . es ist nicht als persönalisches 'Album,' "Skizzen-
buch' oder 'Promemoria' entstanden, sondern als ein wirkliches
Bauhüttenbuch; es ist tatsächlich in derselben Sprach- und Baugegend,
d. h. von den Nachfolgen der gleichen pikardischen Werkstatt benützt
worden. . . ." This single sentence states the tradition that
Hahnloser established concerning the Villard manuscript, as it pre-
vails in the literature today.

Hahnloser's principal interest in Villard's life was not so much
in the specifics of his career as in his personality as an artist.
He believed (p. 232) that Villard worked ca. 1230-1235 and that he
was a "fertiger Meister" when he went to Hungary ca. 1235, either
through his Cistercian connections or due to his association with
Cambrai, but what he built in Hungary is unknown: "Was Villard in
Ungarn gebaut hat, wird zu weiteren Funden ein Geheimnis bleiben."
However, Hahnloser was not inclined (p. 226) to attribute Cambrai to
Villard. The one building that Hahnloser proposes (pp. 236-37)
Villard may have designed is Saint-Quentin, adopting the thesis of
Bénard (1864.1).

Much consideration is given to Villard as an artistic personal-
ity, especially in the sections "Villard's Stylistic Development and
his Treatment of Models" (pp. 201-15), "The Personal Drawing Style of
the Artist" (pp. 216-24), and "The Selection and Usefulness of
[Villard's] Models" (pp. 247-79). Hahnloser's contention is that
Villard selected models for different reasons, either for their
beauty or for their practicality (ideally combining the two when pos-
sible), and that he treated different models in different ways.
Hahnloser's most controversial conclusion (p. 207 and elsewhere) is
that Villard's human figures in which the facial features are missing
were drawn from sculpture: "Wir dürfen demnach jene Zeichungen, bei
denen die Innenzeichnung der Köpfe fehlt, als Abbilder von Skulpturen
(oder, wenn es der Gegenstand fordert, nach der Natur) ansprechen."
This is a very doubtful proposition indeed, but typical of Hahnloser's
personal approach to Villard as an artist.

Hahnloser's approach to Villard is unique among commentators. In
the same way that Bucher in his edition attempted a more detailed
biography of Villard than anyone to date, Hahnloser attempted a
psycho-artistic analysis approached by no one before or since 1935.
His analysis is intensely subjective and personal, with the result
that one agrees or disagrees rather completely. Whatever his short-
comings or limitations, Hahnloser attempted more thoroughly than any
other author to solve the riddles of the artist who (p. 2) "biete
vorläufig noch mehr Ratsel als Lösungen" (see Gall, 1925.1).

F.V
    BOWIE, THEODORE [ROBERT]. The Sketchbook of Villard de
        Honnecourt. Bloomington: Indiana University Press,
        n.d. [1968 but © 1959]. 80 pp. [There is confusion

about the proper bibliographic designation and dates of
the three printings of this item.  Bowie (p. 9) claims
that the two earlier editions were printed privately,
but each carried an Indiana University copyright dated
1959.  Bowie also states that the second printing was
in 1961, when in fact the date was 1962.  Both edi-
tions were distributed by George Wittenborn, New York.
The second printing or edition is termed "revised" in
its preface, but differs very little from the first
edition save as noted below.  The first two editions
have translations and brief commentaries preceding the
illustrations; the third edition has these on pages
facing the appropriate illustrations.]

This was the second English edition of the Villard manuscript,
appearing exactly a century after that by Willis.  It has since been
followed by the English edition of Bucher and, with the latter, is
the only English edition currently in print.  Bowie's edition is a
facsimile only in a very special sense, and less so than any other
facsimile discussed in this section.  It does reproduce most of the
Villard folios but these are arranged in a different sequence from
that of the manuscript itself.  Bowie claims (p. 5) that his arrange-
ment is based, insofar as possible, on the "logic of their [the
folios'] subject matter."  Admitting this to be a "major liberty,"
one of the great understatements in all Villard literature, Bowie
attributes this idea to the warm encouragement of Erwin Panofsky and
other scholars.

Bowie's edition is very difficult to use when studying the origi-
nal manuscript or when comparing it with other facsimiles which are
arranged, in Bowie's phrase, in the "official order."  In all three
editions there is a "Table of Concordance" at the back.  In the
second and third editions, in response to Barnes's review (1960.1),
a concordance number is given with each plate, keyed to Hahnloser.
This is not as useful as might appear, however (assuming that the
user has the Hahnloser facsimile available), for the following
reasons:  it is keyed to Bowie's arrangement of the folios (as is
the "Table of Concordance"); it contains errors [Bowie's pl. 17 =
Hahnloser Taf. 33, not his Taf. 38; Bowie pl. 41 = Hahnloser Taf. 28,
not his Taf. 23]; and it is given in a confusing manner (Hahnloser's
plates are assigned roman numerals rather than arabic, and in the
third edition each number is preceded by "C.", for example, "C.XI",
with the "C" standing for concordance and not the roman numeral for
100).  Because of this and because Bowie omitted fols. 33 and 33v--
until 1978, the Bibliothèque nationale did not possess negatives of
fols. 33 and 33v, which may explain their omission by Bowie--it is
virtually impossible to compare Bowie's edition with the original or
with other facsimile editions without recourse to a separate con-
cordance.

Bowie's plates are photographic reproductions after negatives in the Bibliothèque nationale, apparently the same negatives employed by Hahnloser. Bowie notes when he turns a folio 45° or 90° but he fails to note anywhere (save regarding fol. 21 where a recipe has been omitted) that he has severely cropped his reproductions, occasionally eliminating materials and giving the misleading impression to anyone unable to examine the manuscript itself or other facsimiles that the original manuscript is a much neater production than it actually is. In response to Branner's review (1959.2), in the third edition Bowie removed Arabic letters which he (?) had inked in on his illustrations and which were easily confused with earlier additions to the manuscript. This apparently explains the severe cropping of illustrations in third edition.

Bowie states (p. 5) that his edition is, "neither critical nor scholarly . . . [and] is intended for the nonspecialist." He admits that most of the contents of his introduction are based on earlier writers and he adds nothing new to understanding the Villard manuscript.

Bowie (1905--) is an American art historian at Indiana University who is interested in many aspects of art. He has written on film, on Baudelaire, and on the art of the Far East. He has also collaborated on an edition of the drawings of Jacques Carrey de Lyon made in Athens in 1674.

F.VI
BOUVET, FRANCIS. "L'Album de Villard de Honnecourt." In
La France glorieuse au moyen âge. Paris: Club des
éditeurs, 1960, unpaginated.

This presentation of the Villard manuscript is along the lines of that by Omont in the sense that it offers little critical commentary, and to that by Bowie in the sense that Bouvet omitted fols. 33 and 33v which did not interest him. Bouvet claims he "n'a d'autre ambition que de faciliter l'examen des planches [which he assigns roman numerals], et de restituer--dans la mesure possible--l'esprit extraordinairement vif et curieux de seul témoignage que nous possedons sur ce qu'il est convenu d'appeler le Haut Gothique."

Bouvet in fact does this better than any other facsimile edition except Hahnloser's by reproducing the Villard folios as contained in the manuscript itself, uninterrupted by intervening commentary. The author notes that he reproduces the "plates" as they appear in the manuscript, including inversions, but does not give the source of his plates. I was able to obtain this publication only in an electrostatic photocopy, from which it is impossible to discern the details of the reproductions. They appear to be made from photographic negatives, assembled to replicate the foliation of the manuscript itself.

Bouvet provides literal French translations of the Villard inscriptions, the most accurate French translations to be published to date.

The author's brief commentary preceding the translations is enthusiastically misleading on several points, yet contains certain important and restrained observations. Bouvet claims that the Villard manuscript is one of only two medieval documents providing information on craft techniques, the other being Theophilus's Diversarium artium schedula. On the other hand, he resists speculation about who Villard was in a professional sense, save to claim that he was "incontestablement 'du batîment'" and that he may have worked for the Cistercians. Bouvet does not attribute any building to Villard, and concerning his trip to Hungary he says, "La date, l'objet et l'emploi du temps de ce voyage sont autant de mystères pour nous."

Bouvet traces briefly the history of the manuscript, basically summarizing Omont's account with some commentary on additions made after the manuscript left Villard's possession. He is very critical of Villard as a draftsman ("ses notions de perspective son enfantines") and of his use of geometry.

The title of this book is taken from an essay by Marcel Aubert, and readers are cautioned that Bouvet's essay is not included in the first edition (Paris, 1949).

F.VII
    BUCHER, FRANÇOIS. "[The Lodge Book of] Villard de
        Honnecourt." In Architector:  The Lodge Books and
        Sketchbooks of Medieval Architects.  Vol. 1.  New York:
        Abaris Books, 1979, pp. 15-193.

This is the third English facsimile of the Villard manuscript and the only one to form part of a larger undertaking, a four-volume survey of medieval architectural drawings. Bucher (1927-) is professor of fine arts at Florida State University at Tallahassee and has published extensively on medieval architecture and manuscripts, especially concerning architectural design, as well as on Joseph Albers. He is a former president of the International Center of Medieval Art and was the first editor of its journal, Gesta. Bucher was educated in his native Switzerland and was a student of Hahnloser, whom he terms (p. ii) his "mentor" and to whose memory he dedicated this volume as well as 1977.2. Hahnloser had planned to prepare an introduction for this section of Bucher's facsimile but died in 1974 before this was accomplished.

Bucher's organization of his facsimile is as follows:  Introduction (p. 15); "Tentative Biography" [of Villard] (pp. 15-26); [Villard's Role in the Tradition of] "The Humanist Architects"

(pp. 27-28); "Appendix I:  Physical Description, Purpose, and History" [of the Manuscript] (pp. 28-30); "Appendix II:  Contents, Style, and Iconography" [of the Manuscript] (pp. 30-33); Conclusion (pp. 34-35); Bibliography (pp. 36-39); and Glossary (p. 40). [Additional discussion of Villard is promised in vol. 4 of this publication, not yet published.]

These sections are followed (pp. 42-176) by photographic reproductions of the manuscript folios at actual size without cropping and without inversions.  No folios are omitted.  Bucher's illustrations are quite dark, with an unpleasant, muddy gray tone.  However, this printing serves better than that of any other facsimile to convey a sense of the variations in texture and tone of the original folios. Bucher employs Hahnloser's scheme of designating each surface of each folio with an arabic number as if it were a plate, hence a total of sixty-six pages or plates.  Because this manuscript is but a part of Bucher's total study, it is designated "V" for cross-referencing purposes, hence each folio number is preceded by "V," for example, "V1" (fol. 1), "V2" (fol. 1v), etc.  Bucher indicates different details, figures, or scenes on various folios as "a," "b," "c," etc., although this is not done consistently.

Bucher intersperses his commentaries and his reproductions of folios.  For the most part, folio and related commentary are contained on facing pages although certain extended commentaries disrupt the neatness of this scheme.  Within his commentaries he provides English translations of the manuscript inscriptions, but no transcriptions of the original inscriptions are given, rendering the glossary rather useless.  Bucher's translations of the manuscript inscriptions are his own (p. 41) in which "we adhered to the often clumsy style and punctuation of the inscriptions which frequently differ from previously published interpretations in order to approximate the basic fabric of the original [inscriptions]."  By and large, Bucher's translations are somewhat "free," and Willis's translations are preferable to Bucher's.

Bucher's facsimile terminates (pp. 177-93) with forty-one figures to accompany and supplement the Villard drawings.  Many of these figures are found in (and are taken from?) Hahnloser, but some reconstruction drawings of Villard's mechanical devices (e.g., sawmill, fol. 22v) and certain perspective renderings of other Villard drawings (e.g., horologe, fol. 6v, and lectern, fol. 7) are helpful in visualizing what Villard may have observed and/or intended the viewer to understand.

The interpretation Bucher gives to the Villard manuscript (p. 15, "our most direct visual witness to the expansive attitude of the first three decades of the thirteenth century") is standard. But his specific view that the manuscript was a lodge book follows Hahnloser's interpretation closely.  In addition, Bucher is a disciple of Paul Frankl (1960.6) in believing that Villard attempted to

organize his manuscript into a "text[book] which others would con-
sult" (p. 26). Bucher cites (p. 28) Frankl's claim that Villard was
"the Gothic Vitruvius" and says he is not unjustly so designated.

For Bucher, Villard was an architect, but he insists on two
qualifications in this regard. The first is that Villard was quite
versatile, worked in stone and in timber, and may have also been a
sculptor in stone and wood, possibly also in metal (or, at least,
that he was interested in metalwork). The second is that Villard
was at best an individual with "mediocre design talents" (p. 18) who
"was probably never given a major commission" (p. 27). This view
does not accord well with Bucher's attribution of work to Villard
(see below). His best summary (p. 26) of Villard as medieval artisan
may be this: "Villard strikes me as a busy individual who may never
have realized his professional limitations."

What Bucher terms "A Tentative Biography [of Villard]" (pp. 15–
26) is more detailed than any offered to date and is the only attempt
to reconstruct his entire professional life. According to Bucher,
Villard was born ca. 1175 at Honnecourt and entered the architectural
profession at Vaucelles where he was a journeyman after 1190, becom-
ing a master ca. 1216 when the choir there was largely completed.
It was at this time that Villard began making his drawings. During
the next five years, ca. 1215–1220, Villard traveled around northern
France, visiting Laon, Meaux, Reims, and Chartres where he may have
been employed as a sculptor on the south arm porch ca. 1217. At
about the same time he may have made a trip to the Meuse Valley
region to study metalwork, and he visited Reims to study and to
sketch sculpture. Sometime after 1221 he was called to Hungary,
either by the Cistercians or due to some association with Saint
Elizabeth of Hungary. Bucher postulates that Villard may have
passed through Bamberg where his drawings (fols. 9v and 10) of the
then new Laon tower influenced the design of the Bamberg towers.
Bucher does not attribute any Hungarian architectural commissions to
Villard, insisting that he may not have remained in Hungary for a
very long time. He does suggest that Villard may have designed
choirstalls for installation in one or more Hungarian churches, and
he accepts Gerevich's contention (1974.1) that Villard "may have
designed and/or participated in the construction of the tomb of
Gertrude de Meran at Pilis Abbey." Villard then returned to France,
passing through Lausanne ca. 1226/1227, possibly after an excursion
into Italy which may have included visits to Milan and Venice. Back
in France, Villard found work as a subcontractor at Reims, where he
was responsible for aisle window and triforium arcade tracery and
for tas de charge vault springers and later discarded vaulting ribs.
Finally, in 1233, Villard became associated with work at Saint-
Quentin and also possibly with work at Cambrai. Bucher accepts
Bénard's interpretation (1864.1) that Villard had a hand in the
design of the Saint-Quentin choir (see Bucher, 1977.2; Barnes,
1978.1; Bucher 1978.3). Bucher states this in different ways in
different places, but his most unqualified claim (p. 25) is that

"It is even possible to defend his [Villard's] presence as maître d'oeuvre [at Saint-Quentin] from 1233 onward." Since Bucher categorically denies that Villard was a cleric, this means master of the architectural work, not keeper of the fabrica. It may be that Villard did not remain at Saint-Quentin very long. His drawings show none of the newer architectural forms or ideas employed there, or elsewhere, and Bucher seems to suggest that by the mid-1230s Villard was something of an anachronism. Then ca. 1235 he began, with the assistance of Master II, to attempt to organize his sketchbook into a lodge book for the benefit of others, although much of his material was then out-of-date and no longer useful. Villard would have died, according to Bucher, ca. 1240, perhaps some sixty-five years of age.

One may or may not accept the specifics of Bucher's essay on Villard's life and career, but no one has better evoked the mood of the world in which Villard must have lived and worked.

In the sections (pp. 28-35) in which Bucher treats the history and significance of the manuscript, his commentary very closely follows that of Hahnloser. Bucher accepts the manuscript as a lodge manual and sees it as a treatise so well organized that he refers to its "chapters." He proposes (p. 28) that the manuscript originally consisted of six quires of sixteen leaves each (ninety-six pages), and states that the original "total number of pages was a minimum of eighty-two." He also claims that the folios were in Villard's day larger (255 mm × 180 mm) than they are now, and he estimates that there were originally between 341 and 425 drawings of which 256 remain.

Bucher dates (p. 29) the drawings between ca. 1215 and ca. 1235, and his most distinct departure from Hahnloser and others is his contention (pp. 29, 118, 122) that Master II worked with, not later than, Villard in redoing certain of the folios, although this Master II inherited the manuscript from Villard. Bucher believes that Master III may have been a cleric and that the manuscript, no longer of any use to the architectural profession after ca. 1240, became something of a curiosity and entered one or more clerical libraries where it was preserved for the very reason that it was no longer practical.

# Concordance between the Manuscript and Facsimile Editions

| Villard Manuscript | Lassus (1858) | Willis (1859) | Omont (1906) | Hahnloser (1935) | Bowie (1959) | Bouvet (1960) | Bucher (1979) |
|---|---|---|---|---|---|---|---|
| 1 | I | I | I | 1 | 1 | I | V1 |
| 1v | II | II | II | 2 | 2 | II | V2 |
| 2 | III | III | III | 3 | 20 | III | V3 |
| 2v | IV | IV | IV | 4 | 9 | IV | V4 |
| 3 | omitted | omitted | V | 5 | 63 | V | V5 |
| 3v | V | V | VI | 6 | 13 | VI | V6 |
| 4 | VI | VI | VII | 7 | 33 | VII | V7 |
| 4v | VII | VII | VIII | 8 | 5 | VIII | V8 |
| 5 | VIII | VIII | IX | 9 | 62 | IX | V9 |
| 5v | IX | IX | X | 10 | 26 | X | V10 |
| 6 | X | X | XI | 11 | 27 | XI | V11 |
| 6v | XI | XI | XII | 12 | 51 | XII | V12 |
| 7 | XII | XII | XIII | 13 | 52 | XIII | V13 |
| 7v | XIII | XIII | XIV | 14 | 34 | XIV | V14 |
| 8 | XIV | XIV | XV | 15 | 10 | XV | V15 |
| 8v | XV | XV | XVI | 16 | 19 | XVI | V16 |
| 9 | XVI | XVI | XVII | 17 | 28 | XVII | V17 |
| 9v | XVII | XVII | XVIII | 18 | 39 | XVIII | V18 |
| 10 | XVIII | XVIII | XIX | 19 | 40 | XIX | V19 |
| 10v | XIX | XIX | XX | 20 | 46 | XX | V20 |
| 11 | XX | XX | XXI | 21 | 4 | XXI | V21 |
| 11v | XXI | XXI | XXII | 22 | 23 | XXII | V22 |
| 12 | XXII | XXII | XXIII | 23 | 11 | XXIII | V23 |
| 12v | XXIII | XXIII | XXIV | 24 | 12 | XXIV | V24 |
| 13 | XXIV | XXIV | XXV | 25 | 15 | XXV | V25 |
| 13v | XXV | XXV | XXVI | 26 | 8 | XXVI | V26 |
| 14 | XXVI | XXVI | XXVII | 27 | 16 | XXVII | V27 |
| 14v | XXVII | XXVII | XXVIII | 28 | 41 | XXVIII | V28 |
| 15 | XXVIII | XXVIII | XXIX | 29 | 48 | XXIX | V29 |
| 15v | XXIX | XXIX | XXX | 30 | 49 | XXX | V30 |
| 16 | XXX | XXX | XXXI | 31 | 50 | XXXI | V31 |
| 16v | XXXI | XXXI | XXXII | 32 | 3 | XXXII | V32 |
| 17 | XXXII | XXXII | XXXIII | 33 | 17 | XXXIII | V33 |
| 17v | XXXIII | XXXIII | XXXIV | 34 | 58 | XXXIV | V34 |
| 18 | XXXIV | XXXIV | XXXV | 35 | 35 | XXXV | V35 |
| 18v | XXXV | XXXV | XXXVI | 36 | 36 | XXXVI | V36 |
| 19 | XXXVI | XXXVI | XXXVII | 37 | 37 | XXXVII | V37 |
| 19v | XXXVII | XXXVII | XXXVIII | 38 | 38 | XXXVIII | V38 |
| 20 | XXXVIII | XXXVIII | XXXIX | 39 | 55 | XXXIX | V39 |
| 20v | XXXIX | XXXIX | XL | 40 | 56 | XL | V40 |
| 21 | XL | XL | XLI | 41 | 57 | XLI | V41 |
| 21v | XLI | XLI | XLII | 42 | 64 (half) | XLII | V42 |
| 22 | XLII | XLII | XLIII | 43 | 25 | XLIII | V43 |
| 22v | XLIII | XLIII | XLIV | 44 | 59 | XLIV | V44 |
| 23 | XLIV | XLIV | XLV | 45 | 60 | XLV | V45 |
| 23v | XLV | XLV | XLVI | 46 | 18 | XLVI | V46 |
| 24 | XLVI | XLVI | XLVII | 47 | 31 | XLVII | V47 |
| 24v | XLVII | XLVII | XLVIII | 48 | 32 | XLVIII | V48 |
| 25 | XLVIII | XLVIII | XLIX | 49 | 14 | XLIX | V49 |
| 25v | XLIX | XLIX | L | 50 | 21 | L | V50 |
| 26 | L | L | LI | 51 | 22 | LI | V51 |
| 26v | LI | LI | LII | 52 | 29 | LII | V52 |
| 27 | LII | LII | LIII | 53 | 30 | LIII | V53 |
| 27v | LIII | LIII | LIV | 54 | 54 | LIV | V54 |
| 28 | LIV | LIV | LV | 55 | 6 | LV | V55 |
| 28v | LV | LV | LVI | 56 | 7 | LVI | V56 |
| 29 | LVI | LVI | LVII | 57 | 53 | LVII | V57 |
| 29v | LVII | LVII | LVIII | 58 | 24 | LVIII | V58 |
| 30 | LVIII | LVIII | LIX | 59 | 61 | LIX | V59 |
| 30v | LIX | LIX | LX | 60 | 43 | LX | V60 |
| 31 | LX | LX | LXI | 61 | 42 | LXI | V61 |
| 31v | LXI | LXI | LXII | 62 | 45 | LXII | V62 |
| 32 | LXII | LXII | LXIII | 63 | 44 | LXIII | V63 |
| 32v | LXIII | LXIII | LXIV | 64 | 47 | LXIV | V64 |
| 33 | LXIV | LXIV | LXV | 65 | omitted | omitted | V65 |
| 33v | omitted | omitted | LXVI | 66 | omitted | omitted | V66 |

# Writings about Villard
# and His Drawings, 1666-1981

<u>1666</u>

1  FÉLIBIEN [des AVAUX], ANDRÉ.  <u>Entretiens sur les vies et les</u>
   <u>ouvrages des plus excellents peintres anciens et modernes</u>.
   Paris:  Sébastien Mabre Cramoisy.  **2d ed. 1696.
       The first (1666) edition of this work probably contains
   the earliest published reference to Villard's drawings,
   although Villard is not specified by name.  Félibien states
   (vol. 1, p. 528), "Il m'est tombé depuis peu entre les
   mains un vieux livre en parchemin d'un Auteur François,
   dont les charactères et le langage témoignent être du
   douzième siècle.  Il y a quantité de figures à la plume qui
   font connoistre que le goust de desseigner estoit alors
   aussi bon [en France] que celuy d'Italie l'estoit du temps
   de Cimabue."  As the Villard manuscript was in the posses-
   sion of the Félibien family in the late sixteenth century,
   it is reasonable for Félibien to have had it "fall into his
   hands."
       André Félibien (1619-1695) was court historian to
   Louis XIV and secretary to the royal Academie de l'archi-
   tecture in Paris.  His analysis of Villard's drawings,
   which he misdated to the twelfth century, may have been
   sincere, although it has unmistakably chauvinistic over-
   tones.  Frankl (1960.6, p. 35) notes that Félibien was a
   "confirmed classicist [who] scarcely had the right per-
   spective to appreciate Villard's book fully."

<u>1825</u>

1  WILLEMIN, NICOLAS X., and POTTIER, ANDRÉ.  <u>Monuments français</u>
   <u>inédits pour servir à l'histoire des arts depuis le XVIe</u>
   <u>siècle jusqu'au commencement du XVIIIe [siècle]</u>.  Vol. 1.
   Paris:  Chez Mlle. Willemin, p. 62 and pl. 102.
       Contains the first published Villard drawings, an en-
   graved composite by Willemin of the leaf-face on fol. 5v,
   the seated couple on fol. 14, and the man mounting a horse

1825

on fol. 23v. According to Willis, Pottier wrote his com-
mentary on the basis of Willemin's engravings and did not
examine the manuscript itself. Despite the incorrect late
dating of the drawings and his limited interest in them
only as examples of costuming, Pottier left an important
legacy to French scholarship because he was the first to
term the manuscript an album, considering it to have been
a notebook.

This work is more significant than might appear, since
it brought the Villard manuscript to the attention of
Quicherat (1849.1).

1849

1 QUICHERAT, JULES [ETIENNE JOSEPH]. "Notice sur l'album de
Villard de Honnecourt, architecte du XIIIe siécle." Revue
archéologique, 1st ser. 6:65-80, 164-88, 209-26, and
pls. 116-18.

The first serious study of the Villard manuscript,
brought to Quicherat's attention by the publication of
Willemin and Pottier (1825.1). Villard scholarship may be
said to have begun with this study by Quicherat (as he
himself claimed; see Quicherat, 1876.1). It prompted the
increased attention to the manuscript in the second half of
the nineteenth century, including publication of the Lassus
facsimile edition nine years later.

This study remains a major source on Villard, partly be-
cause of Quicherat's analyses, but mainly because of his
classification of the manuscript's subject matter. This
first attempt at classification is still the most widely
used. Quicherat's classification (p. 72) is: (i) mechan-
ics, (ii) practical geometry and trigonometry, (iii) stone-
cutting and masonry, (iv) carpentry, (v) design of archi-
tecture, (vi) design of ornament, (vii) design of figures,
(viii) furniture, and (ix) materials foreign to the exper-
tise of the architect or designer. The two shortcomings of
this classification are immediately apparent. category
nine is an uninformative throwaway, and the entire scheme
depends on the belief that Villard was an architect.

While Quicherat was interested only to a limited degree
in Villard as an architect, he was the first author to
term him one, starting a tradition which persists today.
Quicherat attributed (p. 69) the design of the choir of
Cambrai, 1230-1243, to Villard and established (pp. 70-71)
the idea that Villard was so well-known as an architect
that he was called to Hungary between 1244 and 1247 to
build one or more unspecified churches after the expulsion
of the Tartars from that country.

2

While these and other undocumented assumptions or out-
right errors (e.g., misattribution to Villard the statement
that the tower of Laon was "la plus belle tour qu'il y ait
au monde") stem from Quicherat, his own principal interest
was in Villard's "engines" and his use of geometry in de-
sign. In this connection, Quicherat terminated (p. 226)
his study with the famous quotation from Vitruvius (De
Architectura, bk. 1, chap. 1, sec. 3) about the areas of
expertise required by the architect and, despite his warn-
ing about the differences between the Vitruvian Age and
that of Villard, this is the basis for the tradition of
referring to Villard as the "French Vitruvius."
  Quicherat redrew thirty-one of Villard's figures to
accompany his text, and provided three plates of drawings
from the manuscript: 116 (Saracen tomb on fol. 6), 117
(seated nude on fol. 22; sleeping apostle on fol. 23v), and
118 (horologe on fol. 6v; lectern on fol. 7; man in chlamys
on fol. 29v). These plates were engraved by Ch[arles?]
Saunier after drawings by Quicherat. Quicherat correctly
designated materials in the manuscript by folio. See
Quicherat, 1886.1.

## 1852

*1   TOURNEUR, VICTOR.  Article in Travaux de l'Académie de Reims
     17.
          Cited by Chevalier, 1905.1, vol. 2, col. 4677, as re-
     ferring to Villard on p. 50.

## 1854

1   VIOLLET-le-Duc, EUGÈNE EMMANUEL.  Dictionnaire raisonné de
    l'architecture française du XIe au XVIe siècle.  10 vols.
    Paris:  Ve A. Morel et Cie, Editeurs, 1854-1868.
         Contains various references to Villard. He notes
    (vol. 1, p. 111, s.v. "architecte") that Villard "dirigea
    peut-être les constructions de la cathédrale de Cambrai"
    and that Villard was called to Hungary "pour entreprendre
    d'importants travaux." In vol. 2 (p. 317, s.v. "cathé-
    drale"), Viollet-le-Duc attributes Reims to Robert de Coucy
    and claims that Villard was his "contemporain et ami," al-
    though he does not attribute to Villard any part in the de-
    sign of Reims. He does cite (vol. 2, p. 321) Villard's
    drawings of Reims as partial proof that the work at Reims
    was well-advanced by 1230, hence indirectly assigning the
    Villard drawings to that date.

1854

In his long article on sculpture (vol. 8), he devotes
pp. 265-67 to the significance of Villard's geometric
schemes for designing figures, claiming that these stem
from Egyptian art as passed into medieval Europe by way of
Byzantium, and that such schemes were intended for ordinary
artists, not for the great masters. He here dates the
manuscript to the middle of the thirteenth century.

## 1856

1    PARIS, LOUIS. "Notices sur le dédale ou labyrinthe de
    l'église de Reims." Bulletin monumental 22:540-51.
    [Published in Reims in 1885 as Le Jubé et le labyrinthe
    de la cathédrale de Reims.]
        While not especially concerned with Villard, this is of
some interest because Paris claims to have been the dis-
coverer of the Villard manuscript in 1836, thirteen years
before Quicherat's study (1849.1). Paris states (p. 548),
"Dans la découverte que nous avons faite, il y a une
vingtaine d'années (on nous permetta de revendiquer ici ce
petit mérite), de l'Album de Vilart de Honecort. . . ." He
incorrectly states that Villard himself claimed credit for
the choir of Meaux, but notes that Villard could "sans
témérité" be considered one of the artists who built Reims.

## 1857

*1   HENSZLMANN, IMRE. Article in Moniteur des architectes.
    (Paris) (July).
        Cited by Gál (1929.2, pp. 234-35) as an article by the
archaeologist whom Gál terms "le Quicherat hongrois", writ-
ten by Henszlmann while he was visiting Paris just at the
time when Quicherat's study (1849.1) of Villard was having
maximum impact. In this article Henszlmann attributed
Kassa to Villard, a view Gál claims he later (1866.2)
renounced.

## 1858

1    BURGES, WILLIAM. "An Architect's Sketch-book of the Thirteenth
    Century." The Builder no. 16 (15 November):758; (20 Novem-
    ber):770-72.
        Burges was one of the first non-Frenchmen to examine the
Villard manuscript, and he provides an amazing amount of
detailed analysis and commentary crammed into three pages.

He refers to the promised Willis facsimile and had studied
the Lassus facsimile, which he criticizes on several
counts:  that Villard's underdrawings are not reproduced
in Lassus's lithographs; that Lassus's interpretations of
Villard's intentions are sometimes uninformative or possi-
bly incorrect; and that Lassus is given to unfounded specu-
lation, for example (p. 758), Lassus's attribution of
Cambrai and Kassa to Villard "is pure conjecture; but, at
least, has the merit of probability, and until we have
something better to substitute [for it], will do as well as
anything else."  Burges also complains that Lassus misled
him about Villard's name by gratuitously employing "Villard"
rather than "Wilars", observing (p. 770n) that "we ought to
give so accomplished a man as our author [Villard] the
credit of spelling his own name correctly."

Burges's study is divided into two parts.  In the first,
he deals mainly with the physical state of the manuscript
and with Villard's drawing techniques.  He notes that the
binding is at least the second employed and that the leaves
are not bound in their original sequence.  Burges claims
that Villard employed a bow-pencil, but not a bow-pen, and
that he made use of compass and straightedge.  He also
claims that the nature of Villard's letters proves he used
a crow- rather than a goose-quill pen for his captions.
In the second part of his article, Burges summarizes the
various subjects found in the manuscript, and concentrates
on Villard's style and ability as a draftsman.

In general, he is very critical of Villard the drafts-
man.  Regarding the architectural drawings, he complains
(p. 758) of their "extreme inaccuracy and contempt of
detail," but admits that this is at least in part due to
the fact that Villard, like other architects of his time,
employed models as points of departure only, altering them
to suit his needs or sense of what was better and making no
attempt at completeness.  For example, in the case of the
Lausanne rose (fol. 16), Burges states that Villard's
rendering "is by no means an improvement upon the original
[design]."  He is also critical of Villard's drawings of
figures, which he places (p. 770) in four categories:
those drawn (i) from life, (ii) after antique models,
(iii) as compositions for or copies of contemporary sub-
jects, and (iv) to show the art of portraiture.  Burges is
particularly suspicious of the utility of this last cate-
gory, as well as its result, claiming that such schemes
(and architectural books in general) are normally "useful
only to those who can do without them."  He concludes, "If
our friend Wilars had studied the human or animal skeleton,
instead of seeking to get his outlines by means of

5

impossible squares and triangles he would, doubtless, have
been a better artist, and a fortiori, a better architect."
    Burges makes only one tentative attribution of a work to
Villard.  Noting Villard's interest in Lausanne and the
quality of his drawings of choirstalls (fols. 27v and 29),
Burges claims that the fact that Villard's wrestlers
(fol. 14v) are found on the Lausanne choirstalls "would
almost lead us to believe that Wilars de Honnecourt had
something to do with the design of the [Lausanne] stalls."
    Burges provides a number of details of Villard's draw-
ings which he made as woodblock prints from his own copies
of the original drawings in the manuscript.  But he insists
these are not facsimiles, their purpose being to study
Villard's techniques and to provide the reader with a
feeling for the original drawings.

2    GARLING, HENRY BAILY.  "Some Remarks on the Contents of the
    Album of Villard de Honnecourt." Transactions of the Royal
    Institute of British Architects 10 (1858-1859):13-20.
        A paper delivered 15 November 1858 which is of greater
    interest for its condemnation of nineteenth-century archi-
    tectural practice and for the comments and questions of
    fellows and guests in attendance (see below), than for
    anything Garling has to say about Villard or his manu-
    script, which Garling knew only in the Lassus facsimile.
    Garling believed (p. 15) that the manuscript was "not a
    mere memorandum book for the author's own use, but that it
    was intended for the instruction of others," although he
    states specifically (p. 15), "There is no pretention to
    mystery; no secrets of craft [in the manuscript]."
        Garling was impressed (p. 15) by Villard's versatility,
    claiming that the manuscript "embraces every department of
    an architect's studies," but he was considerably less
    favorably impressed by Villard's skill as a draftsman.  He
    criticizes (p. 14) the drawing of the Lausanne rose
    (fol. 16) as made "from memory, and very incorrect."  He
    explains the discrepancies between Villard's drawings of
    Reims and the actual building by the fact that Villard
    probably drew from working drawings which were later
    abandoned or modified.  He dates (p. 13) Villard's activi-
    ties to the period between 1230 and 1250 and claims "there
    is very strong reason for believing that he was the archi-
    tect of the Choir of Cambray."
        Garling refers to the article "last week" of Burges
    (1858.1), who was in the audience and who summarized the
    contents of that article.  Much of the discussion following
    Garling's presentation was directed at the hubris of Lassus,
    "who claimed for France the merit of almost all the great

architectural works of the period." Gilbert Scott praised
(p. 19) Villard by stating that he "did not believe that
architects of the present day could draw the figure so
well as De Honnecourt."

*3  HENSZLMANN, IMRE.  Article in Pesti Napló [Journal of Pest]
    (Budapest), no. 217.
        Cited by Gál (1929.2, p. 233) as an article in which
    Henszlmann claimed that Villard worked in Hungary between
    1260 and 1270, called there by Stephen V.  In Hungarian.

4   LASSUS, J[EAN]-B[ATISTE]-A[NTOINE].  See "The Facsimile
    Editions," F.I, 1st ed.

5   MÉRIMÉE, PROSPER.  "Album de Villard de Honnecourt."  Moniteur
    universel (20 December).  Reprints.  Études sur les arts du
    moyen âge.  Paris:  Michel-Lévy Frères, 1875; **Paris:
    Flammeron, 1969, pp. 229-70.
        While basically a review of the Lassus facsimile,
    Mérimée ranges afield in an attempt to place Villard in
    the general context of thirteenth-century art.  He sees
    (p. 232) Villard as parallel to Leonardo da Vinci in his
    wide range of interests, the first author to make this com-
    parison.
        Mérimée concentrates on Villard's interest in antique
    sculpture and expresses amazement that Villard, as a pro-
    fessional architect, was interested in sculpture and paint-
    ing.  He attempts to determine the purpose of Villard's
    drawings, concluding that they and their captions were too
    random and inconsistent to have collectively served as a
    book of instruction for other masons, terming (p. 230) the
    manuscript a "notation mnémonique à son [Villard's] usage
    particulier."
        The 1858 article refers to Villard's drawings by
    Lassus's plate numbers, whereas the 1969 reprint employs
    photographic reproductions identified by folio number
    without a concordance to the text.

## 1859

*1  EITELBERGER, JULES.  Article in Mittheilung der k. k. Central-
    Commission zur Erforschung und Erhaltung der Baudenkmaler 4
    (June).
        Cited by Renan (1862.1, p. 206 n. 4) and by Schneegans
    (1901.1, p. 53 n. 8) as published in Vienna and having to
    do with "proof" of the activities of Villard in Hungary.

1859

2    VIOLLET-le-Duc, EUGÈNE EMMANUEL. "Premiére Apparition de
Villard de Honnecourt, architecte du XIIIe siècle."
Gazette des beaux-arts, 1st ser. 1:286-95.
    An amusing imaginary piece in which Villard appears at
night in Viollet-le-Duc's study demanding to know why
Lassus went to the trouble to publish his "carnets incom-
plets"? Villard explains the sources of certain of his
drawings and stresses (p. 288) that the variety of subjects
in his manuscript is due to the multiplicity of responsi-
bilities of the medieval architect ("Nous n'avons pas
inventé ce que vous appelez les spécialités, mot barbare
comme la chose qu'il exprime."). Villard likewise defends
his style of drawing and explains (p. 290) that he drew the
Reims window (fol. 10v) when it was "encore sur l'épure"
when he had been called to Hungary "vers 1250" to build
Kassa, the drawing having been made because, "je ne voulais
pas oublier cette forme des meneaux de Reims, pour m'in-
spirer au besoin." Villard's most amazing revelation
(p. 292) is that he and the aged Pierre de Corbie drew the
plan of a church on fol. 15 as a project for Reims. Before
vanishing, Villard promises to return to Viollet-le-Duc
"et nous causerons." See Viollet-le-Duc, 1860.2.
    Reproduces the sleeping apostle on fol. 23v, the geo-
metric sheep on fol. 18v, and the geometric wrestlers on
fol. 19 after Lassus.

3    WILLIS, ROBERT. See "The Facsimile Editions," F.II.

<div align="center">1860</div>

1    BURGES, WILLIAM. "Architectural Drawing." Transactions of
the Royal Institute of British Architects 11:15-23.
    A paper read by Burges, a newly elected member of the
institute, on 19 November 1860. In a brief survey of
medieval architectural drawings from the plan of Saint Gall
to Jan van Eyck's tower in St. Barbara, Burges briefly dis-
cusses (pp. 18-19) the Villard (called Wilars) manuscript
which he had examined "two months ago" (September 1860?).
Burges claims that the Villard drawings "are the most per-
fect and largest collection of the [architectural] drawings
of the Middle Ages which have come down to us." He praises
Villard's drawing technique and claims that Villard was an
architect, not a painter or sculptor as other have claimed.
Burges was particularly favorably impressed by Villard the
draftsman, referring to his "extreme precision of . . .
touch" and "decidedly good style of drawing." Burges ex-
plains Villard's variations from known models as being due

to the fact that "when he copied any executed work, he copied it not as he saw it, but with variations of his own, and as he would execute it himself."

Reproduces Burges's redrawing of the Cambrai plan (fol. 14v) and a detail of the Reims choir buttress (fol. 32v).

2    VIOLLET-le-Duc, EUGÈNE EMMANUEL.   "Deuxième Apparition de Villard de Honnecourt à propos de la Renaissance des arts." Gazette des beaux-arts, 1st ser. 5:24-31.
        Recounts the reappearance of Villard to Viollet-le-Duc (see Viollet-le-Duc, 1859.2) to describe to him a visit Villard made to Rome "vers 1260" at which time he was "ravi d'admiration" for ancient monuments and learned how much more sensitive and skilled French artists were than their Italian counterparts.  Villard thus demands (p. 26) to know why the great flourishing of art in France in the thirteenth century is not termed a renaissance.  He points out to Viollet-le-Duc that the true French renaissance began in the late twelfth century, and that what passes for the French renaissance of the sixteenth century is but a super-ficial importation of a foreign style by a few grandees. Villard insists throughout his monologue on the integrity of French Gothic art:  "nos oeuvres sont roturières, elles sont sorties du peuple et sont restées [du] peuple."  Be-fore vanishing, Villard gives Viollet-le-Duc "un petit volume relie en veau" (his manuscript?), telling him to read it for it is very interesting and instructive, having been written "longtemps après la Renaissance."

1861

1    CERF, CHARLES.  Histoire et description de Notre-Dame de Reims.  2 vols.  Reims:  Imprimerie de P. Dubois.
        Cites (vol. 1, p. 47) Viollet-le-Duc (1854.1) as saying that Villard could have built the radiating chapels of Reims, but states that no other authors mention Villard as the architect of Reims.  In vol. 1, pp. 390-400 ("De l'architecte de la cathédrale"), Cerf discusses the con-flicting claims that present either Hugues Libergier or Robert de Coucy as the Reims architect, dismissing the idea that Villard was involved save possibly as builder of one of the radiating chapels.  He attributes (vol. 1, p. 390) Cambrai to Villard, but claims that nothing in the tradi-tions of Reims attributes the design of that cathedral to him.

## 1862

1  RENAN, [JOSEPH] ERNEST. "L'Art du moyen âge et les causes de
   sa décadence." Revue des deux mondes 40:203-28.
      This article was inspired by the Lassus facsimile but is
   not a review of Lassus and does not concern Villard to any
   great degree. Renan makes a scathing attack on French
   Gothic architecture as unimaginative in its essentials and
   unrealistic in its effects. Villard is included (p. 215)
   as an example of the inconsistency of the Gothic period,
   the variety of subjects in his manuscript being, to Renan,
   as objectionable as the superfluous decoration of Gothic
   architecture. Renan characterizes Villard as having be-
   longed to that confraternity of architects who only created
   for and understood each other. He does identify (p. 206)
   Villard as a Picard architect of the time of Louis IX, the
   Saint, and while not attributing to him any French build-
   ings, supports (p. 207) the contention that Villard prob-
   ably designed Kassa.
      Renan praises (p. 206) Villard's ideas on portraiture
   (probably in reference to fols. 18, 18v, 19, and 19v) as
   "original and new" and makes the specific observation that
   the man in the chalmys on fol. 29v resembles a character
   in a Terence comedy.

## 1863

1  VIOLLET-le-Duc, EUGÈNE EMMANUEL. "Album de Villard de
   Honnecourt, architecte du XIIIe siècle." Revue archéolo-
   gique, n.s. 7:103-18, 184-93, 250-58, 361-70.
      Despite its title, this has little to do with Villard or
   with his manuscript, being mainly a response to Renan
   (1862.1), who is criticized for his disdain of French
   Gothic art and his ignorance of medieval architecture.
      Viollet-le-Duc defends the spontaneity of popular-based
   Gothic art against the contrived, academic character of
   Renaissance art and offers Villard as proof that the medi-
   eval architect was interested in a wide variety of sub-
   jects. He admits that Villard was not a particularly
   gifted draftsman, but claims his intentions were more
   important than his accomplishments.
      Dating the manuscript ca. 1250, he terms Villard a
   Picard lay architect without ascribing any specific build-
   ings to him. Viollet-le-Duc admires, but is perplexed by,
   Villard's interest in painting and sculpture, concluding
   that less-gifted Gothic artists had to rely on aids for
   their designs. He suggests that this is why Villard was

interested in geometry in painting and that in this sense
his drawings do provide some insight into the geometric
basis of medieval design (which he speculates may have been
transmitted from ancient art through Byzantine art).

All references are to plates in the Lassus facsimile,
and there are redrawings of certain of Villard's human
figures from fols. 18, 18v, 19, and 19v, with detailed
analysis of the geometry involved in the design; p. 191
contains an illustrated explanation of the use of the
spiral in designing arches.

Viollet-le-Duc characterizes the manuscript as a
"carnet de voyage," stating clearly (p. 104) that it is,
"ni un traité, ni un exposé de principes classés avec
méthode, ni un cours d'architecture théorique et pratique,
ni le fondation d'un ouvrage [sur l'architecture]."

<u>1864</u>

1 BÉNARD, PIERRE. "Recherches sur la patrie et les travaux de
Villard de Honnecourt." <u>Travaux de la société académique
des sciences, arts et belles lettres, agriculture, et
industrie de Saint-Quentin</u>, 3d ser. 6:260-80.
Bénard notes (pp. 260-62) how little is known about
Villard (fl. 1230-1260) and how little Villard tells about
himself and his works in his manuscript, then offers an
hypothesis of his own. He claims that in the thirteenth
century Honnecourt was located in the Vermandois, not the
Cambrésis, region of Picardie. Villard would therefore
have been a native of the Vermandois probably associated
in some way with Saint-Quentin, which had a priory in
Honnecourt. He then argues that Villard was not a modest
individual and, had he been the architect of Cambrai, would
not have referred to himself with the impersonal pronoun <u>on</u>
(fol. 30v). Bénard thus disattributes Cambrai from
Villard, claiming (p. 266) that Villard drew his Cambrai
and Reims drawings on the basis of visits to both these
sites and of examinations of drawings at each site, but
that in his own drawings he included no edifices which he
built, his manuscript being "un simple carnet de notes et
croquis de voyage."

He next (p. 267) surmises that for a building to be
attributed to Villard, it must be in his native region,
must date to the right time, and must have some extraordi-
nary, previously unnoted connection with Villard's draw-
ings. He finds that Saint-Quentin (choir dedicated in
1257) fits in every particular. Bénard claims to have
discovered (when dismantling an altar in a radiating chapel

1864

at Saint-Quentin) an engraving for a rose window with a
"ressemblance extraordinaire" to Villard's drawing of the
Chartres west rose (fol. 15v), and he concludes (p. 272),
"il est évidemment impossible que celui qui l'a tracée
n'ait pas en sous les yeux le dessin de l'album." He then
(pp. 272-74) calls attention to the similarities between
Villard's Hungarian pavement drawing (fol. 15v) and the
pavement of the chapel of St. Michael in the axial west
tower of Saint-Quentin: "il est d'ailleurs bien visible
que les motifs des . . . panneaux du dallage de la chapelle
Saint-Michel dérivent du croquis de Villard, et qu'ils ont
été composés sous leur inspiration."
    Bénard concludes (p. 275) that Villard obviously was the
architect of Saint-Quentin, employing ideas taken from
locales as far away as Chartres and Hungary and near as
Reims.

*2    BRUNET, JACQUES-CHARLES. <u>Manuel du librairie et de l'amateur
    des livres</u>. Vol. 5. Paris: Firmin Didot Frères, Fils et
    Cie.
       Cited by Chevalier, 1905.1, vol. 2, col. 4677, as re-
    ferring to the Villard manuscript on p. 1233.

<center>1865</center>

*1    BÉNARD, PIERRE. "Recherches sur la patrie et les travaux de
    Villard de Honnecourt." <u>Mémoires [en archéologie] lus à la
    Sorbonne</u> 1865-1866:215-29.
       Cited by Chevalier, 1905.1, vol. 2, cols. 4676-4677, and
    as having been published separately (16 pp.) in Paris in
    1865. Chevalier indicates that both are the same as
    Bénard, 1864.1. See also Bénard, 1867.1.

2    RENAN, [JOSEPH] ERNEST. <u>Discours sur l'état des beaux-arts:
    Histoire littéraire de la France au quatorzième siècle</u>.
    Vol. 2. Paris: Michel Lévy Frères.
       Contains a number of passing references to Villard,
    mostly as contrasts between him and fourteenth-century
    French artists. Renan finds Villard to be superior to the
    latter since he sees fourteenth-century art as decadent
    (p. 234), "L'Album de Villart est un témoignage incompa-
    rable de la vie et de la jeunesse d'imagination qui dis-
    tinguait alors [XIIIe siècle] nos artistes," and he men-
    tions elsewhere (p. 214) that no fourteenth-century French
    artist is the equal of Villard (and others, such as Robert
    de Luzarches) in originality. While praising the Italian

school as superior to the French school, he notes (p. 215)
that at least three figures in the Villard drawings "sont
des études faites sur l'antique ou le byzantin."

Renan attributes (p. 245) to Villard a very early emo-
tional interpretation of the Crucifixion showing Christ as
the "homme de douleurs."

3   STREET, GEORGE EDMUND.  Some Account of Gothic Architecture in
    Spain.  London:  J. Murray.  2d ed.  London, 1869; rev. ed.,
    edited by Georgiana King, New York:  E. P. Dutton, 1914
    (**reprint:  New York:  Benjamin Blom, 1969).

    Discussing the triangular vaults found in the Cathedral
    of Toledo, Street notes (vol. 2, p. 236) that the plan by
    Villard and Peter de Corbie on fol. 15 may be the "original
    scheme" for such vaults.  He suggests that the Petrus Petri
    who was architect of Toledo may have studied with Villard
    and Pierre de Corbie, from whom he got the idea for triangu-
    lar vaults, which he then (vol. 2, p. 237) developed into a
    "much more scientific and perfect form."  Street cites the
    Willis facsimile as his source of information about Villard.

4   WILPERT, ALCIBIADE.  "Substructions de la seconde église de
    Vaucelles erigée au XIIIe siècle sur les plans et sous la
    direction de Villars d'Honnecourt."  Mémoires de la société
    d'émulation de Cambrai 28:137-61.

    The title of this article tells more than the text about
    the author's attribution of Vaucelles to Villard.  On p. 145
    he refers to fig. 1, which shows results of excavations
    carried out in 1861 superimposed on Villard's plan of
    Vaucelles (fol. 17).  While the details of the piers found
    are different from those drawn by Villard, the author
    states that Villard's plan shows what the Vaucelles choir
    looked like in overall layout.

1866

1   ASSIER, ALEXANDRE.  Notre-Dame de Chartres.  Collection Arthur
    Savaète, no. 9.  Paris:  Arthur Savaète, Editeur.  **2d rev.
    ed.  1908.

    Following a brief characterization of Gothic architec-
    ture as the French national art where Assier cites Viollet-
    le-Duc, 1854.1 but in fact gives the latter's view as
    expressed in 1863.1, together with that of Lassus, Villard
    is discussed (pp. 53-54) as a wandering French artist who
    may have lived as late as 1300.  This appears to be the
    latest date any commentator has assigned to Villard.

1866

    Assier credits Villard with Kassa, and states that he had very extensive knowledge of physics, mechanics, mathematics, medicine, and music. This claim must have been made with Vitruvius's list of the qualities of the ideal architect in mind.
    Assier cites Lassus as his source of information on Villard.

*2  HENSZLMANN, IMRE. Müřégészti Kalaůz [Archaeological guide]. Budapest: n.p., pt. 2, p. 68.
    Cited by Gál (1929.2, p. 235) as a study in which Henszlmann reversed his earlier view about Villard and Kassa, here claiming that Villard had not been associated with this church. In Hungarian.

## 1867

*1  BÉNARD, PIERRE. "Recherches sur la patrie et travaux de Villard de Honnecourt." In La Collégiale de Saint-Quentin: Renseignements pour servir à l'histoire de cette église. Paris: n.p., pp. 1-18.
    Cited by Hahnloser (p. 280) and Héliot (1959.5, p. 49 n. 2) as equal to Bénard, 1864.1.

*2  GRÄSSE, JOHANN GEORG THEODOR. Trésor des livres rares et precieux, ou nouveau dictionnaire bibliographique. Vol. 1, pt. 2. Dresden: R. Kuntze.
    Cited by Chevalier, 1905.1, vol. 2, col. 4677, as referring to the Villard manuscript on p. 320.

## 1869

*1  RENAN, [JOSEPH] ERNEST. Histoire littéraire de la France. Vol. 25. Paris: Michel Lévy Frères.
    Cited by several authors, e.g., Chevalier, 1905.1, vol. 2, col. 4677 and Gál, 1929.2, p. 232 n. 2, as concerning Villard's trip to Hungary on pp. 1-9.

2  VERNEILH, JULES (Baron Jean-Baptiste-Joseph-Jules de Verneilh-Puyraseau). "Compte-rendu du Dictionnaire raisonné de l'architecture française du XIe au XVIe siècle par M.E. Viollet-le-Duc." Bulletin monumental 35:601.
    One of the rare expressions of disinterest in the drawings of Villard as unimportant. Verneilh's statement in full is, "L'album de Villard de Honnecourt, rédigé il est vrai à son usage [par Lassus?], semblerait indiquer que les

architectes du XIIIe siècle étaient un peu sommaires dans
leurs explications et leurs croquis, et s'en rapportaient,
dans beaucoup de cas, à la pratique intelligente de leurs
interprètes. Qu'importe, après tout? C'est par leurs
oeuvres, non par leurs dessins, que nous devrons les
juger. . . ."

### 1872

1  LANCE, ADOLPHE-ETIENNE. "Villard de Honnecourt." In Diction-
naire des architectes français. vol. 2. Paris: Vve. A.
Morel et Cie, pp. 327-28.
Attributes no buildings to Villard, and rejects as un-
substantiated Bénard's (1864.1) claim that Villard was the
architect of Saint-Quentin. Lance refers to Viollet-le-
Duc's (1854.1) assertion that Villard was architect of
Cambrai. Villard's trip to Hungary is dated ca. 1244-
ca. 1247, with nothing said about his activities there.
Lance terms the manuscript a "recueil de croquis et des
notes manuscrits" and credits Quicherat (1849.1) with
bringing the manuscript to public attention, although ref-
erence is made to the Lassus facsimile.

*2  PÉCHEUR, LOUIS. Article in Bulletin de la Société archéolo-
gique de Soissons, 2d ser. 3.
Cited by Chevalier, 1905.1, vol. 2, col. 4677, as re-
ferring to Villard on p. 206.

### 1875

1  BÉNARD, PIERRE. Collégiale de Saint-Quentin: Discussion sur
la nature et sur les causes de l'inclination des piliers du
choeur et des transsepts. Paris: Librairie centrale de
l'architecture.
A short (19 pp.) publication discussing exactly what its
subtitle promises. Villard's association with Saint-
Quentin is only mentioned (p. 1) as having been brought to
the public's attention by Bénard (1864.1). Bénard refers
(p. 1) to Villard's "travaux" (i.e., his manuscript) having
been revealed "il y a quelques années par MM. Lassus et
Darcel."

1876

1   LECOCQ, ADOLPHE.  "La Cathédrale de Chartres et ses maîtres-
    de-l'oeuvre."  Mémoires de la Société archéologique d'Eure-
    et-Loir, 6:396-479.
        Contains several passing references to Villard and terms
    (p. 445) him one of the immortals of thirteenth-century
    French architecture.
        Lecocq's principal interest in Villard was (p. 456 n. 1)
    in his drawing (fol. 22v) for a mechanical device which
    Villard claimed would make an angel turn so that it always
    faced the sun.  Lecocq was interested in this because such
    an angel surmounted the chevet roof at Chartres until a
    fire in 1836.  Lecocq terms Villard's mechanism "très
    grossier."

2   QUICHERAT, JULES [ETIENNE JOSEPH].  "Un Architecte française
    du XIIIe siècle en Hongrie."  Revue archéologique, n.s. 32:
    248-51.
        Notice on a thirteenth-century epitaph of a mason named
    Martin Ravesv--found in 1869 during excavations of the
    Cathedral of Colocza in Hungary.  Quicherat claims it may
    refer to an individual from Ravizy in the Nivernais region
    of France, hence a thirteenth-century predecessor to
    Villard de Honnecourt in Hungary.
        Quicherat claims (p. 251) that Villard's "célébrité a
    pris naissance dans la Revue archéologique."  See Quicherat,
    1849.1.

1879

1   HOUDOY, JULES.  "Histoire artistique de la cathédrale de
    Cambrai, ancienne église metropolitaine Notre-Dame."
    Mémoires de la Société de l'agriculture et des arts de
    Lille, 4th ser. 7 [1880]:1-439.
        The entire volume is devoted to Cambrai, but with little
    concern for Villard.  Houdoy discusses him on pp. 22-23
    only, noting that it is said that, after having built the
    abbey church at Vaucelles, Villard "fut très probablement
    aussi l'architecte du choeur de la cathédrale [de
    Cambrai]."  However, on p. 418, in a list of successive
    architects of the cathedral, Houdoy heads the list with
    Villard.  He dates (p. 23) the Villard plan of Cambrai
    (fol. 14v) specifically to 1230 and claims that "le plan
    [de la cathédrale de Boileau] relevé avec soin lors de la
    démolition de la cathédrale, est absolument conformé au
    trace retrouvé plus tard sur l'Album de l'architecte du
    XIIIe siècle."

Houdoy refers to the article by Quicherat (1849.1) for
information about Villard.  It is likely that Houdoy did
not examine the Villard manuscript, for he refers to it by
its pre-1865 shelf designation (S.G. Lat. 1104).

### 1881

*1  BULTEAU, [L'Abbé] MARCEL-JOSEPH.  Notice archéologique sur les
     anciennes abbayes d'Honnecourt et de Vaucelles.  Lille:
     Imprimerie de L. Danel.
         Cited in Baron, 1960.2, p. 96 n. 1.  Chevalier, 1905.1,
     vol. 2, col. 4677, gives the publication date as 1882.
     This item is apparently the same as Bulteau, 1883.1.

2   DURAND, PAUL.  Monographie de Notre-Dame de Chartres [de
     J.B.A. Lassus; Paris, 1842-1867], Explication des planches.
     Paris:  Imprimerie nationale.
         In his commentary on pl. V, the west rose of Chartres,
     Durand observes (p. 63) that Villard drew this rose in his
     album (fol. 15v) and stresses how Villard understood it:
     "Ce qui l'a frappé, c'est son apparence de légèreté et, en
     effet, son croquis n'a pas la même fermeté que l'original;
     il représente une decoupure a jour telle qu'on observe à la
     fin du XIIIe siècle et aux XIVe et XVe [siècles] dans les
     fenêtres analogues."
         Durand does not specifically state how he knew the
     Villard drawing, but considering that he was working on
     expansion of a study by Lassus, he surely must have known
     the Lassus facsimile.
         Durand is one of the earliest authors to suggest that
     Villard specifically modernized his models, as distinct
     from merely noting that he altered them.

### 1883

*1  BULTEAU, [L'abbé] MARCEL-JOSEPH.  "Étude historique et
     archéologique sur les abbayes d'Honnecourt et Vaucelles."
     Mémoires de la Société d'émulation de Cambrai 46.
         The index volume (57 [1895]) for this journal for the
     years 1879-1895 lists no study by Bulteau, although it is
     cited by several authors, e.g., Gál, 1929.2, p. 232.  The
     correct reference apparently is Bulletin de la commission
     historique du Nord 16 (1883):1-111.  See Bulteau, 1881.1.

1883

2    SAINT-PAUL, ANTHYME.  Histoire monumentale de la France.
        Paris:  Librairie Hachette et Cie.
           In a listing of well-known French Gothic architects,
        Villard is mentioned (p. 164) as "célèbre par ses voyages
        en France, où il prit des notes qu'il nous a laissées, et
        en Hongrie, ou il fut appelé."

<u>1886</u>

1    QUICHERAT, JULES [ETIENNE JOSEPH].  "Notice sur l'album de
        Villard de Honnecourt, architecte du XIIIe siècle."  In
        <u>Mélanges d'archéologie et d'histoire, archéologie du moyen</u>
        <u>âge</u>.  Edited by Robert de Lasteyrie.  Paris:  Alphonse
        Picard, pp. 238-98.
           Despite the claim (p. 238 n. 1) that "nous [De
        Lasteyrie] avons introduit dans le texte de ce mémoire de
        nombreuses additions et corrections que l'auteur
        [Quicherat] avait consigné sur les marges d'un exemplaire
        que nous avons retrouvé dans ses papiers," this is essen-
        tially a reprint, with minimal corrections and alterations,
        of the original (1849.1).

<u>1887</u>

1    BAUCHAL, CHARLES.  "Villard de Honnecourt."  In <u>Nouveau Dic-</u>
        <u>tionnaire biographique et critique des architectes fran-</u>
        <u>çais</u>.  Paris:  André, Daly Fils et Cie.
           Gives (p. 568) an extraordinarily imaginative biography
        of Villard.  Bauchal states that the plan on fol. 15 of the
        manuscript was made in 1215 by Villard and Pierre de Corbie
        for Reims but, when it was rejected, Villard and Pierre
        used it at Cambrai where they worked until 1251.  Bauchal
        dates Villard's trip to Hungary from 1244 to 1247 and
        attributes to him "plusieurs églises," especially Kassa and
        Marburg.  He also attributes Vaucelles to Villard and
        states that Meaux and Saint-Quentin are attributed to him,
        but if Villard worked at Saint-Quentin, it was only on the
        smaller of the two transepts and the choir because these
        were completed in 1257 and Villard died "vers 1260."
           Bauchal refers to the manuscript as "un curieux porte-
        feuille, qui renferme un certain nombre de notes et
        croquis d'un grand intérêt."

## 1888

1  BULTEAU, [L'abbé] MARCEL-JOSEPH. Monographie de la cathédrale de Chartres. 2d rev. ed. Chartres: Librairie R. Selleret. [This was the first edition actually published; vol. 2 appeared in 1891; the title page carries the imprint "Société archéologique d'Eure-et-Loir."]

Bulteau claims (vol. 2, p. 26) that Villard visited Chartres ca. 1225 and was so struck by the beauty of its west rose that he made a drawing of it (fol. 15v) with the intention of using it at Cambrai, which Bulteau states Villard "devait reconstruire." Bulteau was the first author to realize (vol. 2, p. 382) that Villard's drawing of Pride (fol. 3v) was made after a relief on the porch of the south arm terminal at Chartres.

Bulteau claims (vol. 2, p. 26 n. 1) that Villard was born ca. 1190 and that his precious album had been exhumed from the Bibliothèque nationale and published by Darcel.

Vol. 3 of this work is an extensive bibliography by Gustave-X[avier?] Sainsot, published in 1900, in which item no. 478 is the Lassus facsimile.

2  TOURNEUR, VICTOR. Description historique et archéologique de Notre-Dame de Reims. Reims: L. Michaud. **7th rev. ed. 1907.

Discussing the question of the original architect of Reims, the author (p. 14) rules out Villard, to whom he attributes Braine and Saint-Quentin. Tourneur states that Villard's drawings of Reims do form an important part of his total collection of drawings.

## 1892

1  HAVARD, HENRY, ed. La France artistique et monumentale. Vol. 1. Paris: Société de l'art français, 1892-1895.

In the study of Reims by Louis Gonse (pp. 1-24), the question of the architects of the building is considered. Gonse dismisses (p. 5) Villard with the comment, "On ne aurait davantage s'arrêter à Villard de Honnecourt, qui n'est venu du Cambraisis à Reims qu'après l'achèvement des chapelles absidales [de la cathédrale]."

## 1894

1   DEMAISON, LOUIS. "Les Architectes de la cathédrale de Reims."
    Bulletin archéologique du Comité des travaux historiques et
    scientifiques, pp. 3-40.
       In an extensive discussion of the architects of Reims
    based upon knowledge of its labyrinth, Demaison dismisses
    (pp. 10-11) the idea that Villard was involved in any
    aspect of the design of the building:  ". . . rien absolu-
    ment, ni dans les dessins [du manuscrit de Villard] eux-
    mêmes, ni dans les notes qui les accompagnent, n'autorise
    à supposer qu'il ait pris une part quelconque à la con-
    struction de notre édifice." He mainly criticizes Bauchal
    (1887.1), but also refers to earlier claims by Paris
    (1856.1) and Cerf (1861.1) and notes that Tourneur (1888.2)
    and Gonse (1892.1) both give reasons for not associating
    Villard with the design of Reims. Demaison dates Villard's
    visit to Reims ca. 1244. He does note that "Villard paraît
    bien avoir été l'auteur" of Cambrai.

## 1895

1   ENLART, [DÉSIRÉ LOUIS] CAMILLE. "Villard de Honnecourt et les
    Cisterciens." Bibliothèque de l'École des Chartes 58:5-20.
       Rejects Villard as architect of Reims Cathedral but
    accepts Bénard's claim (1864.1) that he was architect of
    Saint-Quentin after his return from Hungary. Enlart
    focuses (p. 18) on Villard's training, concluding that he
    was an ultraconservative who had to have received his early
    training as an architect at Vaucelles. Whether or not he
    was later associated with the design of Cambrai, on the
    basis of his success at Vaucelles Villard was called to
    Hungary from 1235 to 1250 to design one or more of ten
    Cistercian churches erected during that period (pp. 18-19).
    If Villard also worked for Hungarian bishops during his
    stay in Hungary, it was because he was recommended to them
    by the powerful and influential French Cistercians in that
    country.
       In passing, Enlart raises (p. 7) the question of whether
    or not the Pierre de Corbie mentioned on fol. 15 of the
    Villard manuscript might have been the Petrus Petri
    (d. 1290) who was the architect of the Cathedral of Toledo.

## 1898

1   MÂLE, EMILE. L'Art religieux de XIIIe siècle en France:
Étude sur l'iconographie du moyen âge et sur ses sources
d'inspiration. Paris: E. Leroux, 1898. **English trans-
lation. The Gothic Image: Religious Art in France of the
Thirteenth Century. New York: Harper & Brothers, Pub-
lishers, 1948, pp. 54-55.
    Cites Villard as proof of the Gothic artist's interest
in nature and in drawing directly from nature, referring to
his small animals (fol. 7v) especially, but noting that
Villard visited a great lord's menagerie to draw his lion
(fols. 24 and 24v) al vif. Mâle also attributes the two
parakeets on fol. 26 to this menagerie, claiming incor-
rectly that Villard noted that these were in a menagerie
and that they were drawn from life.
    Mâle makes the most sweeping attribution of buildings on
record to Villard:  Saint-Quentin by name, but stating
flatly that he "built churches through the length and
breadth of Christendom."
    References are to Lassus's plate numbers; he reproduces
a detail of fol. 26 after Lassus.

## 1901

1   SCHNEEGANS, F.E. "Über die Sprache des Skizzenbuches von
Vilard de Honnecourt." Zeitschrift für romanische Philolo-
gie 25:45-70.
    A long and detailed analysis of the inscriptions in the
Villard manuscript. Schneegans was the first author to
observe that not all the inscriptions were by Villard, a
fundamental discovery for accurate analysis of the hands in
the manuscript and for understanding the work's early his-
tory.
    Schneegans identified three different hands which he
termed "masters" (abbreviated as "Ms."). Villard himself
was Ms. 1. Ms. 2 wrote only in French (fols. 3v, 17, 21v,
and 31v). Ms. 3 wrote in French (fols. 6v, 13, 18, 20,
20v, 21, 22v, and 23) and in Latin (fols. 15, 16, and 17).
On the basis of the handwriting styles and the philology
of the inscriptions, the author dates the manuscript be-
tween ca. 1230 and ca. 1260. Schneegans provides a de-
tailed analysis of the different hands (pp. 48-53) and a
glossary (pp. 67-70) which has served as the basis for all
later glossaries.
    WARNING! Hahnloser believed (p. 194) that Schneegans's
Ms. 3 came sooner in time after Villard than Schneegans's

1901

Ms. 2, so he reversed Schneegans's designations:
Hahnloser's Mr. 2 = Schneegans's Ms. 3 and Hahnloser's
Mr. 3 = Schneegans's Ms. 2. As noted above, Schneegans
termed Villard Ms. 1, a scheme not followed by Hahnloser,
who considered Villard as the first master but never desig-
nated him as Mr. 1.

2   STURGIS, RUSSELL.  A Dictionary of Architecture and Building.
New York:  Macmillan Co.
This is the earliest mention of Villard in a book by an
American author, three years prior to that by Adams
(1904.1). Sturgis claims (vol. 3, col. 1048), "From in-
ternal evidence contained in the book [i.e., the Villard
manuscript], it is supposed that he was one of the leaders
in the development of Gothic architecture in the thirteenth-
century, and that he built, between 1227 and 1251, the
choir of the cathedral of Cambrai. . . ." Sturgis notes
that various churches in Hungary, as well as Meaux and
Vaucelles, have been attributed to Villard by different
authors. Sturgis cites Willis in his bibliography and
employs the spelling "Wilars."

*3   WATSON, THOMAS LENNOX.  The Double Choir of Glasgow Cathedral:
A Study of Rib Vaulting.  Glasgow:  Hedderwick.
Cited by Fitchen (1961.4, p. 304) who includes a long
quotation from Watson relative to Villard's device for
lifting heavy objects (fol. 22v). Watson observes that if
such lifting devices had been in common use, "the proba-
bility is that Vilars would not have thought it necessary
to depict it." Watson's spelling of Villard as Vilars sug-
gests he knew of Villard's drawings through the Willis
facsimile.

1902

1   BRUTAILS, [ELIE] J[EAN]-A[UGUSTE].  "'Tiers-Point' et 'quint-
point.'"  Bulletin archéologique, pp. 273-79.
Not concerned with Villard per se, but with the accurate
use of the terms for third-point and fifth-point arches on
fol. 20v (which are not by Villard). Brutails concludes
that Villard and other Gothic architects used these terms
in a vague way to indicate pointed rather than rounded
arches.

2 DEMAISON, LOUIS. "La Cathédrale de Reims, son histoire, les
dates de sa construction." Bulletin monumental 66:3-59.
   In a long analysis of the various visual documents which
shed light on the dates of Reims, Demaison considers
(pp. 17-21) the croquis of Villard. He terms them "exactes"
with the reservation that Villard ignored features which he
considered unimportant, added his own modifications, or
drew from plans, details of which were subsequently modi-
fied or omitted when actual construction was done, for
example, the crétiatus of the radiating chapels and the
nave. He then dates (p. 20) Villard's drawing of the Reims
nave window "vers l'année 1244," when Villard was on his
way to Hungary following interruption of construction at
Cambrai in 1243.
   Demaison considers (pp. 20-21) Bénard's argument
(1864.1) proposing Villard as architect of Saint-Quentin
rather than of Cambrai and dating Villard's trip to Hungary
ca. 1235. He appears to reject this interpretation, but
claims that whether Villard was architect of Cambrai or of
Saint-Quentin, his Reims drawings date to the second quar-
ter of the thirteenth century and prove that the "chevet
était alors terminé ou sur le point d'être, et les pre-
mières travées de la nef étaient au moins en cours de con-
struction." Demaison discusses (p. 21 n. 1) Renan's
(1862.1) late dating (1261-1272) by of Villard's trip to
Hungary and dismisses this as a possibility unless Villard
made two trips there, one in the 1240s and a second in the
1260s when he worked at Kassa.

3 ENLART, [DÉSIRÉ LOUIS] CAMILLE. "Notes sur quelques maîtres
d'oeuvres: Villard de Honnecourt." In Manuel d'archéolo-
gie française depuis les temps mérovingiens jusqu'à la
renaissance. Vol. 1, Architecture religieuse, Pt. 2,
Période française dit gothique, style flamboyant, renais-
sance. Paris: Auguste Picard et Fils, 1902-1904. **Rev.
ed. Paris, 1920, pp. 745-47.
   Essentially repeats the contents of 1895.1. Enlart here
claims that "on a des preuves" (without citing what these
are) that Villard erected the sanctuaries of Vaucelles and
Saint-Quentin and built some unspecified monuments, now all
destroyed, in Hungary. He also states that Cambrai, Meaux,
and Reims are wrongly attributed to Villard, and that Kassa,
Marburg, and the Liebfrauenkirche at Trier are attributed
to Villard without "preuve certaine." Dating (p. 746)
Villard's death to ca. 1260, he again places Villard's trip
to Hungary between 1235 and 1250.
   Enlart concludes with the hypothesis that the manuscript
had been found at Cambrai by the sculptor Jean de Roupy

1902

(d. 1438), also known as Jean de Cambrai, who adopted cer-
tain of Villard's figures (e.g., the sleeping apostle on
fol. 23v [incorrectly termed a seated figure and designated
as fol. XLVI by the author]) for the tomb of Jean, Duke of
Berry, in the early fifteenth century. He also claims that
Jean de Roupy made some additions to the manuscript, one of
which was the swan (Fr. cygne) of fol. 4 which, together
with Villard's bear (Fr. ours) on that folio, forms a rebus
symbolizing Duke Jean's "dame par amours," one Oursine;
cf. the Très Riches Heures de Jean Duc de Berri (Chantilly,
Musée Condé, MS. 1284, fols. 26 and 112v).

1904

1   ADAMS, HENRY [BROOKS]. Mont-Saint-Michel and Chartres.
    Washington, D.C.: privately printed. **Reprint. Boston:
    Houghton Mifflin Co., 1963.
       Adams is interested in Villard to the degree that
    Villard was interested in the west rose of Chartres
    (fol. 15v), although Adams claims (p. 65) that the Villard
    manuscript "is the source of most that is known about the
    practical ideas of medieval architects." He terms Villard
    a "professional expert" of ca. 1200-1250 who came to
    Chartres and made a rough sketch of the west rose when it
    was relatively new. He later (p. 114) offers Villard's
    sketch as proof that this rose was of "great value" to
    architects of the time (and incorrectly states that this
    rose was the only thing at Chartres of which Villard made
    a drawing). Yet later (p. 144) Adams proposes that while
    the transept roses probably had been completed by the time
    Villard visited Chartres, Villard consciously selected the
    west rose as a model because of "some quality of construc-
    tion which interested him."
       Adams is one of the first American authors to mention
    Villard (see Sturgis, 1901.2), and he may have been the
    first American to examine the manuscript (see "Miscel-
    laneous").

2   LETHABY, W[ILLIAM] R[ICHARD]. Medieval Art from the Peace of
    the Church to the Eve of the Renaissance, 312-1350. New
    York: C. Scribner's Sons. **Rev. ed., edited by D[avid]
    Talbot Rice, New York: Philosophical Library, 1950.
       One of the first English language surveys of medieval
    architecture to include commentary on Villard and his manu-
    script. Lethaby refers to Villard a number of times, and
    summarizes (p. 181) his view of the manuscript by noting
    that its inscriptions indicate that it is "probable that

the book [elsewhere termed a "sketchbook"] was prepared to
be handed on either to [Villard's] descendants, or to his
guild, or for 'publication.'" He accepts (pp. 124 and 181)
the Bénard thesis (1864.1) that Villard may have been the
architect of Saint-Quentin after his trip to Hungary, which
is indirectly dated after 1230 since he also attributes
Vaucelles, ca. 1230, to Villard and dates his visit to
Reims ca. 1225.

Lethaby comments on other aspects of Villard's varied
interests, misquoting him (p. 146) about the beauty of the
Laon tower, but his principal interest in Villard is in his
drawings of masonry. He notes (pp. 131-32) that Villard
fully understood the construction of the Reims tracery,
correctly showing (fol. 31) the joggle joints required in
this construction. In addition, he comments (pp. 119-20)
in some detail on the significance of Villard's [sic =
Master II's] use of three-, four-, and five-point arches
(fol. 20), claiming that these were shorthand geometric
schemes which permitted construction without the use of
large-scale working drawings: "the sketchbook of Villars
de Honnecourt shows how much building recipes of this sort
were valued."

Reproduces, after Lassus or Willis, a number of details
from the manuscript.

## 1905

1   CHEVALIER, CYR ULYSSE JOSEPH. Répertoire des sources histo-
    riques du moyen âge: Bio-bibliographique. 2 vols. Paris:
    A. Picard, 1905-1907.
        Contains (vol. 2, cols. 4676-77) a list of several
    nineteenth-century bibliographic items concerning Villard
    not found or cited elsewhere, e.g., Brunet, 1864.1; Grässe,
    1867.1; Pécheur, 1872.2; Tourneur, 1852.1. Chevalier
    (vol. 2, col. 4676) terms Villard an architecte and gives
    the date 1262 without indicating to what the date refers
    (Villard's death?).

2   FORSTER, GYULA B. "A müemlékek védelme a magyar kormány vis-
    szaállitasa ota" [The protection of artistic monuments
    since reestablishment of the Hungarian government]. In
    Magyarország müemlékei [The artistic monuments of Hungary].
    Budapest: Magyar Tudományos Akádemia.
        Questions (p. 27) the attribution by Möller (1905.3) of
    a mason's mark at Gyulafehérvár to Villard. In Hungarian.

1905

*3    MÖLLER, ISTVÁN. "A gyulafehérvári székesegyház" [The cathe-
      dral of Gyulafehérvár]. In <u>Magyarország müemlékei</u> [The
      artistic monuments of Hungary]. Budapest: Magyar
      Tudományos Akádemia.
           Cited by Forster (1905.2) and Gál (1929.1) as attribut-
      ing a mason's mark at Gyulafehérvár to Villard. Both
      authors reject this attribution. In Hungarian.

                              <u>1906</u>

1     OMONT, HENRI. See "The Facsimile Editions," F.III, 1st ed.

                              <u>1909</u>

1     FAURE, ELIE. <u>Histoire de l'art</u>. 5 vols. Paris: H. Floury,
      1909-1911. **English translation. <u>History of Art</u>.
      Vol. 2, <u>Mediaeval Art</u>. New York: Harper & Row, Pub-
      lishers, 1922.
           In an enthusiastic essay on the influence of French
      Gothic art on thirteenth-century Europe, Faure cites
      (p. 346) as an example of French expertise abroad the
      visits of Martin Ragevy [sic] (see Quicherat, 1876.2) and
      Villard de Honnecourt to Hungary, stating that both "built
      churches in distant parts of Hungary."

                              <u>1910</u>

1     MORTET, VICTOR. "La Mesure de la figure humaine et le canon
      des proportions d'après les dessins de Villard de
      Honnecourt, d'Albert Dürer et Léonard de Vinci." In
      <u>Mélanges offerts à Monsieur Émile Chatelain</u>. Paris, n.p.,
      pp. 367-82.
           Terms Villard an "architecte picard du XIIIe siècle,"
      and claims that his drawings prove that geometry, not
      mathematics, was the basis of design and proportion in
      medieval art. Mortet states (p. 369) that Villard knew
      Latin and took his geometric design-schemata from a Latin,
      or possibly Picard translation of a Latin, treatise on
      practical geometry (e.g., Paris, Bibliothèque Sainte-
      Geneviève, MS. 2200).
           For Mortet (p. 372) the key to Villard's schemata is
      found in the "face in the square" on fol. 19v, which he
      terms "un véritable canon des proportions de la tête, bien
      que Villard de Honnecourt ne nous l'ait dit expressément,"
      passed from Vitruvius to the Renaissance where it is found

                                26

used by Albrecht Dürer and Leonardo da Vinci. According to Mortet, these artists and Villard employed a proportional system of four modules by four modules for the human head. In the "face in the square" the outer two vertical modules and the uppermost horizontal module determine the location of the hair, thus the face itself is designed with a pro- portion of 2:3. (For different interpretations of Villard's "face in the square," see Panofsky, 1921.1, and Frankl, 1945.1.)

Reproduces after Lassus various of the geometric faces and heads on fol. 18v and the head of the seated Christ on fol. 16v, which he claims is designed on the same basis.

2   SERBAT, LOUIS. "L'Age de quelques statues du grand portail de la cathédrale de Reims." Bulletin monumental 74:107-24.
Claims (p. 112) that the classical figures of Reims and Villard's "études de nu d'après l'antique" (fols. 6, 11v, 22, and 29v) prove that medieval artists were more capable of copying the works of antiquity than artists of the classical period would have been of copying medieval work.

Refers (p. 112 n. 4) to plates in the Omont facsimile and reproduces (between pp. 122-23) Villard's Ecclesia figure (fol. 4v), apparently made from the same negative used for the Omont plate.

1911

1   JUSSELIN, MAURICE. "Une Maison du XIIIe siècle récemment découverte au cloître Notre-Dame, à Chartres." Bulletin monumental 75:351-95.
Compares (p. 386) the reliefs of a second-story window tympanum of a house from the former cloister of Chartres discovered in May 1911 with Villard's dice-players (fol. 9) and wrestlers (fol. 14v), dating the reliefs ca. 1225/1250 and claiming that Villard surely saw them, possibly in 1260 on the occasion of the dedication of the cathedral. Jusselin notes that wrestlers are found on stalls at Lausanne, but that Chartres is the only place where Villard could have seen wrestlers and dice-players side by side. He observes that there are some differences between the Chartres reliefs and Villard's drawing, attributing this to the fact that Villard "dessinait de mémoire et ne respectait pas les formes des originaux."

Jusselin provides excellent photographs of the Chartres reliefs and reproduces the Villard figures from photographic negatives, possibly those used for the Omont facsimile.

1912

<u>1912</u>

1   HAENDCKE, BERTHOLD. "Dürers Selbstbildnisse und 'Konstruierte
    Figuren.'" <u>Monatshefte für Kunstwissenschaft</u> 5:185–89.
        Contains a brief reference to Villard's human faces with
    proportional schemata, especially the "face in the square"
    on fol. 19v. Its quadrature is compared with Mathes
    Roriczer's design schemes. Haendcke also mentions Lassus's
    plates XXIV and XXVI but describes the geometric drawings
    found on Lassus's plates XXXIV–XXXVI (fols. 18 and 19).
        There is a parallel between Albrech Dürer's division of
    the human face into horizontal proportional units and the
    drawing of two human faces in the upper right corner of
    Villard's fol. 18v, but there is no evidence that Dürer
    knew the Villard manuscript. Panofsky (1921.1, p. 83
    n. 52) claims that Haendcke gives a "false impression"
    when he states that Villard's two figures in pentagrams
    (bottom of fol. 18) represent a proportional construction
    of an entire eight-faced figure.

2   KUNZE, HANS. <u>Das Fassadenproblem der französischen Früh– und
    Hochgotik</u>. Leipzig: Oscar Brandsetter.
        Although frequently cited in studies on Villard, this
    famous essay has very little to do with Villard or his
    drawings. Kunze mentions Villard in connection with three
    buildings: Chartres, Laon, and Reims. He states (p. 24,
    in n. 2 continued from p. 23) that Emile Boeswillwald could
    have restored a spire at Laon on the basis of Villard's
    drawing (fol. 10) of its tower, and he accepts the view
    (p. 33 n. 1) that, in drawing the Chartres west rose
    (fol. 15v), Villard "improved it": "Villard de Honnecourt
    hat sie, mit einigen Veränderungen im Sinne einer stärkeren
    Durchbrechungen, also im Sinne einer stilistischen Weiter-
    bildung, in einer Skizze wiedergegeban."
        The most extensive discussion of Villard (pp. 52–64
    passim) concerns his drawings of Reims, but Kunze draws few
    concise or convincing conclusions. His view is that
    Villard modified what he saw and/or that some of his draw-
    ings were his projections of what was intended, but subse-
    quently modified, thus accounting for the discrepancies
    between the drawings and the actual fabric of the building
    itself.
        Refers to the Lassus plates.

1913

3    LEFEBVRE des NOËTTES, [Commandant] RICHARD. "La Tapisserie de
     Bayeux datée par les harnachement des chevaux et l'équipe-
     ment des chevaliers." <u>Bulletin monumental</u> 76:213-41.
         Offers (pp. 222-24) Villard's fol. 8v as proof that the
     bit-bridle was in use as early as the thirteenth century,
     although no mention is made of fol. 3v where the same piece
     of harness appears to be shown. This is one of the earliest
     uses of Villard to prove the existence of a specific tech-
     nological innovation (see also Watson, 1901.3).
         Reproduces fol. 8v probably after Omont.

4    MIHALIK, JÓZSEF. <u>A kassai Szent-Erzsebet templom</u> [The Saint
     Elizabeth Church at Kassa]. Budapest: n.p.
         Devotes pp. 15-20 to Villard and Kassa and concludes
     that Henszlmann (1857.1, 1858.3) misdated Kassa and there-
     fore associated it with Villard for the wrong reason.
     After a summary of the Villard manuscript in which he con-
     cludes (p. 17) that Villard was not a very imaginative or
     talented designer, he dates his visit to Hungary immediately
     after the Tartar invasion of 1242. Mihalik concludes
     (p. 20) that it is universally believed that Kassa was
     built by Villard and that Villard became known to Béla IV
     through his work at Cambrai, and he appears to accept the
     attribution of Kassa to Villard. In Hungarian.
         Reproduces after Lassus details of fols. 10v (inscrip-
     tion) and 15v (pavement and inscription).

1913

1    SZABÓ, LÁSZLÓ. <u>Magyarország àrpàdkori épitészete</u> [Architec-
     ture in Hungary during the Arpad Age]. Budapest: Magyar
     Tudományos Akádemia.
         Reviews (pp. 354-64) earlier claims about Villard's
     activities in Hungary, especially those of Henszlmann
     (1857.1, 1858.3, 1866.1). Szabó claims (p. 356) that the
     only certain information about Villard's activities in
     Hungary is that contained (fols. 10v and 15v) in the manu-
     script. He supports (p. 360) the date 1244-1247 for
     Villard's trip to Hungary and the explanation that it may
     have been due to Villard's work at Cambrai, but insists
     this cannot be proved. He then raises the question of the
     correct interpretation of Villard's expression (fol. 15v)
     <u>maint jor</u> and the problem of whether or not Villard was
     "sent" or was "called" to Hungary.
         Szabó concludes (pp. 361-64) with a comparison of the
     plans of Braine and Kassa, stating that Villard must have
     known Braine because of its proximity to Laon and to Reims.

1913

His most important contention is that Villard was involved only in the design/construction of the foundations at Kassa, the church itself dating from the fifteenth century. In Hungarian.
Reproduces details of fols. 2, 10v, and 15v after Lassus.

1914

1   NICQ-DOUTRELIGNE, C[HARLES?]. "L'Abbaye de Vaucelles (Nord)." Bulletin monumental 78:316-28.
Claims (p. 317) that in 1216 Abbot Robert de Saint-Venent "fit appel pour la construction du choeur à l'architecte Villard de Honnecourt, originaire d'un village voisin de l'abbaye et dont l'éducation artistique s'était formée sur les chantiers de Vaucelles."

2   VITZTHUM, GRAF. "Fragment eines Missale von Noyon mit Miniaturen von Villard de Honnecourt." Beiträge zur Studien und Mitteilungen aus dem Antiquariat Jacques Rosenthal. Vol. 1/4-5. Munich: n.p., pp. 102-13 and pls. XIV-XVI.
On the basis of style attributes (p. 113) to Villard the miniatures on six surviving folios of a lavish missal (Cambridge, Mass., Harvard University, MS. Typ 120H) made ca. 1200 for use in (and probably made in) the diocese of Noyon: ". . . des vorliegenden Fragments eines Missale von Noyon eigenhändige Arbeiten des Villard de Honnecourt erhalten sind."
This attribution is rejected by most scholars (see Hahnloser; Walters Art Gallery, 1949.5).
Reproduces a number of details of the Villard manuscript after Lassus.

3   VON SCHLOSSER, JULIUS. "Materialien zur Quellenkunde der Kunstgeschichte, I: Mittelalter." Kaiserlichen Academie der Wissenschaften in Wien, Sitzungsberichte 177:1-102.
Claims (p. 29) that the Villard's Skizzenbuch proves that geometry dominated the design process of the Gothic period, and is "eine der wichtigsten Quellen zur Erkenntnis des inneren Wesens jenes Stils, den wir den gotischen zu nennen gewohnt sind."

### 1918

1    COULTON, G[EORGE] G[ORDON].  "An Architect's Notebook."  In
     Social Life in Britain from the Conquest to the Reforma-
     tion.  Cambridge:  Cambridge University Press, pp. 476-80.
         Translates an apparently random sampling of inscriptions
     from the Lassus facsimile into English with some additional
     commentary.  Coulton claims (p. 476) that Villard "is the
     only medieval architect whose sketchbook has survived," but
     nowhere suggests how this relates to life in medieval
     Britain.
         Coulton notes it is probable that Villard designed
     Vaucelles, ca. 1230; another unspecified church in Hungary
     later; and the Saint-Quentin choir, ca. 1250.
         Reproduces fols. 5, 10, and 10v after Lassus or Willis.

### 1919

1    LEFÈVRE-PONTALIS, EUGÈNE [AMÉDÉE].  "L'Origine des arcs-
     boutants."  Congrès archéologique de France (Paris) 82:
     367-96.
         In an analysis (p. 395) of the two-tier flying buttresses
     of the choir of Saint-Quentin notes that the church was
     "construit peut-être par Villard de Honnecourt."

### 1921

1    PANOFSKY, ERWIN.  "Die Entwicklung der Proportionslehre als
     Abbild der Stilenwicklung."  Monatshefte für Kunstwissen-
     schaft 14:188-219.  **English trans.  "The History of the
     Theory of Human Proportions as a Reflection of the History
     of Styles."  In Meaning in the Visual Arts.  Garden City:
     Doubleday & Co., 1955, pp. 55-107.
         Argues that there are two basic schemes for determining
     human proportions:  the "technical," in which proportions
     are determined without reference to the appearance of the
     object to be depicted (Egyptian scheme); and the "objec-
     tive," in which the object depicted is observed from the
     point of view of its inherent mathematical relationships,
     with a geometric or mathematical system then established
     to control these (Greek and Renaissance schemes).  Panofsky
     sees the Gothic scheme, as exemplified by Villard, as
     parallel to the Egyptian scheme.  The result is planimetri-
     cal, with the purpose of the geometry to establish forms,
     not proportions.

1921

Panofsky discusses Villard on pp. 83-86 and concludes that his approach was thoroughly inorganic, forcing human and animal figures to fit a priori schemata which had nothing to do with nature or with what he terms natural forms. He suggests (p. 85) that while Villard's "face in the square" (fol. 19v) is found elsewhere (in a window at Reims), most of his schemata on fols. 18, 18v, 19 and 19v are individual and very nearly "sheer fantasy."

Panofsky provides an interesting explanation of the two standing figures on the bottom of fol. 18, seeing the difference between the two as an attempt by Villard to use geometry to transpose a frontal view into a three-quarter view. Elsewhere (p. 80 n. 42), Panofsky notes, with reference to the head of Christ on fol. 16v, that Villard was aware of the Byzantine "three-circle" scheme for determining proportions.

Reproduces (after Lassus?) drawings of various geometric constructions on the folios noted above, and a photographic detail of the "face in the square."

## 1922

1   GILLET, LOUIS. <u>Histoire des arts</u>. Histoire de la nation française, 11. Paris: Librairie Plon-Nourrit et Cie.
Attributes (p. 126) Saint-Quentin to Villard and states that the manuscript contains fifty leaves. Gillet's enthusiasm for Villard, when compared with modern architects, has no parallel: "C'est un homme qui écrit le latin d'une manière qui embarrasserait plus d'un des ses confrères modernes, et qui est aussi savant qu'eux en épure, en méchanique, en géometrie."

## 1925

1   GALL, ERNST. <u>Die gotische Baukunst in Frankreich und Deutschland</u>. Vol. 1, <u>Die Vorstuffen in Nordfrankreich von der Mitte des Elften bis gegen Ende des Zwölften Jahrunderts</u>. Braunschweig: Klinkhardt und Biermann. **2d rev. ed. 1955.
Contains several passing references to the Villard manuscript, termed (p. 52) a <u>Skizzenbuch</u>. Gall questions the usefulness of the manuscript in the study of medieval architecture, for in his section on "Sources and Monuments" (pp. 10-16) he says (p. 13) that the "bekannte 'Skizzenbuch' des Architekten Villard de Honnecourt bietet mehr Rätsel als Lösungen."

<u>1926</u>

1  DE LASTEYRIE [du SAILLANT], ROBERT [CHARLES]. <u>L'Architecture</u>
   <u>religieuse en France à l'époque gothique</u>. 2 vols. Paris:
   Auguste Picard, 1926-1927. [This work was edited by Marcel
   Aubert and published after De Lasteyrie's death.]
       Contains (vol. 2, p. 601) a number of well-indexed ref-
   erences to Villard, mostly citing his drawings as proof of
   the existence of various architectural features which De
   Lasteyrie discusses; for example, the vault plan on fol. 21
   proves that lierne and tierceron vaults existed in France
   earlier than in England (vol. 2, pp. 50-51). De Lasteyrie's
   comments on Villard himself are limited to noting (vol. 2,
   p. 278) that his "album" proves how widely thirteenth-
   century French architects wandered in their work and
   (vol. 1, p. 221) that he may have been the architect of
   Cambrai.
       Reproduces details of fols. 17 and 21 after Lassus.

2  VAN MARLE, RAIMOND. "L'Iconographie de la décoration profane
   des demures princières en France et en Italie au XIVe et
   XVe siècles." <u>Gazette des beaux-arts</u>, 5th ser. 14:162-82,
   259-74.
       Two principal points are made. The first (pp. 166-67)
   is that the secular images in the Villard manuscript re-
   flect the standard iconography of secular wall-painting in
   the thirteenth century, where landscape played no role.
   The second (pp. 170 and 177) is that a later reflection of
   the same standard iconography is found in the (now dis-
   assembled) sketchbook of Pisanello in the Louvre. Van
   Marle claims (p. 273) that "le répertoire [de ces deux
   artistes] est exactement le même" but (p. 274) that this
   is due to their reflection of a common tradition and not to
   Pisanello's knowledge of the Villard manuscript.
       It is suggested (p. 172) that Villard observed his lion,
   ostriches, porcupine, and other exotic animals in a
   menagerie.
       Reproduces fols. 14, 18v, and 23v (twice).

<u>1927</u>

1  BRIGGS, MARTIN S. <u>The Architect in History</u>. Oxford:
   Clarendon Press. **Reprinted in the series Architecture
   and Decorative Art, edited by Adolf K. Placzek. New York:
   Da Capo Press, 1974.
       Claims (p. 94) that Villard was a professional master
   mason, "the only medieval architect of whom we have [in

1927

his manuscript] so full a record," and (p. 93) that his
drawings of Reims were made to be used at Cambrai, thus
apparently attributing Cambrai to Villard.
Reproduces fols. 17 and 29 after Lassus or Willis al-
though reference is made to J. Quicherat, Facsimile of the
Sketchbook of Villard de Honnecourt (London, 1859), appar-
ently an inaccurate reference to Willis.

2   DIVALD, KÓRNEL. Magyarország müvészeti emlékei. Budapest:
n.p.
Claims (p. 72) that Villard's visit to Hungary should
not be measured in terms of years and that it is not known
what he did while there. Divald proposes that Villard may
have worked on fortifications for Béla IV and that if he
worked on any cathedral, it would have been that at Eger.
In Hungarian.

3   HASKINS, CHARLES HOMER. The Renaissance of the Twelfth
Century. Cambridge, Mass.: Harvard University Press.
**Reprint. New York: Meridian Books, 1957.
In a discussion of medieval zoology, Haskins makes
(p. 329) passing note of the fact that Villard drew his
lion (fols. 24 and 24v) from life. Haskins seems to sug-
gest (p. 331) that Villard's sketchbook provides informa-
tion about medieval construction when he notes that "Even
the artist's sketchbook fails us before the time of Villard
de Honnecourt, and for long thereafter."

4   OMONT, HENRI. See "The Facsimile Editions," F.III, 2d ed.

5   PANOFSKY, ERWIN. "Über die Reihenfolge der Vier Meister von
Reims." Jahrbuch für Kunstwissenschaft, pp. 55-82.
Although frequently cited in Villard studies, Panofsky
has very little to say about Villard, noting (p. 55) only
that Villard's drawings may provide secondary information
about the history of the construction of Reims. He notes
that it is uncertain when Villard was there, giving a date
in all probability of between 1225 and 1235.

1928

1   COULTON, G[EORGE] G[ORDON]. Art and the Reformation. Oxford:
Blackwell. 2d ed. Cambridge: Cambridge University Press,
1953. **Published as Medieval Faith and Symbolism. New
York: Harper & Brothers, 1958.
Under the heading "Four Self-Characterizations" Coulton
gives (pp. 95-109) a rather thorough summary of Villard's

career as he understood it. He claims that Villard was a
French master mason working ca. 1250 who died ca. 1260,
although he states that Villard "wandered back to France"
from Hungary after 1272. He attributes to Villard Meaux
and Saint-Faron at Meaux (apparently unaware that Villard's
plan on fol. 15 is misidentified Saint-Faron as Meaux); and
Cambrai and Kassa.

Coulton interprets the manuscript as both a wanderer's
sketchbook and a technical manual showing "the variety of
a master mason's jobs." He disagrees with Willis that the
drawings were originally made in the manuscript as it now
exists, arguing that they were copied therein from earlier
sketches or from memory. He repeats (p. 219) the inaccu-
rate claim that Villard called the Laon tower "the fairest
he has seen in all his travels." Coulton claims (p. 206
n. 1) that Villard may have discussed architecture with
Hugues Libergier.

Reproduces drawings, from Willis (?), of the Chartres
rose, and fols. 7v and 18.

## 1929

1   ANON. "A Thirteenth Century Glass Panel." International
    Studio 92 (March):40-41, 92.
        Claims that a stained glass roundel with a Christ in
    Majesty figure from the Philadelphia collection of Raymond
    Pitcairn exhibited at the Demotte Gallery in New York in
    March 1929 is designed as a composite based on drawings
    (head of Christ, fol. 16v; body of Christ, fol. 11; and
    drapery of a seated king [Solomon?], fol. 25) in the
    Villard manuscript. The author states (pp. 40-41) that the
    panel "has, as far as can be ascertained by comparison,
    been inspired by some of the drawings of Villard de
    Honnecourt . . . [and] although none [of these] can be said
    to be the exact model for this stained glass, [these draw-
    ings] have each some relationship with it." The author
    does not suggest that the panel itself is the work of
    Villard. The panel is said to have no major restoration
    and is dated (p. 92) ca. 1230.
        Reproduces from the manuscript the details specified
    above.

1929

2    GÁL, LADISLAS.  "Villard de Honnecourt."  In <u>L'Architecture</u>
     <u>religieuse en Hongrie du XIIe au XIIIe siècles</u>.  Études
     d'art et d'archéologie.  Paris:  Librairie Ernest Leroux,
     pp. 232-43.
         Discusses Villard and Hungary on the basis of three
     questions:  when was he there (and how long did he stay)?;
     by whom was he sent?; and with what monuments was he asso-
     ciated as builder?  Gál rejects (p. 233) Enlart's thesis
     (1895.1) that Villard came to Hungary ca. 1235 as too early
     and rejects Henszlmann's thesis (1858.3) that he was there
     ca. 1260-1270 as too late, adopting Quicherat's thesis
     (1849.1) that Villard was in Hungary between 1244 and 1251
     during suspension of construction at Cambrai.  His reasons
     for going were his devotion to Saint Elizabeth of Hungary
     and his response to the call of her brother, Béla IV, to
     help rebuild his country after the Mongol invasion of 1242.
         Gál then reviews the various claims, especially those of
     Henszlmann (1857.1), concerning Villard's association with
     Kassa and states (p. 238) that the church was not built or
     rebuilt in the thirteenth century, thus Villard had nothing
     to do with it.  Gál then considers other buildings, espe-
     cially Jaák and Zsámbék.  He criticizes (p. 241) Möller's
     association (1905.2) of Villard with Gyulafehérvár as un-
     acceptable and does admit that if Villard were in Pannonia,
     the former two projects were the most important underway at
     that time, and if Villard were connected with any building
     projects there, it could have been one or both of those.
         Gál's conclusion (p. 242) summarizes the situation very
     honestly, "En fin de compte, on doit avouer que le dernier
     problème, soulevé par le séjour de Villard de Honnecourt
     en Hongrie et qui concerne son activité dans ce pays, est
     actuellement indéterminable."  He notes that any definite
     association of Villard with any Hungarian building would
     have to be based on the discovery of new evidence.

3    STEIN, HENRI.  <u>Les Architectes des cathédrales gothiques</u>.
     Les Grands Artistes.  Paris:  Henri Laurens.
         Claims (p. 40) that the manuscript is a unique survival
     of its type, composed by Villard with the "intention de
     [le] léguer aux gens de son métier."  Stein takes the plan
     invented by Villard and Pierre de Corbie (fol. 15) as proof
     of collaboration between Gothic architects.
         Stein repeats (p. 43) the misattribution to Villard of
     the statement that the Laon tower is "the most beautiful in
     the world."  He (p. 70) attributes the choir of Cambrai to
     Villard but notes (p. 108) that Kassa is attributed to
     Villard without "preuves suffisantes" and that the fact is

that "on ne sait au juste quel rôle fut le sien sur la terre étrangère."

Reproduces fol. 15 with photo credit given to Berthaud, indicating the negative was the same used for the Omont facsimile.

4    VITRY, PAUL.  French Sculpture during the Reign of Saint
     Louis, 1226-1270.  Florence: Pantheon; New York:
     Harcourt, Brace, & Co.  Reprint.  New York: Hacker Art
     Books, 1973.
         Vitry states (p. 54), "It is strange to note that in the
     designs of Villard de Honnecourt, several figures denoting
     a very great acquaintance with certain antique themes or
     types of costume and drapery are treated in their naked
     parts with a spirit of reality that is sometimes injudi-
     cious but is, nevertheless, concise and vigorous."  For a
     very different assessment, see Clark, 1956.2.

## 1931

1    FOCILLON, HENRI [JOSEPH].  "L'Art de géometrie au moyen âge."
     In L'Art des sculpteurs romans, recherches sur l'histoire
     des formes.  Paris: Librairie Ernest Leroux.  **Reprint.
     Paris: Presses universitaires de France, 1964, pp. 209-22.
         Discusses in detail Villard's use of geometry on fols.
     18 and 19 for designing figures and indicating movement.
     Focillon rejects the idea (see Viollet-le-Duc, 1854.1) that
     Villard's interest in or use of geometry is haphazard,
     claiming (p. 211) that it is a system employed by all
     artists, that it closely parallels the one expounded by
     Robert Grosseteste of Lincoln, and that both learned it by
     means of translations of Arabic treatises on mathematics.
         Focillon speculates (p. 217) that Villard may have known
     certain examples of Hiberno-Saxon work in which the same
     geometric motifs occur.  More than most French writers,
     Focillon insists (p. 210) that the Villard manuscript is
     not merely an album de croquis, terming it a "travail con-
     certé" or at least "notes mises au point."  He also empha-
     sizes that while Villard was an architect and technician of
     construction, he possessed the great range of interests
     characteristic of Renaissance man and was a transition
     figure from Romanesque to Renaissance.  Focillon's most
     accurate observation occurs in his opening sentence,
     "Nous ne savons rien, ou presque rien, de Villard de
     Honnecourt. . . ."
         Reproduces fol. 18 from Lassus.

1931

2   OMONT, HENRI.  See "The Facsimile Editions," F.III, 3d ed.

### 1932

1   SWARTWOUT, R.E.  The Monastic Craftsman.  Cambridge:
    W. Heffner and Sons.
        The classic attack on Montalembert's "monastic artist"
    thesis in which Villard is identified as a lay architect,
    whatever his association with the Cistercians.  Villard's
    architectural drawings are said (p. 116) to be "of the
    greatest excellence, but they are drawings of actual build-
    ings for the most part, and by no means always correct in
    detail."  This is noted in the context that there is no
    proof that medieval architects ever drew detailed working
    drawings for entire buildings.  Swartwout suggests (p. 102)
    that Villard's fol. 32 may indicate the types of templates
    or template models employed by William of Sens at Canter-
    bury in the 1170s.
        The author's information on the interpretation of
    Villard is taken principally from Briggs (1927.1) and
    Willis.
        Reproduces fol. 31.

### 1933

1   HAHNLOSER, HANS ROBERT.  "Entwürfe eines Architeken um 1250
    aus Reims."  In Actes du XIIIe Congrès international
    d'histoire de l'art.  Stockholm: n.p., pp. 260-62.
        Summary of a paper presented at the XIIIth International
    Congress on the History of Art held at Stockholm in 1933.
    Hahnloser's principal concern is the architectural drawings
    in the Reims Palimpsest (Reims, Archives de la Marne, MS.
    G.661) which he dates ca. 1250.  Villard's manuscript is
    discussed briefly (p. 262) as a precursor to these finer
    architectural drawings and as confirmation of the Gothic
    architect's habit of balancing between practical experience
    (Handwerk) and theoretical treatises (geometrischen Trak-
    taten) in creating their designs.

### 1935

1   AUBERT, MARCEL.  Review of Hahnloser facsimile.  Bulletin
    monumental 94:403-5.
        Generally laudatory review claiming that "il [Hahnloser]
    a épuisé tout ce que l'on peut désirer savoir de 'l'Album'

et de son auteur." This review was more important for what it did <u>not</u> say, since Aubert steadfastly referred to the manuscript as an <u>album</u>, thus indirectly rejecting Hahnloser's claim that it was a <u>Bauhüttenbuch</u> (see Hahnloser, 1971.4).

2  HAHNLOSER, HANS ROBERT. See "The Facsimile Editions," F.IV, 1st ed.

3  MOREY, C[HARLES] R[UFUS]. Review of Hahnloser facsimile. <u>Art Bulletin</u> 17:509-11.
   Terms (p. 509) Hahnloser's study "a beautifully executed book, the definitive monograph" on the Villard manuscript and appears to accept most of Hahnloser's interpretations and conclusions.
   For Morey, the manuscript was a pattern book more than either an <u>album</u> or a <u>Bauhüttenbuch</u>, and he claims (p. 510) that many of the drawings (e.g., the <u>Ecclesia</u> figure, fol. 4v) clearly were copied from other pattern books. More than any other reviewer, Morey does his own analysis of the contents of the manuscript and makes some very important observations. He considers in some detail Villard's drawing style and, especially, his approach to drawing as assembling parts rather than being concerned with the whole, a process Morey terms "progressive construction." (fols. 20 and 20v).
   Morey observes (p. 510) that Master II's expression "par chu fait om" is a translation of stock Greek **οὕτως ποίει** or Latin <u>sic quaeres</u> formulas in pattern books or instructional manuals, "whereby he [Master II] betrays his dependence on earlier collections [of recipes]."
   Morey's summary of the importance of the Villard drawings is (p. 511) that "It is difficult to find a more suggestive material with which to build a theory of Gothic aesthetic."

4  ÜBERWASSER, WALTER. "Nach rechtem Masz [Mass]: Aussagen über den Begriff des Maszes in der Kunst des XIII.-XVI. Jahrhunderts." <u>Jahrbuch der Preuszischen Kunstsammlung</u> 56: 250-72.
   One of the most frequently cited studies on the use of <u>ad quadratum</u> and <u>ad triangulum</u> design principles in medieval art, principles of design "according to correct measure" (<u>nach rechtem Mass</u>). Überwasser devotes a special discussion (pp. 259-61) to Villard, although Villard is also mentioned elsewhere.
   Überwasser claims (p. 259) that the Villard manuscript has falsely been called a "sketchbook," since it contains "Blatt für Blatt . . . Anweisungen zum Planen von Bauten,

1935

Tier- und Menschenfiguren und von Maschinen." He says all
these figures are for instructional purposes and that the
geometry of each is clear, whether left exposed (fols. 18,
18v, 19, and 19v) or not. He does not accept the view
(see Frankl, 1960.6) that these geometric schemata were
secrets known to only a few, but rather, that they were
commonly known and used by all designers. He notes that
Villard's followers (Werkstattnachfolgern, i.e., Master II
and Master III) knew and drew (fol. 20) the key to design-
ing ad quadratum (quadrature) and that this is the same
schema found later in Mathes Roritzer. He analyzes
(pp. 260-61) these figures, admitting that while their
purpose is not always clear, let alone obvious, their
geometry is invariable.

    Überwasser also claims (p. 261) that Villard understood
the principle of ad quadratum design and could recognize it
when it was in use, most notably in connection with the
plan of the Laon tower (fol. 9v). Misquoting Villard on
the "loveliness" of this tower, Überwasser reproduces
(fig. 7) Villard's drawing with his own geometric overlay
of rotating squares to illustrate how the design was made.
His conclusion, that it was designed from the outside in
and from the bottom up, is the exact opposite of that
reached by Velte (1951.3) in her study of the same problem
(see Ackerman, 1953.1, and Branner, 1955.2).

    Überwasser concludes (p. 261) that when Villard used the
expressions faire droit (fol. 9) and droite montee (fol.
30v) he meant that something had to be designed "according
to correct measure," that is, on the basis of a standard
geometric principle; and that because he understood these
principles so well and could adopt them so widely, Villard
should not be thought of as a little master like Roriczer
but as a great master like Albrecht Dürer.

    Überwasser refers (p. 260 n.1 ) to Hahnloser's pending
publication of a facsimile edition of the Villard manu-
script which he criticizes and claims should be published
only after the appearance of this article.

### 1936

1    HORVÁTH, HENRI. "Villard de Honnecourt et la Hongrie."
      Nouvelle Revue de Hongrie (October):332-44.
        Inspired by the Hahnloser facsimile, this study examines
the relationship between Villard and Hungary. Horváth
accepts (p. 332) Hahnloser's view of the manuscript as a
Bauhüttenbuch and claims that its purpose was the instruc-
tion of other masons, Villard's variation from reality

being a "correction consciente du modèle." He believes
(p. 335) that Villard had played an important role in the
construction of Cambrai and Meaux, and had worked possibly
at Chartres and Reims before his visit to Hungary. He in-
sists that Villard was an established master who was called
to Hungary ca. 1235 by Béla IV or by the Cistercians.

Horváth's principal thesis (pp. 336 and 341) is that
Villard's trip and works preceded the Tartar invasion and
that he represents the last great wave of French influence
on Hungarian Gothic art, "l'influence française . . . cul-
mine en la personne de Villard."

He then considers one by one the buildings ascribed by
earlier authors to Villard and concludes that not one can
definitely be associated with Villard. For Horváth,
Esztergom and Kassa are traditionally and circumstantially
the most likely projects on which Villard worked, but no
definite connection can be proven in either case. He does
claim (p. 334) that the pavement design on fol. 15v of the
manuscript is Roman work at the royal palace at Esztergom
(see, however, Gerevich, 1971.3). Horváth dismisses
(pp. 340-41) Eger, Gyulafehérvár, Jaák, and Zsámbék as
Romanesque buildings completely different from Villard's
style as known through his manuscript.
Reproduces fols. 2, 10, 10v, and 15v.

2  RÉAU, LOUIS. Review of Hahnloser facsimile. Gazette des
   beaux-arts. 6th ser. 16:265-66.
       Terms the Hahnloser facsimile the monumental and defini-
   tive edition of the Villard manuscript and agrees (p. 265)
   that Hahnloser's designation of the manuscript as a
   Bauhüttenbuch or Livre de l'oeuvre is more accurate than
   the traditional designation album. Réau characterizes
   (p. 265) the manuscript as being "un recueil de modèles de
   caractère didactique, à l'usage des architectes qui tra-
   vaillaient avec lui [i.e., Villard] et sous sa direction."
   Réau also employs (p. 266) the term Livre du chantier.
       He summarizes Hahnloser's biography of Villard, which he
   apparently accepts: trained at Vaucelles, architect of
   Saint-Quentin, in Hungary no later than 1235 and possibly
   as early as 1220.

3  WORMALD, FRANCIS. Review of Hahnloser facsimile. Burlington
   Magazine 68:251-52.
       Emphasizes the thoroughness of Hahnloser's study, point-
   ing out that it is much more than a straightforward fac-
   simile edition. Wormald concentrates on Hahnloser's
   analysis of the form of the manuscript and Villard's style
   as an artist, noting that the leaves were originally kept,

1936

unbound, in a portfolio and (p. 252) that the Hortus
Delicarum of Herrad of Landesberg was also originally so
maintained. Wormald reports Hahnloser's conclusions that
the Villard manuscript was a pattern book made by Villard
for those working under him, and that Villard's figures
without facial details are based on sculpted models whereas
those with detailed facial features are based on painted
models. He appears to accept both interpretations.

Wormald concludes (p. 252) that "The book [by Hahnloser]
is packed with detail of every kind, almost too packed for
comfortable and digestible reading."

### 1937

1   ANON. Les Plus Beaux Manuscrits français du VIIIe au XVIe
siècle conservés dans les bibliothèques nationales de
Paris. Catalog no. 73. Paris: Bibliothèque nationale,
pp. 39-40.

The Villard manuscript was exhibited showing fols. 18v
and 19, with the geometric figures of those folios termed
"modèles de dessins." It is claimed that in these drawings
proportions were determined by geometry and that, "Plus
encore que les pages qui portent des dessins de sculpture
et l'architecture les feuillets exposés révèlent un tech-
nique sûre."

Villard is said to have been born at the beginning of
the thirteenth century and is called a "dessinateur," but
no mention is made of him as an architect, possibly because
"Nous ignorons les détails de sa carrière."

A detail of the Virgin and Child on fol. 10v appears on
the title page.

2   VAN MOÉ, ÉMILE-AURÈLE. "Les Manuscrits sous les capetiens."
Arts et métiers graphiques 60 (1 November):40-41, 44.

One of a series of summaries of the periods of manu-
scripts exhibited in 1937 at the Bibliothèque nationale in
Paris. The Villard manuscript is mentioned (p. 44) in
passing as a "document unique . . . de l'architecte Villard
de Honnecourt, qui montre de si curieuses constructions
géometriques pour mettre en place les figures animées."
Pages 40-41 present a full-scale, double-page-spread of
fols. 18v and 19.

## 1938

1  FOCILLON, HENRI [JOSEPH]. Art d'occident. Paris: Armand
    Colin. **English trans. The Art of the West in the Middle
    Ages. Vol. 2, Gothic Art. London: Phaidon Press, 1963.
       Contains scattered references to Villard, attributing
    (p. 49) to him the design of Saint-Quentin, stating (p. 66)
    that he went to Hungary as a designer of Cistercian build-
    ings (none of which are specified), and noting (p. 85 n. 1)
    that he was especially influenced by the sculpture of Reims
    and what Focillon terms the "Atticism of Champagne."
       Focillon's most important observation (p. 192) is that
    "no one was ever more vigorously of his own time" and that
    it is a mistake to view Villard as a precursor of the
    Renaissance. See, however, Focillon, 1931.1.

## 1939

1  ADHÉMAR, JEAN. "Villard de Honnecourt." In Influences an-
    tiques dans l'art du moyen âge français: Recherches sur les
    sources et les thèmes d'inspiration. Studies of the Warburg
    Institute, no. 7. London: Warburg Institute, pp. 278-80.
    [Photographic Reprint. Nendeln: Kraus Reprint, 1968]
       Calls (p. 278) Villard an "artiste rémois," the
    "meilleur élève français" of the Master of the Antique
    Figures of the north arm portals of Reims. While he sug-
    gests that Villard played an important role at Reims, col-
    laborating with the architects, designing at their sides,
    and even offering his own designs (e.g., fol. 31v: dado
    arcade for the nave aisle wall), Adhémar stops short of
    terming Villard an architect. He apparently considers him
    to have been a sculptor, although he does not explicitly
    say so. He states that because Villard was called to
    Hungary ca. 1241, he knew only the north arm statues at
    Reims and not the more famous Visitation group of the cen-
    tral portal of the west facade.
       Adhémar stresses Villard's knowledge of geometry from
    Vitruvius and his interest in antique statuary as a source
    for models. He concludes (p. 279) that Villard's drawing
    of what Villard termed a Saracen tomb (fol. 6) was in fact
    an ivory Byzantine consular diptych (now lost), and that
    the drawing is so poor because Villard tried to alter the
    model which he had apparently seen only briefly and later
    drew from memory. This may represent an error on Adhémar's
    part, where Villard's statement that the drawing was of a
    tomb he once saw is taken as an indication that the drawing
    followed the encounter with the model rather than that the

1939

inscription was a later addition. Adhémar contrasts this
drawing with Villard's more accurate renderings of nudes
(fols. 11v and 22) based on classical bronze statuettes
(the sources of which Adhémar identifies; the statuettes
are reproduced in pls. XXXIV and XXXV). He says these
drawings are more accurate than that of the ivory because
Villard had time to study these models with some care; but
he concludes (p. 280) that Villard's drawings after the
antique are nonetheless "étrange, mi-gothique, mi-clas-
sique."

Despite its brevity, this is one of the better analyses
of Villard's attitude toward and ability to deal with
antique models.

1940

1   SCHÜRENBERG, L[ISA]. "Villard de Honnecourt." In Allgemeines
    Lexikon der bildenden Künstler von der Antike bis zur
    Gegenwalt, begründet von Ulrich Thieme und Felix Becker.
    Vol. 34. Leipzig: Verlag E.A. Seemann, pp. 368-69.
        Gives a brief biography of Villard and a somewhat longer
    analysis of the manuscript, both following Hahnloser
    closely. The author states (p. 368) that the manuscript,
    made ca. 1230/1235, is now (since Hahnloser) correctly
    called a Bauhüttenbuch whereas formerly it had unjustly
    been termed a Skizzenbuch. She also claims that the manu-
    script, when Villard and his successors added inscriptions,
    became a teaching treatise (Traktates).

2   VON STOCKHAUSEN, HANS-ADALBERT. "Zur ältesten Baugeschichte
    der Elisabethkirche in Marburg a[n]. d[er]. Lahn." Zeit-
    schrift für Kunstgeschichte 9:175-87.
        An attempt to determine the sources and dates of the
    choir of Marburg. The author traces the trefoil plan, and
    especially the construction, to France. The source of the
    construction of Marburg, on the basis of the building's
    details, is said to be Reims. Von Stockhausen compares
    Cambrai and Marburg in some depth, but rejects (largely by
    ignoring) the attribution of either church to Villard.

1942

1   KURTH, BETTY. "Matthew Paris and Villard de Honnecourt."
    Burlington Magazine 81:224, 227-28.
        Traces the iconographic history of wrestlers (fol. 14v)
    and of the image of a man falling from a horse (fol. 3v)

as found in Matthew of Paris's Historia Maior and the
Villard manuscript. Kurth notes the parallelism of the two
but stresses that whereas both of Paris's images were in-
spired by actual events, Villard's cannot be proved to be
so. She specifically associates (p. 228) Villard's Pride
with a relief at Chartres. Pointing out the common inter-
est Matthew and Villard had in the antique and in animals
drawn from life, Kurth nonetheless concludes (p. 228), "No
direct influences [between the two artists] can be traced.
Their stylistic ways are widely different."
Reproduces details of fols. 3v and 14v.

## 1943

1   PEVSNER, NIKOLAUS.   An Outline of European Architecture.
    Harmondsworth:  Penguin Books.  **7th rev. ed.  1963.
        Terms (p. 94) Villard an architect and calls his manu-
    script a "textbook, prepared about 1235" which was ad-
    dressed to his pupils.  Pevsner claims that the manuscript
    is "invaluable as a source of information on the methods
    and attitude [of an artist?] of the thirteenth century."
        While he summarizes and appears to emphasize the variety
    of subjects found in the manuscript (without distinguishing
    between Villard's drawings and later additions), he
    stresses (p. 116) the lack of imagination of the Gothic
    artist and his dependency on existing models, making the
    sweeping and undocumented generalization that "Even Villard
    de Honnecourt copied [existing designs] in nine out of ten
    of his pages."
        Reproduces fols. 14v, 17, and 30v after Lassus or
    Willis.

## 1944

1   FRANKL, PAUL.   Review of A Brief Commentary on Early Mediaeval
    Church Architecture . . ., by Kenneth John Conant.   Art
    Bulletin 26:200.
        Villard is brought into this review as typifying the
    medieval architect who was "unable to explain his ideas
    save with the pencil alone," lacking the technical vocabu-
    lary necessary to explain verbally his ideas and design
    processes.

1944

2   LAVEDAN, PIERRE [LOUIS LÉON].  L'Architecture française.
    Paris:  Librairie Larousse.  **English trans.  French
    Architecture.  Harmondsworth:  Penguin Books, 1956.
        Makes (p. 45) the astonishing claim that Villard's note-
    books [sic] are the only document from the Middle Ages
    "dealing with the practice of the architect's profession,"
    and that the "regulations" therein seem to confirm that
    Viollet-le-Duc (1854.1, s.v. "proportion") was correct in
    insisting that geometry was the basis of design in medieval
    architecture.

## 1945

1   FRANKL, PAUL.  "The Secret of the Mediaeval Masons."  Art
    Bulletin 27:46-64.
        Very important although brief commentary on the use of
    geometry in the Villard manuscript claiming (pp. 57-58) that
    Villard's "net of squares" (the human "face in the square"
    on fol. 19) was not a system of design but a means of "en-
    largement of a small sketch to the desired size of the
    finished work," for which reason this geometry did not have
    to be as precise as that used by masons.  Conversely, Frankl
    states that the schema for halving and doubling a square
    employed on fol. 20 by Master II, ca. 1260, were taken from
    Vitruvius and, although incomplete or unclear, prove the
    use of quadrature in medieval architecture long before it
    was more carefully explained by Mathes Roriczer and Hanns
    Schmuttermayer.
        Reproduces a detail of fol. 20 after Hahnloser.

2   HARVEY, JOHN H[OOPER].  "The Education of the Mediaeval
    Architect."  Journal of the Royal Institute of British
    Architects 53:230-34.
        Cites (p. 232) Hahnloser as proof that Villard was lit-
    erate, writing in both French and Latin.  Harvey then uses
    this statement as proof "that the highest class of
    craftsman-architect of the Middle Ages was literate."
        He follows Hahnloser's Bauhüttenbuch theory, terming the
    manuscript a "practical encyclopaedia of the building arts
    and crafts compiled for the permanent 'lodge' of a great
    church, probably . . . Saint-Quentin," and he suggests that
    Master II and Master III were Villard's successors in this
    lodge.

<u>1946</u>

1   KAYSER, HANS.  <u>Ein harmonikaler Teilungskanon, Analyse einer</u>
    <u>geometrischen Figur im Bauhüttenbuch Villard de Honnecourt</u>.
    Zurich:  Occident-Verlag.
        An article-length (32 pp.) attempt to demonstrate the
    use of Pythagorian musical proportion as the basis for the
    geometry in three of Villard's figures:  fol. 18, two fig-
    ures at the bottom; and fol. 19, rightmost figure in the
    second row from the top.  While the geometric design itself
    is unquestionably that generated from the Pythagorian mono-
    chord, Kayser does not convince the reader that Villard
    understood its musical basis.  Kayser apparently worked
    from a photograph of the original folio, and the signifi-
    cance of Kayser's claim may be summarized in his own admis-
    sion (p. 30) that Villard's geometry does not match that of
    the Pythagorian design when correctly drawn.
        Kayser makes a number of references to Hahnloser and
    clearly accepts his view that the manuscript was a <u>Bauhüt-</u>
    <u>tenbuch</u>, as his title proves.

2   SAMARAN, CHARLES.  "Lectures sous les rayons ultra-violets,
    V:  L'album de Villard de Honnecourt."  <u>Romania</u> 69 (1946-
    1947):91-93.
        Brief analysis of the inscriptions found on fols. 1 and
    23v of the Villard manuscript, which can be read only under
    ultraviolet light.  Contains the same conclusions given
    more fully in his later study (1973.4) but dates the in-
    scriptions to the reigns of Henry IV (1572-1610) or
    Louis XIII (1610-1643).  Samaran claims (p. 91) that
    "aucun dessin nouveau n'est apperçu" when the manuscript
    was examined under ultraviolet light by Hahnloser.

<u>1947</u>

1   AUBERT, MARCEL.  <u>L'Architecture cistercienne en France</u>.
    Vol. 1.  Paris:  Vanoest Editions d'art et d'histoire.
        Compares (pp. 194-195) Villard's Cistercian church plan
    (fol. 14v) to that of Fontainjeans and to those of several
    English Cistercian churches (Byland, Dore, Waverley).  On
    pp. 225-26 Aubert discusses Villard and Vaucelles, which he
    dates 1190-1235, and claims that Villard's plan (fol. 17)
    of the Vaucelles choir is "sommaire mais précis."  On
    p. 225 n. 5 Aubert cites Enlart (1895.1) and states that
    Villard "travailla sur les chantiers de Vaucelles, et
    peut-être en assuma la direction."  He also notes that

1947

Villard's Vaucelles plan was the source of inspiration for
the plan (fol. 15) devised in discussions with Pierre de
Corbie.
Reproduces details of fol. 14v and 17 after Lassus.

2   HECKSHER, WILLIAM S.  "Bernini's Elephant and Obelisk."  Art
Bulletin 19:155-82.
Claims (p. 164) that "the palm for 'intended realism'
has always gone to Villard de Honnecourt's famous lion"
(fol. 24v), and that what is important is Villard's inten-
tion (wollen), not his actual achievement (können).  On
p. 164 n. 40 he notes that Villard's side view of the lion
(fol. 24) "has some merits for realism" and suggests two
very close parallels, possibly models, for Villard's
frontal view of the lion (fol. 24v):  the lion of San Marco
in Venice and that in Lambert de Saint-Omer's Liber Flori-
dus, ca. 1120 (Ghent, Universiteitsbibliotheek, MS. 92,
fol. 56v).

1948

1   EVANS, JOAN.  Art in Mediaeval France, 987-1498.  Oxford:
Clarendon Press.
Contains a number of references to Villard, most of
which are taken from or based on earlier studies.  Evans
calls (p. 89) Villard an architect and claims (p. 126 n. 2)
that he may possibly have been the architect of Saint-
Quentin.  She also proposes, at least indirectly, that he
was a sculptor or that certain of his drawings were for
sculpture, suggesting (p. 96 n. 5), after Adhémar (1939.1),
that Villard may have been a pupil of the Master of the
Antique Figures at Reims.
Reproduces fol. 16.

*2   WISSNER, ADOLPH.  "Die Entwicklung der zeichnerischen Dar-
stellung von Maschinen unter besonderer Berücksichtigung
des Maschinenbaus in Deutschland bis zum Beginn des 20.
Jahrhunderts."  Ph.D. dissertation, Universität München.
Wolfgang Schöller (see 1978.6) called this unpublished
work to my attention as containing a discussion of
Villard's mechanical devices.

<u>1949</u>

1   DIMIER, M.-ANSELME.  <u>Recueil de plans d'églises cisterciennes</u>.
    Paris:  Librairie d'art ancien et moderne.
       Discusses (pp. 39-41) the history of the Gothic choir at
    Vaucelles, dated 1190-1235, which because of its sumptuous-
    ness caused a great scandal in the Cistercian order.
    Dimier claims that Vaucelles "était et reste la plus grande
    de toutes les églises cisterciennes."  In a note (p. 41
    n. 67) he states "On croit que c'est Villard de Honnecourt
    qui en [i.e., choeur de Vaucelles] fut l'architecte" but
    that the sole evidence for this belief is Villard's drawing
    of the Vaucelles plan (fol. 17) and also the analogous plan
    (fol. 15) done in collaboration with Pierre de Corbie.
    Reproduces fol. 17 after Lassus.

2   HAMANN-MacLEAN, RICHARD H.L.  "Antikenstudium in der Kunst des
    Mittelalters."  <u>Marburger Jahrbuch für Kunstwissenschaft</u> 15
    (1949-1950):157-250.
       Repeats (p. 193) Adhémar's (1939.1) and Hahnloser's
    identifications of antique models in what the author terms
    Villard's <u>Musterbuch</u>, illustrating a seated bronze satuette
    to which Villard's seated male figures on fols. 14 and 22
    are compared.  The author provides (p. 246) a brief list of
    Villard's studies after the antique:  the two figures cited
    above, the leaf-faces (fols. 5v and 22), two standing
    figures (fol. 28).  Hamann-MacLean believes Villard en-
    countered most (all?) of these models at Reims.

3   LEFRANÇOIS PILLION, LOUISE.  "Un maître d'oeuvre et son album:
    Villard de Honnecourt."  In <u>Maîtres d'oeuvres et tailleurs
    de pierre des cathédrales</u>.  Paris:  Robert Laffont,
    pp. 61-70.
       Poetic view of Villard as (p. 63) "le type les plus
    illustre et le plus significatif de ces artistes français
    [du moyen âge] à l'étranger" and as (p. 70) "un prince de
    métier."  Stresses the unique significance of the manu-
    script, suggesting (p. 62) that it has lost twenty to
    twenty-five leaves and noting (p. 65) that its <u>pêle-mêle</u>
    character and cluttered drawings are attributable to the
    high cost of parchment.
       Lefrançois Pillion dates (p. 63) Villard's activity to
    1230-1250 and his trip to Hungary to 1244-1247, attributing
    Kassa to him.  She attributes no French buildings to
    Villard.
       Her analysis of Villard's wide range of interests leads
    to criticism of two of Hahnloser's claims:  that Villard's
    figures with unfinished faces are based on sculpted models

and that Villard did not know Latin. The author proposes
that Villard was so technical-minded that he must have had
some encounter with the trivium in a university setting.

She makes the important point (p. 67) that it is her
instinct that Villard first made his drawings on fols. 18,
18v, 19, and 19v, then applied the geometric patterns to
them.

Reproduces fol. 19 redrawn after Lassus.

4    ÜBERWASSER, WALTER.  "Massgerechte Bauplanung der Gotik an
     Beispielen Villards de Honnecourt."  Kunstchronik,
     pp. 200-204.

Summary of a lecture in which Überwasser reaffirmed his
belief (1935.4) that Villard understood both ad quadratum
(fol. 9v, Laon tower plan) and ad triangulum (fol. 7, lec-
tern) geometric principles of design and that he designed
from the outside in (see Velte, 1951.3).

Überwasser insists on the accuracy of quadrature for
determining the correct replacements of all elements of a
building, for example, piers, and claims that this can be
proven by analysis of Villard's drawn plans although it is
not readily apparent.

In the discussion which followed, Dagobert Frey sug-
gested that Villard's geometric schema were only aids to
craftsmen and that in actual construction measurements had
to be determined in more detail.  Ernst Gall questioned
whether Villard's plans could be executed and criticized
the inaccuracies of his drawings of Reims, which accord
neither with the building itself nor with one another.

5    THE WALTERS ART GALLERY.  Illuminated Books of the Middle Ages
     and Renaissance.  Baltimore:  Trustees of The Walters Art
     Gallery.

Catalog of an exhibition held in Baltimore in 1949, with
text by Dorothy Miner.  Item 63 in this exhibition was a
fragment of a missal made for Noyon use, from the Hofer
Collection in Rockport, Maine (now, according to Scheller,
1963.5, p. 93, at Harvard University, MS. Typ 120H), which
has been attributed to Villard (see Vitzthum, 1914.2).
Miner (p. 25) agrees that the style of the figures in this
manuscript is close to that employed by Villard but the
"outright attribution of these paintings to Villard is no
longer agreed to by scholars."

## 1950

*1   DEGENHARDT, BERNHARD. "Autonome Zeichungen bei mittelalter-
lich Künstlern." Münchener Jahrbuch 3.
Called to my attention by Wolfgang Schöller (1978.6)
as concerning Villard.

2   HARVEY, JOHN [HOOPER]. The Gothic World, 1100-1600:  A Survey
of Architecture and Art. London:  B.T. Batsford.  **Re-
print.  New York:  Harper & Row, Publishers, 1969.
Emphasizes (pp. 7 and 26) the Villard manuscript as "a
thoroughly practical 'building encyclopaedia.'"  Harvey
claims (p. 29) that Villard's drawings are "the earliest
surviving [medieval] drawings which are strictly archi-
tectural," speaks of their "exquisite quality, precision,
and finished technique," and apparently believes in the
"secret of the medieval masons" theory, for he states
(p. 22) that the manuscript "throws light on the secrets of
the craft." He cites Hahnloser as proof that Villard knew
both French and Latin and calls Master II and Master III
"presumably the next two masters of the lodge," meaning the
lodge which Villard headed.  Despite his familiarity with
Hahnloser, Harvey misattributes (p. 26) the celebrated
phrase inter se disputanto (fol. 15) to Villard.
He states (p. 69) that Villard probably was chief master
of Saint-Quentin and possibly was designer of the Cambrai
choir.  He dates Villard's trip to Hungary before 1250 but
does not attribute any specific buildings there to Villard.
Much of this material is taken from 1945.2.

## 1951

1   PANOFSKY, ERWIN.  Gothic Architecture and Scholasticism.
Latrobe, Pa.:  Saint Vincent Archabbey Press.  **2d ed.
London:  Thames and Hudson, 1957.
Claims (pp. 87-88) that the plan (fol. 15) drawn by
Villard and Pierre de Corbie proves that by the mid-
thirteenth century "Scholastic dialectics had driven archi-
tectural thinking to a point where it almost ceased to be
architectural." Panofsky notes that Master II's inscrip-
tion inter se disputando is a specifically scholastic term
and that this plan is an attempt to reconcile opposites
(rounded and square chapels).  He elsewhere (p. 77) claims
that Villard observed and exaggerated the scholastic use of
an enlarged central colonnette in the Reims triforium.
Reproduces fol. 15 and a detail of fol. 31v.

1951

2  ÜBERWASSER, WALTER. "Die Turmzeichungen Villards de
   Honnecourt." In Festschrift für Hans Jantzen. Berlin:
   Verlag Gebr. Mann, pp. 47-50.
      A section of an article entitled "Deutsche Architektur-
   darstellung um das Jahr 1200" which reproduces Villard's
   horologe (fol. 6v) and Laon tower elevation (fol. 10v),
   claiming that both are based on the design principle of
   quadrature and that both illustrate the medieval principle
   of reductiones formae et numeri from actuality in order to
   indicate essentials.

3  VELTE, MARIA. Die Anwendung der Quadratur und Triangulatur
   bei der Grund- und Aufrissgestaltung der gotischen Kirchen.
   Basler Studien zur Kunstgeschichte, no. 8. Basel: Verlag
   Birkhauser AG.
      A short essay concentrating mainly on late Gothic uses
   of geometry in design, for example, by Mathes Roriczer and
   Lorenz Lechler. Velte analyzes (pp. 53-55) Villard's plan
   of a tower at Laon (fol. 9v) for the use of quadrature and,
   despite noting clearly that "Selbstverständlich ist eine
   händig auf das Pergament geworfene Skizze nicht so exakt wie
   der Pergamentriss einer Baühutte," and admitting that one
   has to work downward from the keystone and from the inside
   out because the baseline is not included in the drawing,
   she concludes that Villard used quadrature to determine
   even the smallest details. The significance of this
   (p. 54) is "Somit hat man auch schon im frühen 13. Jahr-
   hundert nach der Quadratur konstruiert."
      Velte's thesis is illustrated in pl. VIII on p. 100.

1952

1  CROMBIE, A[LISTAIR] C[AMERON]. Augustine to Galileo: The
   History of Science, A.D. 400-1650. London: Falcon Press.
   **Rev. ed. Medieval and Early Modern Science. Vol. 1,
   Science in the Middle Ages: V-XIII Centuries. Garden
   City: Doubleday & Co., 1959.
      Terms Villard a thirteenth-century architect and at-
   tributes (p. 205) to him "parts of Laon, Reims, Chartres,
   and other French cathedrals." Specific focus is on
   Villard's mechanical devices. It is claimed (p. 198) that
   if Villard's waterpowered sawmill (fol. 22v) represents
   something actually used, it is earlier by a century that
   the first documented example of this device in Europe.
   Crombie also says (p. 211) that Villard's device for making
   an angel turn so its finger always points to the sun is the

earliest known drawing of an escapement movement in the West.

Reproduces a cropped photograph of fol. 22v for which the source is given as the "Bodley's Librarian, Oxford."

2    SALZMAN, L[OUIS] F.  Building in England Down to 1540:  A Documentary History.  Oxford:  Clarendon Press.  2d rev. ed.  1967; 3d rev. ed.  1979.
     Does not refer to Villard as an architect but praises his drawings of architecture (p. 16) as "jottings for his own use, . . . workmanlike little drawings containing all the essential features of such plans [as were used in the thirteenth century] and perfectly comprehensible to any craftsman."
     Salzman is especially taken by Villard's two drawings illustrating the principle of the hammer-beam (fol. 17v), noting (p. 18) that these must represent Villard's theories and not actual examples of the hammer-beam roof since no actual example "is known for about a century after Villard's time."
     Reproduces fol. 15, to which the statement cited from p. 16 refers.

3    VON SIMSON, OTTO.  "The Gothic Cathedral."  Journal of the Society of Architectural Historians 11:6-16.
     Citing neither Bénard (1864.1) nor Enlart (1895.1), Von Simson makes (p. 15) one of the strongest claims, without offering any proof whatsoever, that Villard "seems to have received his architectural training at the Cistercian mon- estery of Vaucelles and certainly was employed as an archi- tect by the [Cistercian] Order."  Von Simson claims (p. 15) that "Villard was a distinguished architect" and notes, "Perhaps the most important single piece of evidence re- garding the principles of Gothic design is the famous model by the Picard architect Villard de Honnecourt . . . in the second quarter of the 13th century."
     In discussing Villard's plan for the Laon tower (fol. 9v), Von Simson repeats the misattribution to Villard of the statement that it was "the most beautiful in the world" and accepts Überwasser's claim (1949.4) that in Villard's drawing, all horizontal sections are recessed "according to true measure."

<u>1953</u>

1   ACKERMAN, JAMES S.  Review of <u>Die Anwendung der Quadratur und</u>
    <u>Triangulatur bei der Grund- und Aufrissgestaltung der</u>
    <u>gotischen Kirchen</u>, by Maria Velte.  <u>Art Bulletin</u> 35:155-57.
        Complete summary of Velte's analysis (1951.3) of
    Villard's fol. 9v plan of the Laon Tower.  Ackerman accepts
    Velte's contention that Villard's drawing proves the design
    principle of quadrature was known and used in the thir-
    teenth century.

2   DU COLOMBIER, PIERRE.  <u>Les Chantiers de cathédrales</u>.  Paris:
    Editions A. et J. Picard et Cie.
        Accepts (pp. 63 and 86) Hahnloser's view that the
    Villard manuscript was a shop manual (termed by Du
    Colombier a <u>Baubuch</u>), although he insists it must be called
    an <u>album</u>.  His view (p. 63) is that the manuscript began as
    a "simple recueil personnel de notes" and later evolved
    into a "vrai encyclopédie" concerning architecture, sculp-
    ture, and mechanics.  However, Du Colombier insists that
    Villard's architectural drawings were mere suggestions, not
    models or working drawings.  He considers (p. 86) the manu-
    script as the best existing proof of the combination of
    medieval architect and sculptor in one person but elsewhere
    (p. 22) claims that Villard was an inventor.
        The main focus (pp. 86-90) of Du Colombier's interest in
    Villard is what the drawings reveal about the working pro-
    cedures of the Gothic artist.  He believes that while
    Villard may have drawn his lion (fols. 24 and 24v) <u>al vif</u>,
    as he claimed, there was interposed between model and draw-
    ing an unavoidable fixed mental image (<u>Gedankenbild</u>) of
    what a lion looked like established by authority and tradi-
    tion, and Villard unconsciously employed this image.  In
    Du Colombier's view, the more difficult the artist's task,
    for example, drawing something in movement or directly from
    nature, the more discernible this <u>Gedankenbild</u> will be.
        The author raises the question of whether sculptors or
    painters first began to observe and model directly from
    nature and concludes that it was sculptors because painters
    relied longer on fixed formulas and geometric schemata.
    However, in examining (p. 86) Villard's use of geometric
    schemata (fols. 18, 18v, 19, 19v), he concludes that the
    relationship between the geometric figure and human or
    animal figure is at best arbitrary and that at least in
    some instances the geometric schemata "ont été ajoutés
    après coup."

1954

3  EICHLER, HANS. "Ein frühgotische Grundriss der Liebfrauen-
   kirche in Trier." <u>Trier Zeitschrift für Geschichte und
   Kunst des Trier Landes und seiner Nachbargebiete</u> 28:145-66.
      Discusses (p. 145) the Villard manuscript, termed a
   <u>Bauhüttenbuch</u>, as the first example since Carolingian times
   of architectural plans drawn on parchment. Eichler says
   that Villard drew his plans as models for his own work and
   that he copied these at least in part from larger working
   drawings in various workshops. He notes that Villard's
   plans have no indication of scale but insists that they
   have correct measure (<u>rechten</u> <u>Mass</u>; see Überwasser, 1935.4),
   being drawn according to binding geometric rules.
      He suggests (p. 165) that there is a conceptual rela-
   tionship in the choir plans of Cambrai, Braine, Marburg,
   and Trier, all stemming from Cambrai, whose plan Villard
   modernized when he drew it, but he does not attribute any
   of these buildings to Villard.

<u>1954</u>

1  DANIEL-ROPS, HENRY [pseud. for Henry Jules Charles Petiot].
   <u>Comment on bâtissait les cathédrales</u>. Visages de l'église,
   no. 1. Paris: Le Centurion.
      Essay with a thesis the exact opposite of Renan's
   (1862.1), namely, that Gothic cathedrals represent one of
   the greatest achievements of the human spirit and the
   Christian faith. Villard is taken (p. 42) as someone who
   belonged to the "aristocratie de son métier" and as proof
   of the extraordinary scientific knowledge possessed by
   thirteenth-century architects. Daniel-Rops stresses the
   idea that Villard is the best known of all medieval archi-
   tects because of his manuscript.

2  DEMAISON, LOUIS. <u>Cathédrale de Reims</u>. Petites Monographies
   des grands édifices de la France. Paris: Henri Laurens,
   Editeur.
      Demaison here (p. 23) repeats in summary form his
   earlier (1902.2) study of Villard's relationship to Reims,
   dating his visit there to the second quarter of the thir-
   teenth century and claiming that Villard's drawings reveal
   the state of construction of Reims at the time of that
   visit.

1955

1   ANON.  Les Manuscrits à peintures en France du XIIIe au XVIe
        siècle.  Preface by Andre Malraux.  Catalog no. 8.  Paris:
        Bibliothèque nationale, p. 11.
            The Villard manuscript was exhibited to show fol. 4.
        The brief text summarizes the contents of the manuscript,
        with one factual error:  fol. 15 is said to contain plans
        of Meaux and Saint-Faron at Meaux in addition to the choir
        plan drawn by Villard and Pierre de Corbie.  The manuscript
        is dated "milieu du XIIIe siècle" and Villard is called an
        architect.  It notes that his use of geometry to permit
        rapid design of figures (fols. 18v and 19) is found in con-
        temporary French manuscripts and refers to a Bible mora-
        lisée (MS. lat. 11.560) in the same exhibition (Catalog
        no. 6, p. 7).

2   BRANNER, ROBERT.  Review of Les Chantiers des cathédrales, by
        Pierre Du Colombier.  Art Bulletin 37:61-65.
            Suggests (p. 64) that the chapter concerning the
        sculptor (in which the bulk of the discussion of Villard
        is found) "seems almost to have been an afterthought.  It
        contains the main results of Hahnloser's study of Villard,
        and especially emphasizes the conclusion that what may
        originally have been an architect's sketchbook was soon
        transformed into a workshop accessory which was used as a
        kind of encyclopaedia of solutions to mathematical and
        structural problems and of models for sculptors."
            Discussing the difficulty of discovering and correctly
        interpreting geometrical schemata in medieval buildings,
        Branner calls attention (p. 63) to the fact that Überwasser
        (1949.4) and Velte (1951.3) "with reasoned explanations,
        arrive at completely different interpretations of the plan
        [of the Laon tower as drawn by Villard, fol. 9v], and
        neither is completely convincing."

*3  CSEMEGI, JÓZSEF.  A budavári fötemplom [The parish church of
        Buda Castle].  Budapest: n.p.
            In Hungarian.  Cited by Gerevich (1977.3, p. 179) as
        containing on pp. 73-80 "full . . . literature on the sup-
        posed works of this architect [i.e., Villard] in Hungary."

1   BOOZ, PAUL. Der Baumeister der Gotik. Munich and Berlin:
    Deutscher Kunstverlag.
        Commonly cited in Villard studies, this work is mainly
    concerned with late medieval designers, for example, Lorenz
    Lechler, Mathes Roriczer, Hanns Schmuttermayer, et alia,
    and has little to do with Villard. Booz terms the Villard
    manuscript a Musterbuch, and his principal observation
    (pp. 73-74) is that Villard's renderings in perspective of
    parts of buildings (Laon tower, fol. 10; exterior and in-
    terior of a Reims chapel, fols. 30v and 31) are unusual,
    most medieval architectural drawings indicating details of
    construction and decoration only (cf. fol. 32).
        He insists that while Villard's drawings stand at the
    beginning of the appearance of orthogonal architectural
    renderings, his drawings do not have consistent one-point
    (Renaissance) perspective and could not have been of any
    help in actual construction. Booz claims (p. 74) that
    Villard copied his architectural drawings from a modelbook:
    "Ferner ist zu beachten, welcher Quelle all diese Zeich-
    nungen entnommen sind, nämlich einem Musterbuch."

2   CLARK, [Sir] KENNETH. The Nude: A Study in Ideal Form.
    Bollingen Series, vol. 35, no. 2. Princeton: Princeton
    University Press.
        Contains (p. 11) one of the harshest condemnations in
    print of Villard's ability to draw the nude figure, which
    is contrasted with his facility in rendering drapery:
    "This [the Villard manuscript] contains many beautiful
    drawings of draped figures, some of them showing a high
    degree of skill. But when Villard draws two nude figures
    [on fol. 22] in what he believes to be the antique style
    the result is painfully ugly. It was impossible for him
    to adapt the stylistic conventions of Gothic art to a sub-
    ject [the male nude] that depended on an entirely different
    system of forms. There can be few more hopeless misunder-
    standings in art than his attempt to render that refined
    abstraction, the antique torso, in terms of Gothic loops
    and pothooks." For a more positive view, see Vitry,
    1929.4.
        Reproduces fol. 22.

3   VON SIMSON, OTTO. The Gothic Cathedral: Origins of Gothic
    Architecture and the Medieval Concept of Order. Bollingen
    Series, vol. 48. New York: Pantheon Books.
        Repeats much of the information, occasionally verbatim,
    from his earlier article (1952.3) but with additional com-
    ment.

1956

Von Simson stresses that Villard's manuscript proves that geometry was the basis of all medieval design. He concentrates on Villard on pp. 198-200, claiming that Villard may have worked under the architect of Chartres in his youth and that his "model book expounds not only the geometric canons of Gothic architecture but also the Augustinian aesthetics of 'musical' proportions," referring to Villard's idealized design for a Cistercian church on fol. 14v.

Von Simson refers to Focillon's claim (1931.1) that there is at least a theoretical association in the geometry of Villard and Robert Grosseteste.

## 1957

1   BRANNER, ROBERT. "A Note on Gothic Architects and Scholars." Burlington Magazine 99:372, 375.

A reaction to Panofsky's thesis (1951.1) about the relationship between Gothic architects and scholastics in which Branner attempts to determine the source of Master II's designs on fols. 20 and 20v (here termed pp. 39-40). He concludes that the source was an "archetype manuscript" written in Picardie ca. 1240-1250, after the manuscript left Villard's possession but before Master II made his additions.

On the basis of relationships between various Master II drawings, Branner suggests the archetype was a Gothic manuscript composed of two vertical columns of figures and captions. He emphasizes that this manuscript was probably a treatise on practicae geometriae and not a learned, theoretical treatise produced at, or for use in, a university. He thus concludes that the relationship between architects and scholastics in the thirteenth century was one of parallelism rather than one of direct influence.

On p. 372 n. 4 Branner says that the letters found in the gutter of fol. 20 "seem to be neither the hand of Villard nor that of Master 2; the writer of this lost text should perhaps be called Master 1."

2   _____. "Three Problems from the Villard de Honnecourt Manuscript." Art Bulletin 39:61-66.

Detailed explanation of the geometry, steps, and tools involved in executing three of Master II's masonry diagrams on fols. 20 and 20v of the Villard manuscript. These concern especially difficult problems: how to cut a voussoir for an oblique opening in a straight wall; how to cut a voussoir for a window opening in a curved wall; and the

en échelon method of cutting voussoirs using a mason's square.

As an introduction to these analyses Branner notes (p. 61) that Master II's "drawings are so cryptic and the texts beneath them so brief, that no adequate explanations have been found for them."

3  HOLT, ELIZABETH GILMORE. "Villard de Honnecourt." In A Documentary History of Art. Vol. 1, The Middle Ages and the Renaissance. Garden City: Doubleday & Co., pp. 88-91.

Terms Villard a thirteenth-century master-mason from northeastern Picardie and says (p. 89) that his "book was begun as a sketch book, but after years of compilation developed into a manual giving for the first time detailed instructions for the execution of certain objects with accompanying explanatory drawings."

Holt questions the attribution of Cambrai to Villard on the basis that "there are no correspondences between the building and his notebook to warrant this," apparently un-aware of fol. 14v. She then states (p. 88) that it "is more probable that he was active in the building of St. Quentin."

Reproduces fols. 1v, 6v, 7, 15, 18, 18v, and 24 with translations of the inscriptions based on Willis and Hahnloser.

4  JANTZEN, HANS. "Das Bauhüttenbuch des Villard de Honnecourt." In Kunst der Gotik, Klassische Kathedralen Frankreichs: Chartres, Reims, Amiens. Rowohlts Deutsche Enzyklopadie, vol. 48. Hamburg: Rowohlt Taschenbuch Verlag GmbH, pp. 81-84. English trans. High Gothic. London: Pantheon Books, 1962, pp. 85-90.

Terms (p. 81) Villard a Picard Hüttenmeister of ca. 1235 and says (p. 82) there is a strong probability that he de-signed Saint-Quentin. Jantzen refers to Hahnloser and accepts the latter's view that the manuscript is a Bauhüt-tenbuch later used by other architects.

Admitting that Villard may not have been the greatest architect of his age and that the manuscript may at first appear disorganized, Jantzen claims that it in fact con-tains "notes on every aspect of the building crafts, tech-nical procedures, and artistic composition (English trans., p. 85)." Jantzen believes that Villard's drawings of Reims were based on other drawings and attributes the discrepan-cies between Villard's architectural drawings and actual models (e.g., Chartres rose, Laon tower, etc.) to the fact that Villard illustrated essentials only.

1957

He claims that Villard's drawings of animals and humans, whether or not they are based on actual models, are all determined by Gothic geometry.

Reproduces (redrawn after Hahnloser?) fols. 10, 31v, and 32v. The frontal view of Villard's lion (fol. 24v) appears on the cover of the German paperback edition.

<u>1958</u>

1  BRANNER, ROBERT. "Drawings from a Thirteenth-Century Architect's Shop: The Reims Palimpsest." <u>Journal of the Society of Architectural Historians</u> 15:9-21.

Detailed analysis of architectural drawings dated between 1230/1240 and 1263/1270 (Reims, Archives de la Marne, MS. G.611), with several references to Villard's drawings. Branner claims (p. 19) that the Reims <u>Palimpsest</u> drawings "seem totally unrelated, in size and in detail, to the drawings in Villard's manual," but notes (p. 18) that the capitals in these drawings are similar to those drawn by Villard (for example, G.661 sheet B and Villard fol. 10) and (p. 19) that Hahnloser had earlier (1933.1) noted a similarity between the choir stalls in each set of drawings.

Branner gives (p. 19) the "ideal date" for Villard as 1230-1235.

2  DIRINGER, DAVID. <u>The Illuminated Book: Its History and Production</u>. London: Faber & Faber.

Within the context of a general summary of the relationship between Gothic architecture and manuscript illumination in thirteenth-century France, Diringer claims (p. 277) that this relationship can be "best studied in an album of sketches, a sort of textbook on architecture, written c. 1235, by Villard de Honnecourt." Much of Diringer's material is taken from Walters Art Gallery, 1949.5.

3  GIMPEL, JEAN. <u>Les Batisseurs de cathédrales</u>. Le Temps qui court, no. 11. Paris: Editions du Seuil. English trans. <u>The Cathedral Builders</u>. New York: Grove Press, 1961.

Chapter VII (pp. 105-43) concerns Gothic architects, and Villard's manuscript is taken as a "véritable encyclopédie" of the interests and concerns of a thirteenth-century architect. Gimpel uses Quicherat's categories (1849.1) of materials, which he misattributes to Lassus, and claims (p. 106) that the material lost from the manuscript concerned carpentry.

He attributes Vaucelles and Kassa, and possibly Cambrai, to Villard but focuses on two aspects of the manuscript:

1958

Villard's interest in mechanics and his knowledge of geome-
try, especially the Vitruvian principle of doubling a
square. Gimpel emphasizes (p. 123) that Villard understood
the principle of quadrature long before German designers of
the late fifteenth century wrote about it.

Reproduces fols. 13 and 23 from the manuscript, both
severely cropped, and a number of details. Each chapter
is headed by a figure redrawn from the manuscript.

4    HUYGHE, RENÉ, ed. <u>Larousse Encyclopaedia of Byzantine and
     Medieval Art</u>. Art and Mankind, vol. 2. Paris: Librairie
     Larousse. **English ed. London: Paul Hamlyn, 1963.

Contains several brief references to Villard, stressing
(p. 345) that he was a "famous Gothic master [architect]"
who traveled widely and (p. 376) that his "curious note-
book . . . [is] valuable for our knowledge of medieval
drawing techniques." This is typical of the attempt to
see Villard in two different ways: as (p. 238) an artist
whose geometric designs reveal the abstract anti-naturalism
characteristic of medieval art and as (p. 318) one who "had
an interest in nature and observation [of nature]," as his
lion drawn <u>al</u> <u>vif</u> (fols. 24 and 24v) proves.

Reproduces details of fols. 14v, 19, and 19v.

5    KIDSON, PETER, and PARISER, URSULA. <u>Sculpture at Chartres</u>.
     London: Alec Tiranti. **Reissued. London: Academy
     Editions, 1974.

Kidson repeats the well-known Chartres models found in
Villard's drawings: the relief of the <u>Fall of Pride</u>
(fol. 3v), the nave labyrinth (fol. 7v), and the west rose
(fol. 15v), then (p. 53) adds two additional items:  cor-
bels from the south arm porch (now preserved in the south-
west tower tribune) which served as models for Villard's
leaf-face (fol. 5v) and lion head (fol. 24v). He also
notes (p. 53 n. 26) that several of Villard's motifs
(gamblers on fol. 9 and wrestlers on fol. 14v) are found
on the Maison canonicale of the cloister at Chartres (see
Jusselin, 1911.1).

Kidson speculates (p. 53) that Villard himself may have
been responsible for "the appearance of the current Reims
style [of sculpture] at Chartres."

Reproduces details of fols. 3v, 5v, and 24v after Lassus
or Willis.

1959

1  BOWIE, THEODORE ROBERT.  See "The Facsimile Editions," F.V,
   1st ed.

2  BRANNER, ROBERT.  Review of Bowie facsimile.  College Art
   Journal 18, no. 4 (Summer):375.
        General review of Bowie's facsimile, noting that it is
   welcome because no other facsimile is in print.  Criticizes
   Bowie's use of Arabic letters inked in on the folios them-
   selves.

3  Encyclopaedia of World Art.  Vol. 15.  London:  McGraw-Hill
   Publishing Co., 1959-1962.
        Contains scattered references to Villard and to his
   manuscript, but no specific entry devoted to either.  Since
   the entries are by various authors, the manuscript is given
   several different designations:  "livre de portraiture"
   (vol. 14, p. 385), "model book" (vol. 4, p. 475), "sketch-
   book" (vol. 4, p. 127), and "technical treatise" (vol. 4,
   p. 127).  The manuscript is also viewed in several differ-
   ent ways, for example, as "the first organic treatise on
   medieval architecture" (vol. 14, p. 385) and as "a model
   book in which[,] typical of the period[,] the artist re-
   duces his subject to such a uniform style that it is often
   difficult to distinguish the technique in which they [sic]
   were originally executed."
        It is elsewhere claimed (vol. 4, p. 127) that the manu-
   script "includes ideas of taste and precise judgments of
   quality . . . [which] express the taste of the French mon-
   archy and of the ecclesiastical and secular milieus which
   were bound to it."  Villard is termed a Picard architect,
   and the manuscript is dated (vol. 2, p. 188) precisely to
   1235.  Only Kassa (identified as Košice, Czechoslovakia) is
   attributed (vol. 4, p. 220) to Villard.

4  GALL, ERNST.  "Villard de Honnecourt."  In Les Architectes
   célèbres.  Vol. 2.  Edited by Pierre Francastle.  Paris:
   Lucien Mazenod, pp. 36-37.
        Notes (pp. 36-37) that Villard was born ca. 1200 near
   Cambrai, and that he is celebrated by his incomplete
   "cahier de croquis," a manuscript "unique en son genre,"
   which came into the Bibliothèque nationale in 1865 [sic].
   Gall claims that the buildings drawn by Villard are those
   which impressed him or those to whose construction he had
   personally contributed.
        The only specific attribution to Villard seems to be
   Saint-Quentin; Gall says, "l'architecte [de Saint-Quentin]

se servit de ces croquis [de Reims] comme modèle pour la construction des parties orientales de l'église abbatiale [sic] de Saint-Quentin," but it is unclear whether specific reference is to Villard or to a different architect who used Villard's drawings of Reims.

On p. 219 in an index Villard is mentioned in connection with his visit, dated ca. 1230-1235, to Hungary. It is claimed that he was then a mature man and an accomplished architect, but that there is no documentation for what he did or built in Hungary.

5   HÉLIOT, PIERRE. "Chronologie de la basilique de Saint-
    Quentin." Bulletin monumental 117:7-50.
        Suggests (p. 49) that Villard was the "auteur probable
    de l'abside et du choeur," dated ca. 1205/1220, of Saint-
    Quentin and (p. 50) calls attention to the many structural
    difficulties of the choir: "On paya cher la témérité du
    maître du choeur: sans doute Villard de Honnecourt en
    personne."

## 1960

1   BARNES, CARL F., Jr. Review of Bowie facsimile. Journal of
    the Society of Architectural Historians 19:85.
        General summary of Bowie's facsimile, noting the diffi-
    culty of comparing it with the Villard manuscript and other
    facsimile editions because of Bowie's unique arrangement of
    the folios.
        Argues that the Villard manuscript may have served dif-
    ferent purposes at different times.

2   BARON, FRANÇOISE. "Les Églises de Vaucelles." Cîteaux 11:
    196-208.
        Treats in detail the architectural history of the suc-
    cessive abbey churches at Vaucelles, with special attention
    to the role of Villard in the design of the Gothic church
    (Vaucelles III). Baron notes (p. 199) that the excavations
    in the 1860s (see Wilpert, 1865.4) confirm the basic accu-
    racy of Villard's plan (fol. 17). On pp. 200-201 she
    adopts Enlart's thesis (1895.1) that Vaucelles III dates
    1216-1235 and claims that the plan of a traditional
    Cistercian church (fol. 14v) is a sketch of Vaucelles II.
    This choir was demolished by Villard, who was the architect
    of Vaucelles III (p. 200): "Est-ce à dire que Villard ait
    été vraiment l'architecte qui, après en avoir conçu le plan
    [fol. 17], assuma la direction des travaux de choeur de
    l'église de Vaucelles? C'est infiniment probable."

1960

Baron offers the three "standard" presumptions for be-
lieving this: that Villard was from nearby Honnecourt;
that he was trained in the abbey workshop; and that he
probably directed work at Vaucelles before his trip to
Hungary (after 1235).

Baron also calls attention (p. 208) to the resemblance
between the Vaucelles plan and that (fol. 15) designed by
Villard and Pierre de Corbie.

Reproduces fol. 17 after Lassus.

Note: Baron's article, "Histoire architecturale de
l'abbaye de Vaucelles." Cîteaux 9 (1958):276-83, contains
no mention of Villard.

3    BOUVET, FRANCIS. See "The Facsimile Editions," F.VI.

4    BRANNER, ROBERT. Review of Bowie facsimile. Journal of
     Aesthetics and Art Criticism 18:396-97.
     Not so much a review of Bowie's edition (praised
     [p. 397] for its ready availability) as a short essay on
     the importance of the Villard manuscript for understanding
     the working procedures of the medieval architect. Branner
     claims (p. 396) that "no collection [of contemporary medi-
     eval textual] statements, however comprehensive, can pro-
     vide as clear a picture of his [the medieval architect's]
     activities and interests as the 'sketchbook' of Villard de
     Honnecourt."
     He claims here (but, see 1957.1) that the manuscript,
     which he dates ca. 1230-1240, "reveals many relationships
     between the architect of 1230 and contemporary academic
     discipline." Branner comments on the fact that the manu-
     script proves that architects sometimes collaborated in
     designs but refers (p. 396) to the plan devised by Villard
     and Pierre de Corbie (fol. 15) as "somewhat monstrous."

5    _____. "Villard de Honnecourt, Archimedes, and Chartres."
     Journal of the Society of Architectural Historians 19:
     91-96.
     A spirited defense of the accuracy of Master II's schema
     on fol. 20v for designing keystones using the Archimedes
     spiral, associated with such a spiral design engraved on
     the underside of a capital found at Chartres. Branner in-
     sists that Master II was more accurate than he is given
     credit for having been (see Brutails 1902.1) and that mod-
     ern scholars have misdefined, and therefore misunderstood,
     medieval three-point and five-point arches, which begin
     with one rather than with zero in counting divisions along
     the baseline. In Branner's reconstruction (p. 93 fig. 4),

a three-point arch has five points and four divisions along the baseline.

Branner dates Master II's drawings, "about 1250," but notes that under ultraviolet light the same spiral design is found to have existed earlier. This he attributes to Villard, not to his Master I (see 1957.1), indicating that Villard was familiar with designs based on the Archimedes spiral.

Branner terms Villard "a thirteenth-century Picard architect" and dates his visit to Chartres "probably in 1225."

Note: This article produced an exchange of charges and counter-charges between Branner and Leonard Cox [Cox's critique of the article: Journal of the Society of Architectural Historians 20 (1961):143-45; Branner's reply: Journal of the Society of Architectural Historians 20 (1961):145-46; Cox's rebuttal: Journal of the Society of Architectural Historians 21 (1962):36-37; Branner's reply: Journal of the Society of Architectural Historians 21 (1962):193] over the correct interpretation of the use of the Archimedes spiral in general and at Chartres in particular. None of these concern Villard per se and therefore are not given individual entries.

6    FRANKL, PAUL. "Villard de Honnecourt and Magister 3" and "Magister 2 and the Secret of the Lodges." In The Gothic: Literary Sources and Interpretations through Eight Centuries. Princeton: Princeton University Press, pp. 35-48 and 48-54.

Considers a number of problems connected with Villard and his manuscript and creates a biography of Villard: born ca. 1195; received the "first impulse toward his profession at Vaucelles"; probably next associated with Saint-Quentin as draftsman of its choir plan; visitor to Cambrai, but not its architect; ca. 1235-no later than 1242, in Hungary to build one or more major monuments, probably there through his association with Saint Elizabeth of Hungary; after 1242, back at Saint-Quentin; died ca. 1260.

Frankl believes (p. 40) that Villard was a painter and sculptor in addition to being an architect, proving that medieval craftsmen were not confined to the work of a single guild. He accepts Hahnloser's view that Villard did not attempt to make literal copies of the architecture he saw, but that he "modernized" these to suit his own taste and for his own purposes. Frankl claims that Villard had no sense of historical development in architecture, that is, he was not interested in what was most recent in his day but in what was most useful to him.

1960

He next analyzes the manuscript, concluding that seven-
teen leaves are lost and incorrectly stating (p. 37) that
the better-quality leaves were reserved for the finer
drawings. Frankl's view of the manuscript is that it began
as a collection of sketches for Villard's personal profes-
sional use; when he became a teacher and headed his own
lodge, he added drawings to serve as models for his stu-
dents and ultimately added still more in an attempt to turn
it into "a textbook (Lehrbuch) encompassing everything that
a Gothic architect needed to learn." Frankl is so con-
vinced of his "textbook" designation that he refers (p. 39)
to "chapters" in the manuscript.

In his section on "Villard de Honnecourt and Magister 3,"
Frankl analyzes the purpose of Villard's geometric figures
and his notation (fol. 18v) that these drawings serve "por
legierment ovrer." Incorrectly pointing out that Villard
himself does not use geometric guidelines in designing or
drawing his own figures, Frankl again (see 1945.1) inter-
prets the purpose of these geometric schemata not as a
means of designing figures de novo, but as a means of
transferring his small-scale figures to a larger scale
in ". . . a process of transference from the small drawing
to the block [of stone] or wall surface, . . . Villard
shows how one must invent that geometrical figure that
approaches the contour or indicates important points of
articulation [of the model]; but anything further is un-
necessary. . . ." (p. 52).

In his section on "Magister 2 and the Secret of the
Lodges," Frankl's conclusion (p. 49) is that all the
masonry drawings of Master II "can be thought of as prob-
lems of practical measurement." He notes that Villard's
drawing of two wrestlers on fol. 19 proves that Villard
knew the principle of quadrature, as did Master II, but
that the usefulness of this means of dividing the sides of
squares into halves, quarters, and eights was not fully
understood by either.

Frankl concludes (p. 54) that while there is no certain
proof from the Gothic period, ". . . we are compelled to
decide that the [quadrature] method of mensuration . . .
must be declared to be the secret of the Gothic free-
masons. . . ." Frankl's principal source is the Hahnloser
facsimile.

Reproduces details of fols. 18, 18v, 19, 19v, 20, and
21.

7   FRISCH, TERESA G.   "The Twelve Choir Statues of the Cathedral
    of Reims:   Their Stylistic and Chronological Relation to
    the Sculpture of the North Transept and of the West
    Facade."  Art Bulletin 42:1-24.
        An attempt to date precisely Villard's visit to Reims on
    the basis of the author's belief (p. 1) that Villard's
    drawing of the exterior of one of the radiating chapels
    showing statues above the culées (fol. 31) provides a
    terminus ante quem for these statues and other stylisti-
    cally related works on the north arm facade and the west
    facade.   On pp. 4-5 Frisch analyzes the various dates given
    for Villard's visit to Reims and concludes that Villard was
    there after 1231, in 1232 "or only slightly thereafter."
    She argues that the key to this date is in Villard's com-
    ment (fol. 30v) about the chapels at Cambrai, as it re-
    flects the uncertain future of construction at Cambrai
    after the death of its patroness, St. Elizabeth of Hungary,
    in fall 1231.   Accepting this date, she then argues (p. 24)
    that Villard's drawing (fol. 10v) of the Reims aisle window
    proves that the nave there was under construction as early
    as 1232.
        Frisch accepts without question the value of Villard's
    drawings as documentation ("Villard's testimony is of
    greatest consequence," p. 2) and offers no comment on why
    Villard shows the chapel vaults (fol. 30v) in an incomplete
    state, nor does she consider the consequences of the fact
    that his inscription about Cambrai was added after the
    drawing was made.   Frisch accepts (p. 5) Villard as chief
    architect of Saint-Quentin, citing Bénard (1867.1) as her
    source.
        Reproduces fol. 31.

## 1961

1   AUBERT, MARCEL.   "La Construction au moyen âge."  Bulletin
    monumental 119:7-42, 81-120, 181-209, 297-323.
        Notes (pp. 35-36) that Villard's Reims drawings (fols.
    30v, 31, 31v, 32, and 32v), made when Villard was passing
    through that city, show a project for the chevet of the
    cathedral which "devait être modifié dans la suite et
    ramené à des proportions moins ambitieuses."  Aubert claims
    (p. 36) that "maître" Villard's album remained for a long
    time in the lodge, where it was added to by his successors.
        Reproduces fols. 15, 16v, and 31v.

1961

2    BRANNER, ROBERT.  Gothic Architecture.  The Great Ages of
     World Architecture.  New York:  George Braziller.
         Terms (p. 19) Villard "one of the most interesting
     architects of the early thirteenth century" and notes that
     his manuscript is "the only one of its kind prior to the
     fifteenth century to have survived."
         Reproduces fols. 10, 22v, and 29.

3    FITCHEN, JOHN.  The Construction of Gothic Cathedrals:  A
     Study of Medieval Vault Erection.  Oxford:  Clarendon
     Press.
         While not concerned with Villard's manuscript to the
     degree one might expect in a book with this title, Fitchen
     makes two important observations concerning the nature of
     Villard's architectural drawings.  The first (p. 6) is that
     even with his captions, it is by no means always clear just
     what Villard intended to stress or demonstrate in his draw-
     ings.  The second (p. 7) is that Villard followed the
     standard artistic conventions of his time, intentionally
     distorting models, eliminating those things which did not
     suit his purposes (for example, the flying buttresses of
     the Reims nave, fol. 31v), and including things not present
     in reality if they did suit his purpose (for example, the
     large hand [of God?] in the Laon tower elevation, fol. 10).
         Fitchen terms Villard a well-trained and successful
     thirteenth-century French architect and states (p. 38) that
     "Hungary sent for and employed" Villard.

4    GIMPEL, JEAN.  See 1958.3.

                              1962

1    BOWIE, THEODORE ROBERT.  See "The Facsimile Editions," F.V,
     2d ed.

2    FRANKL, PAUL.  Gothic Architecture.  Pelican History of Art,
     no. Z19.  Baltimore:  Penguin Books.
         Contains a number of passing references to Villard,
     three of which are of some interest.  Frankl claims (p. 1)
     that Villard is the first writer to use the word ogive to
     refer to a rib vault.  He also stresses the early occur-
     rence of two other Gothic innovations in Villard's manu-
     script:  the pear-shaped arch profile (p. 151, referring to
     fol. 21); and the "pendant" crucifixion image, "which may
     well have been intended as a guide for both sculptors and
     painters" (p. 254, referring to fol. 2v and/or fol. 8).

                               68

Frankl makes (p. 125) the astonishingly incorrect claim that Villard's unknown work in Hungary is the "only case of the [French] Gothic being exported through the activities of a Frenchman."

3   JANTZEN, HANS. Die Gotik des Abendlandes. DuMont Kunstge-
    schichte Deutung Dokumente. Cologne: Verlag M. DuMont
    Schauberg.
       Refers to the Hahnloser facsimile and basically follows
    Hahnloser's thesis concerning Villard. Jantzen (p. 19)
    calls Villard an "Architek . . . um 1235" and refers to the
    manuscript as a Bauhüttenbuch or Hüttenbuch. He briefly
    discusses (p. 20) Villard's interest in Reims and dates his
    visit there "um 1230." Jantzen misquotes (p. 40) Villard
    as having said that the Laon tower was the most beautiful
    he had ever seen.
       Reproduces fol. 31v after Lassus or Willis.

4   ROSS, D[AVID] J.A. "A Late Twelfth-Century Artist's Pattern-
    Sheet." Journal of the Warburg and Courtauld Institutes
    25:113-28.
       While discussing a late twelfth-century pattern sheet,
    (Rome, Biblioteca Vaticana, Codex lat. 1976, fols. 1-2),
    Ross questions the purpose of the Villard manuscript,". .
    in some respects [the Villard manuscript] is an artist's
    pattern-book, though its miscellaneous contents cannot by
    any means all be made to fit that category [of manuscript]."
       Ross calls the Villard manuscript both an album and a
    sketchbook and dates it to the first quarter of the thir-
    teenth century, thus slightly later than the Vatican
    pattern sheet.

### 1963

1   BOBER, HARRY. The St. Blasien Psalter. New York: H.P. Kraus.
       Attributes a psalter in the H.P. Kraus Collection in New
    York to the scriptorium of the Benedictine monastery of
    Saint-Blasien in the western half of the diocese of
    Constance, dating this manuscript ca. 1230/1235. Bober
    notes (pp. 37-38 and 59-60) that several minatures in this
    psalter bear close resemblances to drawings found in the
    Villard manuscript, which he dates ca. 1235: two gamblers
    (fol. 9), a sleeping apostle (fol. 17), and another sleep-
    ing apostle and horse and rider (fol. 23v).
       He attributes the sleeping apostle motif to Sicilian
    Byzantine mosaics but notes that the dramatic foreshorten-
    ing found in these particular interpretations is too

1963

similar to the psalter to be related only thematically.  He
suggests (p. 38) that Villard either used the Saint-Blasien
Psalter as his source or that both Villard and the master
of the psalter had as inspiration one of the "remarkable
German model-books of Byzantine themes" found in Germany
from the late twelfth century on.

Bober concludes (p. 38), "For Villard, the pattern of
this line of evidence is of considerable significance be-
cause it shows that we must look to him not so much as the
source of so many of these [Byzantine-inspired] motifs, but
rather as an alert artist who picked up new things as he
went along, serving in turn as their most famous distribu-
tor.  Finally, this particular group of drawings consti-
tures the first tangible evidence of his artistic contacts
on his travels through the upper Rhineland."

2    BRANNER, ROBERT.  "Villard de Honnecourt, Reims, and the
Origin of Gothic Architectural Drawing."  Gazette des
beaux-arts, 6th ser. 61:129-46.

Detailed analysis of Villard's drawings of Reims (fols.
10v, 30v, 31, 31v, 32, and 32v) in which Branner concludes
that Villard drew from the building itself and not from
project drawings, in contrast to his Cambrai drawings which
were from project drawings.  He proposes (p. 138) that
Villard's Reims drawings "give us a rather precise idea of
the lost ones of Cambrai" and that Villard first visited
Cambrai "probably about 1220," then later, "probably about
1240-1245," visited Reims.

Branner compares Villard's drawings with their actual
subject at Reims, noting the discrepancies in each in-
stance.  From this comparison he concludes (p. 137) that
". . . Villard drew the elevations inaccurately from the
cathedral of Reims itself.  It is strange, when one comes
to think of it, that he has ever been considered an accu-
rate draftsman. . . ."

Although Branner does not consider the question of
whether Villard was an architect, he notes (p. 137) that
Villard's inaccuracy in drawing the Reims flying buttresses
produces a solution that "would be considered nothing short
of irresponsible on the part of any master mason."

Reproduces all of Villard's Reims drawings, except the
templates (fol. 32), together with comparable modern draw-
ings or photographs of the details drawn by Villard.

3    REINHARDT, HANS.  "Villard de Honnecourt."  In La Cathédrale
de Reims.  Paris:  Presses universitaires de France,
pp. 83-88.

Attempts to use the Villard drawings of Reims to answer four questions: when did Villard come to Reims?; did he draw from the actual construction or from the shop drawings of Jean d'Orbais?; if he drew the construction, what do his drawings tell about its state at the time of his visit?; and what was the purpose of his drawings?

Reinhardt concludes that Villard came to Reims from Laon ca. 1220; that his drawings are all from construction and not from shop drawings; that his drawings confirm the state of construction of at least parts of Reims ca. 1220; and that Villard made the drawings for application at Cambrai, although Reinhardt does not actually say that Villard was the architect of that cathedral.

Reinhardt explains the inaccuracies in Villard's drawings in two ways: since he drew from construction only, he had to guess at the intended appearance and details of projected work (and he frequently guessed wrongly); and because "il a introduit sur place les transformations qu'il envisageait à la cathédrale picarde [Cambrai]."

Reinhardt's most novel suggestion (p. 87) is that there are no Cambrai drawings lost from the manuscript because, when Villard refers on fol. 14v to other drawings of Cambrai, he was alluding to the "modified" drawings of Reims. Reinhardt claims (p. 102) that Villard's fol. 32 helps to reconstruct the original, intended choir buttresses of Reims.

Reproduces all the Villard Reims drawings and fols. 9v and 14v.

4   SCHELLER, R[OBERT] W[ALTER]. "Cat[alog] No. 10: Villard de Honnecourt (ca. 1230-1240)." In A Survey of Medieval Model Books. Haarlem: De Erven F. Bohn N.V., pp. 88-93.

Emphasizes Villard's drawing technique and sources rather than his architectural drawings, although Scheller states that Villard was an architect and suggests (p. 90) that Master II and Master III "probably [were] Villard's successors as chef de chantier." The drawing of drapery indicates the diocese of Cambrai as the locale where the drawings were made.

Scheller observes (p. 92) that in Villard's geometric figures (fols. 18, 18v, 19, and 19v) the figures were drawn before the geometric overlays were added.

Scheller states that whatever the exact meaning of al vif in Villard's claim that his lion (fols. 24 and 24v) was drawn from life, Villard clearly followed the normal medieval practice of transposing a subject into a schematized mental image or model before making his drawing.

Includes a bibliography and reproduces fols. 1v, 16v, 19, 27, and details from fols. 18 and 20v.

71

<div align="center">1964</div>

1  MESSERER, WILHELM. "Vorzeichungen." In <u>Romanische Plastik</u>
   <u>in Frankreich</u>. Cologne: Verlag M. DuMont Schauberg,
   pp. 57-60.
      Contrasts the use of constructive geometry in designing
   Romanesque and Gothic figures and concludes that, whereas
   in Romanesque figures the geometric bases are discernible,
   the organic nature of Gothic figures conceals their geo-
   metric bases. He cites Villard's geometric drawings as
   exemplars of the Gothic practice but insists that Villard
   had no single system. The basis of this short essay ap-
   pears to be Focillon (1931.1).
      Reproduces fol. 19 redrawn.

2  MITCHELL, SABRINA. <u>Medieval Manuscript Painting</u>. Compass
   History of Art, no. 7. New York: Viking Press.
      Makes (p. 21) the point that the Villard manuscript does
   not fall within the scope of manuscript painting, without
   saying why, but presumably because Villard's drawings are
   not polychromed. Mitchell claims (p. 22) that the Villard
   manuscript gives a good example of what medieval painters'
   model books must have looked like and that "it tells us a
   good deal about the spread of artistic ideas [in the thir-
   teenth century]."

<div align="center">1965</div>

1  SCHULTZ, SIMONE. "Villard de Honnecourt et son 'carnet.'"
   <u>Oeil</u> 123:20-29.
      A state-of-the-question essay in which the theses of a
   number of authors, most notably Branner, are presented and
   analyzed. Even though no buildings can be attributed to
   Villard and his manuscript provides less information about
   his career than many authors have claimed, Schultz argues
   on the basis of the manuscript that Villard is the best-
   known thirteenth-century architect, better known even than
   Robert de Luzarches or Pierre de Montreuil. She denies
   that the manuscript was a treatise or collection of prac-
   tical instructions yet terms it (p. 20) "le document le
   plus explicite [qui nous reste] sur l'art et le métier d'un
   architecte du XIIIe siècle."
      Schultz concludes (p. 28) that while Villard was "ni
   grand architecte, ni grand sculpteur . . . c'est à lui que
   nous devons l'essentiel de nos connaissances sur le 'condi-
   tion intellectuelle' d'un architecte du XIIIe siècle."

1966

The most interesting aspect of this study is the side-
by-side presentation of a number of Villard drawings and
photographs of the models for these drawings.
Reproduces a number of Villard's drawings in small scale
and fols. 9, 14v, 15, and 31 in nearly full scale.

2    SHELBY, L[ON] R.  "Medieval Masons' Tools, II:  Compass and
Square."  Technology and Culture 6:236-48.
Discusses (p. 240) fol. 20 of the Villard manuscript,
termed a sketchbook, as proof of the existence in the
thirteenth century of the compass or dividers consisting of
two legs ending in needlepoints controlled by a tension bar
and (pp. 242-43) in terms of Villard's technique of using a
compass in certain of his drawings, for example, fol. 16
(reproduced from Bowie).  Referring to earlier analyses by
Hahnloser and Burges (1858.1), Shelby concludes that
Villard used a compass to inscribe circles but that he did
not use a bow-pencil or a bow-pen.

1966

1    AUBERT, MARCEL.  The Art of the High Gothic Era.  The Art of
the World.  New York:  Greystone Press.
General treatment of Villard as representing the train-
ing required of a Gothic master mason, claiming (p. 24)
that, on the basis of his sketchbook, his "architecture is
a pragmatic science, supported by the geometric and alge-
braic formulas his master had taught him."  On p. 154
Villard's trip to Hungary is reported, his visit there
associated with the Cistercians "with whom he was on
friendly terms."  Aubert states that Villard "was undoubt-
edly connected with the building of Estergom and of Kassa."
A number of Villard figures, redrawn after the originals,
are used as margin illustrations unconnected with the text.
Fols. 17 (sleeping apostle only), 28 (prophet only), 29,
30v, and 32v are all included, redrawn after the originals.

2    HARVEY, JOHN [HOOPER].  "The Mason's Skill:  The Development
of Architecture."  In The Flowering of the Middle Ages.
Edited by Joan Evans.  New York:  McGraw-Hill Book Co.,
pp. 81-132.  Reprint.  **The Master Builders:  Architecture
in the Middle Ages.  New York:  McGraw-Hill Book Co., 1971.
Similar in content to his earlier studies (1945.2 and
1950.2).  Harvey here states the French view that the
Villard manuscript is an album and Hahnloser's view that it
is a Bauhüttenbuch, and sides with Hahnloser, calling it

1966

(p. 38) "a sort of manuscript technical encyclopaedia of
the building trades."
   He indirectly attributes Saint-Quentin to Villard, not-
ing (p. 82) that "Villard de Honnecourt's known journeys
took him from Saint-Quentin in Picardy to Laon and Rheims,
to Lausanne in Switzerland and across Austria to Hungary
and back."
   Reproduces fol. 10 and fol. 32v, the latter after Lassus
or Willis.

3   PEVSNER, NIKOLAUS; FLEMING, JOHN; and HONOUR, HUGH.   A Dic-
    tionary of Architecture.  Harmondsworth:  Penguin Books.
    **Rev. ed.  Woodstock:  Overlook Press, 1976.
       Included as an example of how Villard has become a part
    of the most general literature on architecture.  Villard's
    biography is given (p. 536) as:  active ca. 1225-1235;
    probably the architect of Cambrai; his book compiled for
    "learners in his lodge."  Pevsner claims that "Villard's
    book gives us the clearest insight we can obtain into the
    work of a distinguished master mason and the atmosphere of
    a [mason's] lodge."

4   STODDARD, WHITNEY S.   Monastery and Cathedral in France.
    Middletown:  Wesleyan University Press.
       Terms (p. 135) Villard an architect born near Cambrai
    who "designed and supervised the construction of buildings
    in northern France."  Stoddard discusses Villard princi-
    pally in connection with Reims, and dates (p. 209) his
    visit there to the early 1230s, when he was either an
    architect or still an apprentice.  He suggests that the
    sketches are inaccurate at least in part because Villard
    eliminated or simplified to capture what interested him
    most.  Stoddard is inconsistent in his view of the manu-
    script, which he variously terms an "album" and a "lodge
    book."  In one place (p. 135) he says it "probably served
    as a textbook for students in the lodge," but elsewhere
    (p. 202) claims it probably was a "visual diary of his
    [Villard's] trips."
       Stoddard proposes (p. 261) that the two male figures on
    fol. 28 were modeled after the figures of the Virgin and
    Saint Elizabeth on the Reims west facade (central portal,
    right embrasure).
       Reproduces fols. 10, 28, 30v, 31v, and 32v.

## 1967

1   DEUCHLER, FLORENS. Der Ingeborgpsalter. Berlin: Walter de
    Gruyter & Co.
        Contains several detailed comparisons of the miniatures
    in the so-called Psalter of Queen Ingeborg of France
    (Chantilly, Musée Condé, MS. 1695), probably ca. 1200, and
    those in the Villard manuscript, both from the point of
    view of iconography and from that of style. Deuchler notes
    (p. 50) their similar treatments of the motif of the sleep-
    ing apostle (fols. 17 and 23v), derived from Byzantine
    models.
        In several places (pp. 124 and 180) Deuchler claims that
    Villard was more advanced in his treatment of Muldenfalten-
    stil drapery than were the artists of the psalter, for
    example (p. 124), "erst bei Villard de Honnecourt und in
    der Synagoge in Strassburg begegnet man einem absoluten
    stilistischen Einklang gebrachten Formelschatz."

2   ESCHAPASSE, MAURICE. Reims Cathedral. Paris: Caisse natio-
    nale des monuments historiques.
        Contains a brief reference (p. 22) to Villard and the
    windows of Reims, possibly suggesting that it was due to
    Villard that the Reims windows enjoyed widespread influ-
    ence, "The windows at Reims were very much admired as soon
    as they were finished; Villard de Honnecourt drew them in
    his album of sketches and knowledge of them rapidly spread
    throughout 13th century Europe."
        Reproduces fol. 31.

3   HÉLIOT, PIERRE. La Basilique de Saint-Quentin et l'architec-
    ture du moyen âge. Paris: Editions A. et J. Picard et
    Cie.
        Héliot makes a number of references (pp. 14, 41, 50, 61,
    62, and 64) to Villard, and on p. 41 discusses briefly the
    tradition that Villard was the architect of Saint-Quentin.
    He comes down right on both sides of the question, stating
    that there is no proof whatsoever that Villard had anything
    to do with the church but that "il est seulement très vrai-
    semblable que Vilard bâtit les étages supérieurs de notre
    abside, sinon davantage."
        Elsewhere (p. 64) he asks if Villard may not have been,
    in the decade 1220-1230, the second master at Saint-
    Quentin. Héliot also speculates (p. 50) that Villard may
    have worked on modifications at Vaucelles between 1216 and
    1235.
        Reproduces a drawing, apparently after Lassus, of the
    Villard plan of Vaucelles.

1967

4   HENDERSON, GEORGE.  Gothic.  Style and Civilization.
     Harmondsworth:  Penguin Books.
          Contains a number of references to Villard and his manu-
     script, the most important of which is his view of the pur-
     pose of the drawings.  Henderson claims (p. 26) that the
     variety of subjects in the manuscript proves the "readiness
     [of the Gothic craftsman] to practice many arts concur-
     rently" and that the manuscript was a "handbook, compiled
     for the instruction of apprentice cathedral builders."
          He notes (p. 35) the similarity of Villard's drawing
     style to that found in the so-called Psalter of Queen
     Ingeborg of France (Chantilly, Musée Condé, MS. 1695) (see
     Deuchler, 1967.1) and he makes (pp. 86-87) an interesting
     contrast between Villard's sleeping apostle (fol. 23v) and
     Giotto's sleeping Joachim in Joachim's Dream (Padua, Arena
     Chapel).
          Reproduces fols. 10, 23v, 28, and 31v.

5   KIDSON, PETER.  The Medieval World.  New York and Toronto:
     McGraw-Hill.
          Notes (p. 104) that pattern- and sketch-books were im-
     portant in the Middle Ages for diffusion of stylistic ideas
     and terms Villard's manuscript a sketch-book.  On pp. 71
     and 104 Kidson proposes that Villard's sleeping apostle on
     fol. 17 may be derived from a mosaic of the Agony in the
     Garden of Gesthemene in the cathedral of Monreale, Sicily,
     possibly through the intermediary of a pattern-book.
          Reproduces a detail of fol. 17 after Lassus or Willis.

6   KURMANN, PETER.  "Saint-Etienne de Meaux d'après Villard de
     Honnecourt."  Bulletin de la Société littéraire et histo-
     rique de la Brie 24:5-13.
          Discusses the relationship between Villard's plan of the
     Meaux choir (fol. 15) and that of the cathedral itself, as
     well as the relationship of both to Villard's plan of
     Vaucelles (fol. 17) and to the plan designed by Villard and
     Pierre de Corbie (fol. 15).
          Kurmann notes (p. 8) that the "inexactitude flagrante de
     tous ces détails [piers, responds, buttresses] prouve de la
     façon la plus évidente que le plan [de Villard] n'est point
     un relevé exact, mais un simple croquis."  However, he in-
     sists that Villard's drawing is important for showing the
     essentials of the Gothic choir plan of Meaux before this
     choir was substantially modified in the mid-thirteenth
     century.
          Kurmann dates (p. 9) Villard's plan of Meaux between
     1220 and 1235 and admits that the cathedral plan was then
     out of fashion.  He explains that Villard probably was

attracted to it because its scheme of noncontiguous radiating chapels was that of his homeland (Vaucelles, Notre-Dame-la-Grande at Valenciennes). But Villard was sufficiently observant to understand that the polygonal rather than the circular plan of the chapels at Meaux was something new, and he uncharacteristically drew window spacings, a possible indication that he found these unusual or satisfactory or both.

Reproduces fol. 15 and a detail of fol. 17.

7   SALET, FRANCIS. "Chronologie de la cathédrale [de Reims]." Bulletin monumental 125:347-94.

Report on "le premier colloque international de la Société française d'archéologie (Reims, 1-2 juin 1965)," containing (pp. 348-362) a detailed analysis of the various interpretations of the labyrinth of Reims and the chronologies and roles of the architects it honored. Villard's association with Reims is mentioned (p. 381) only briefly, proof that the 'official' stance in France is that Villard was in no way associated with construction of the cathedral.

Salet notes that he does not believe that the absence of vaults in Villard's drawing of a radiating chapel (fol. 30v) proves that Villard was at Reims before the vaults were erected by ca. 1221, only that Villard eliminated the vaults "pour mieux faire voir ce qui l'intéressait, l'élévation et le dessin des fenêtres." The same interpretation presumably applies to Villard's other drawings of Reims.

8   WIXOM, WILLIAM D. Treasures from Medieval France. Cleveland: Cleveland Museum of Art.

Catalog of an exhibition held in Cleveland in 1966-1967 in which Item IV-14 (p. 144) was a leaf from a missal made for Noyon use (now in Cambridge, Mass., Harvard University MS Typ 120, here dated ca. 1240/1250) showing the figures of Ecclesia and Synagoga. Wixom calls attention to the relationship of these two figures to figures drawn by Villard ("especially similar to Villard's draped figures in their fluid linear style, tall proportions, rhythmic stance, and perky treatment of the features"), although he does not attribute the missal folio to Villard himself.

Wixom characterizes Villard's drawings as showing "remarkable facility in a decorative and expressive use of line as well as a keen eye for the essentials of the particular model before him," and he dates Villard's drawings after ca. 1250.

See Vitzthum, 1914.2, and Walters Art Gallary, 1949.5.

1967

*9   WORRINGER, WILHELM.  L'Art gothique.  Paris:  Gallimard.
         This French edition of Worringer's famous essay Form-
      probleme der Gotik is said (National Union Catalog, 1968-
      1972, vol. 103, p. 32) to have "planches provenant de
      l'Album de Villard de Honnecourt."  Earlier German and
      English editions contain no reference to or illustration
      taken from the Villard manuscript.

                              1968

1   BOWIE, THEODORE ROBERT.  See "The Facsimile Editions," F.V,
      3d ed.

2   BRANNER, ROBERT.  Review of La Basilique de Saint-Quentin et
      l'architecture du moyen âge, by Pierre Héliot.  Speculum
      43:728-32.
         Branner rather optimistically says (p. 732) he is
      "delighted to report that Héliot no longer agrees with" the
      attribution of Saint-Quentin to Villard, but it is by no
      means clear that Héliot (1967.3) rejects that attribution.

3   BUCHER, FRANÇOIS.  "Design in Gothic Architecture:  A Prelim-
      inary Assessment."  Journal of the Society of Architectural
      Historians 27:39-71.
         Discusses Villard (pp. 52-53) as a thirteenth-century
      architect who was less academic than his later Gothic
      counterpart, meaning that he apparently felt at ease in
      altering designs and models which he saw.  Bucher empha-
      sizes a different explanation of Villard's deviations from
      his models, however, saying that he was unable to under-
      stand or to remember the basis for design of these models.
      He states, concerning the Lausanne rose (fol. 16), that
      Villard "completely missed the simple geometric development
      [i.e., quadrature] on which the original concept was based,
      and which he should have remembered even if he drew
      [fol. 16] the rose from memory."
         Bucher analyzes the Lausanne window and proposes the
      "presumed original concept," which is closer in feeling to
      Villard's drawing than Villard's drawing is to the actual
      window.  Bucher does not raise the possibility that Villard
      might have had as his model not the actual window but a
      project drawing with different details or an entirely dif-
      ferent design.
         Reproduces a detail of fol. 16.

                              78

1969

4  CORNELL, HENRIK. Gotiken. Stockholm: Albert Bonniers För-
   lag.
       Villard is discussed briefly (pp. 105-7) in connection
   with Reims, principally in terms of his interest in antique
   revival sculpture. The biography of Villard is short and
   traditional.
       According to Thomas Thieme, this is the most extensive
   mention of Villard in all the art historical literature of
   Scandinavia. In Swedish.
       Reproduces fols. 3v and 6.

5  LORGUES, CHRISTINE. "Les proportions du corps humain d'après
   les traités du moyen âge et de la Renaissance." Informa-
   tion d'histoire et de l'art 13:128-43.
       Discusses (pp. 133-35) Villard's use of geometric
   schemata in designing the human face and body and the
   relationship of his schemata to those of classical antiq-
   uity. Lorgues claims that Villard's division of the face
   into three equal horizontal parts (top left of fol. 18v)
   stems from Vitruvius but that Villard's employment of geo-
   metric figures is generally arbitrary and less a system
   than a reflection of his fascination with various geometric
   figures (circle, equilateral triangle, square) commonly
   employed in medieval design.
       She summarizes (p. 135) her analysis as follows,
   "Villard abandonne non seulement le canon constitué, mais
   aussi les figures géométriques arbitrairement 'canoniques,'
   et il lui est arrive de géométriser après coup, au hasard
   d'inspiration, une figure dessinée d'abord sans l'aide d'un
   schema."
       Reproduces fols. 18v and 19v.

1969

1  BUCHER, FRANÇOIS. "Cistercian Architectural Purism."
   Comparative Studies in Society and History 3:89-105.
       Claims (p. 91) that no medieval commentator "was more
   clearly aware of the principles, possibilities, and limi-
   tations of the [square] Cistercian [church] plan than the
   early thirteenth century architect Villard de Honnecourt."
   Bucher compares Villard's Cistercian plan (fol. 14v) with a
   plan of Morimond, drawn to imitate Villard's style. It is
   not proposed that Villard designed Morimond.
       Reproduces the Cistercian plan on fol. 14v, redrawn.

1969

2    EVANS, M.W.  <u>Medieval Drawings</u>.  London:  Paul Hamlyn.
        Terms (p. 14) the manuscript the "most comprehensive
     model-book" of the Middle Ages and proof that medieval
     artists worked in different media.  The manuscript is dated
     ca. 1230-1240.
        Evans does not speculate on Villard's primary profession
     as a craftsman and does not even mention architecture.
     Emphasis is on the technique and purpose of the drawings in
     the manuscript.  Evans criticizes Villard's drawings as
     imprecise (when drawn from things he saw) and impractical,
     serving as guides rather than models because Villard
     stressed essentials only.  It is claimed (p. 36) that
     Villard used geometry (fol. 19) not to generate figures
     but to demonstrate how geometry underlies all art.
        Reproduces fols. 6, 6v, and 19.

3    SHELBY, LON R.  "Setting out the Keystones of Pointed Arches:
     A Note on Medieval 'Baugeometrie.'"  <u>Technology and Culture</u>
     10:537-48.
        Offers a variant of Branner's interpretation (1960.5) of
     how Master II used (fol. 20v) geometry to design keystones
     for arches.  He states (p. 544) that while the Archimedian
     spiral works, it is unnecessarily complex, and in attempt-
     ing to explain any medieval design schema, one should al-
     ways seek the simplest possible solution.
        Shelby terms (p. 537) Villard a thirteenth-century
     French master mason and dates Master II's additions to the
     manuscript later in the thirteenth century without specify-
     ing when Villard's activity ended.
        Reproduces a detail of fol. 20v from Bowie.

<u>1970</u>

1    GIMPEL, JEAN.  "Villard de Honnecourt."  In <u>Le Siècle de
     Saint-Louis</u>.  Paris:  Librairie Hachette, pp. 140-41.
        An appendix to an essay by Robert Branner ("La Place du
     'style du cour' de Saint Louis dans l'architecture du
     XIIIe siècle") in a collection of essays published to com-
     memorate the 700th anniversary of the death of Louis IX,
     the Saint (d. 25 August 1270).  Gimpel draws a parallel
     between thirteenth-century France and twentieth-century
     America, claiming that both are characterized by a belief
     in progress based on technology and that each era is known
     for the way it exported its technological expertise through-
     out the world.
        Gimpel gives, as a thirteenth-century French example,
     Villard's trip to Hungary.  He claims that Villard would be

right at home in New York with its glass-walled skyscrapers
because these are the modern equivalents of the glass-
walled cathedrals and churches of the thirteenth century.

Gimpel summarizes Villard's fascination with a variety
of subjects, from the serious to the trivial (his mechani-
cal gadgets), and compares this multiplicity of interests
to that of Leonardo da Vinci. He dates the Villard manu-
script between ca. 1225 and ca. 1250 and here, as else-
where (1976.2), fails to mention that part of its contents
are not by Villard.

2    HOFSTÄTTER, HANS H.  Living Architecture:  Gothic.  New York:
     Grosset & Dunlap.
         Terms (p. 56) Villard a master builder whose drawings
     "reveal to us his intensive analysis of the great buildings
     of his time."
         Reproduces fol. 31 after Lassus.

3    MURBACH, ERNST.  La Rose de la cathédrale de Lausanne.  Guides
     de monuments suisses.  [Basel]:  Société d'histoire de
     l'art en Suisse.
         Attributes (p. 8) the Lausanne rose to Pierre d'Arras
     and dates it between 1217 and 1235.  Murbach dates (pp. 3-
     4) Villard's drawing (fol. 16) of the rose ca. 1230, "La
     composition géométrique de cette dernière [loi d'unité], à
     Lausanne, suscita, vers 1230, le vif intérêt du célèbre
     architecte picard, Villard de Honnecourt."

4    CHAPPUIS, FRANÇOISE.  La Rose de la cathédrale de Lausanne.
     n.p., n.d. [1970+].
         An eight-page tourist pamphlet of interest because, in
     summarizing the documentation for the Lausanne rose, it
     states (p. 5) that the Villard drawing (fol. 16) may only
     be "selon toute vraisemblance" one of this rose.

5    SAUERLÄNDER, WILLIBALD.  Gotische Skulptur in Frankreich,
     1140-1270.  Munich:  Hirmer Verlag.  **English trans.
     Gothic Sculpture in France, 1140-1270.  New York:  Harry N.
     Abrams, Publishers, 1972.
         Mentions Villard only three times in passing but makes
     two very important observations.  The first (p. 26) is that
     "The fragmentary manuscript of Villard de Honnecourt . . .
     is too heterogeneous in content, and contains too much that
     is curious and discursive, to have served as a pattern book
     for working craftsmen.  Some of its sheets, however, may
     resemble the sketches of figures and scenes which the
     sculptors [of thirteenth-century France] had to work from.
     The drawings have been done with a pen, in a way that

1970

leaves the calligraphy noticeably regular and unemphatic.
Figures are often shown in unusual positions or from un-
usual aspects, but this again may be due to the author's
penchant for the curious and the unfamiliar."

The second (p. 42) is that by the epression al vif
(fols. 24 and 24v, referring to his lion), Villard meant
simply that he was not using traditional sources such as a
pattern book or a bestiary but that he was drawing a lion
"as it is," whatever his model was.

It would appear that Sauerländer has a low opinion of
Villard's drawings, although he does not specifically state
so. In discussing (p. 447) the coronation tympanum, ca.
1230, of Saint-Etienne at Beauvais, he notes that the style
is weak and that the drapery renderings are late examples
of Muldenfaltenstil which are a "mechanical repetition of
'antique' fold motifs." He compares this treatment to that
of the metalwork of Hugo d'Oignies and the drawings of
Villard.

6    SENÉ, A[LAIN]. "Un Instrument de precision au service des
     artistes au moyen âge: L'equerre." Cahiers de la civili-
     sation médiévale 13:349-58.
         Very similar to his later article (1973.5), with empha-
     sis on the different types of masons' squares found in
     medieval representations. Sené stresses that the purpose
     of the type of square illustrated in the Villard manuscript
     (fol. 20) is not to determine angles but to establish pro-
     portions based on the golden number. He claims (p. 356)
     that these squares have angles of 90°, 31°43'03", and
     58°16'57", but it is very doubtful if the size of the
     drawings in the manuscript permits such detailed determina-
     tions, especially if he used the Lassus lithograph which he
     reproduces as his source.
         Sené does not indicate that he is aware that the draw-
     ings on fol. 20 are not by Villard.

7    SHELBY, LON R. "The Education of the Medieval English Master
     Mason." Mediaeval Studies 32:1-26.
         Stresses (pp. 12-13) that the contents of Villard's
     sketchbook are quite different from the passing references
     to "the technical knowledge required by a practicing mason"
     found in medieval scholastic treatises but most emphatically
     denies Frankl's contention (1960.6) that the Villard manu-
     script is a "textbook encompassing everything that a Gothic
     architect needed to learn."
         Shelby does not here (but, see Shelby, 1975.2) contest
     Hahnloser's view that the manuscript was a Bauhüttenbuch,
     but he notes that it is a unique example of the period and

that those who argue that it is "merely one of species that
has otherwise disappeared have the burden of proof [that
this is so] on their shoulders."

Shelby terms Villard a French master mason of the thir-
teenth century.

## 1971

1   FRISCH, TERESA G. "The Architect of the First Generations of
the Gothic Period: Villard de Honnecourt." In Gothic Art
1140-ca. 1450. Sources and Documents in the History of
Art. Englewood Cliffs: Prentice-Hall, pp. 43-51.

Confused and misleading summary of Villard's career
based mainly on Hahnloser with translations of the Villard
inscriptions taken mainly from Frankl (1960.6). Frisch
states (p. 46) that Villard presided over a mason's lodge
and claims (p. 44) that "the only known personal record of
an architect's interests and concerns in the thirteenth
century is the lodge book of Villard de Honnecourt."

Frisch basically associates Villard with the Cistercians
but misidentifies (p. 44) the plan of Meaux (fol. 15) as
that of a Cistercian church and incorrectly terms (p. 45)
Saint-Quentin a Cistercian foundation.

Reproduces, as a frontispiece, fol. 10v from Hahnloser
(misdated to 1953).

2   GEREVICH, LÁSZLÓ. "A Gótikus klasszicimus és magyarország"
[Gothic classicism and Hungary]. Magyar tudományos
akadémia 20:55-72.

General essay concerning Villard and Hungary, the de-
tails of which the author exposes elsewhere (1971.3, 1974.1,
1977.3). What is emphasized here is that Villard cannot be
disassociated from the appearance of French classical (High)
Gothic style in Hungary ca. 1220 and that he may also have
introduced French technological innovations into Hungary.
In Hungarian.

Reproduces various details from the Villard manuscript.

3   _____. "Villard de Honnecourt magyarországon" [Villard de
Honnecourt in Hungary]. Müveszettörténeti értesitö 20:
20:81-105.

The most extensive of Gerevich's studies of Villard's
role in Hungary (see Gerevich, 1971.2, 1974.1, and 1977.3).
He reviews the earlier Hungarian literature on Villard and
categorically denies that Villard was involved in any way
with the various buildings, including Kassa, attributed to
him by one or another of these authors.

1971

He proposes that Villard visited Hungary ca. 1220, pos-
sibly in association with the Cistercians and/or possibly
in association with the Latin emperor of Constantinople,
Robert de Courtenai (1219-1228), who spent the winter of
1220 in Hungary.

Gerevich claims that pavement patterns and other details
of architecture (capitals and bases) and sculpture frag-
ments, especially those of the tomb of Gertrude de Meran
(d. 1213), excavated at Pilis are related to drawings found
in the Villard manuscript. He states that "there is foun-
dation for the belief that Villard had something to do with
the planning of the final phase of construction of Pilis."
He compares the quality of the Pilis sculpture fragments to
that of the sculpture of Chartres and Reims and attributes
the work to a French artist, concluding that "that artist
had to be Villard de Honnecourt."

In addition, he attributes to Villard the design but not
the execution of a buckle from Kigyóspusztai and claims
that there are grounds for the hypothesis that Villard may
have partially or wholly designed the royal palace at
Buda(pest). In Hungarian.

Reproduces a number of details from the Villard manu-
script.

4  HAHNLOSER, HANS ROBERT. "Nouvelles Recherches sur le livre de
   Villard de Honnecourt." Bulletin de la Société nationale
   des antiquaires de France, pp. 95-96.
   Unsigned summary of a presentation made to the society
   by Hahnloser in which he dated the last Villard drawings
   ca. 1235 and must have again made his plea that the French
   adopt his designation of the manuscript as a Bauhüttenbuch.
   In answer to a question posed by Louis Grodecki,
   Hahnloser said that Villard's last visit to Reims was
   ca. 1235/1236 but that he had been at Reims earlier, prior
   to his trip to Hungary.

5  KURMANN, PETER. "Le Croquis [du choeur de la cathédrale de
   Meaux] de Villard de Honnecourt." In La Cathédrale Saint-
   Etienne de Meaux: Étude architecturale. Bibliothèque de
   la société française d'archéologie, no. 1. Geneva: Droz,
   pp. 31-33.
   Detailed analysis of the information provided by and the
   degree of correctness in Villard's plan (fol. 15) of the
   choir of Meaux. Kurmann states that Villard's plan is a
   very significant document for Meaux, since the choir was
   modified in the thirteenth and fourteenth centuries after
   Villard made his drawing.

Kurmann claims (p. 32) that "le plan de Villard et celui du chevet actuel [de Meaux] sont si proches l'un de l'autre que Villard paraît bien avoir dressé effectivement le plan du choeur primitif." He also notes (p. 33) that Villard uncharacteristically drew in the plan of the windows of the choir and chapel walls, perhaps because he found these to be novel, or satisfactory, or both. See Kurmann, 1967.6.

Reproduces a detail of fol. 15v showing the Meaux plan.

6 MARCQ, MICHEL. "Cambrai." In <u>Dictionnaire des églises de France, Belgique, Luxembourg, Suisse</u>. Paris: Editions Robert Laffont.

Contains (vol. 5, p. V.B.28) one of the most outstanding misquotations of Villard on record, "Godefroy de Fontaines (1220-1237) fit édifier le choeur [de la cathédrale de Cambrai] selon les dessins de Villard de Honnecourt, originaire du Cambrésis. Ce dernier se dit lui-même l'auteur du choeur de 'Notre-Dame-Sainte-Marie de Cambrai'; son album contient quelques [sic] feuillets consacrés à cette construction qu'il aurait terminée vers 1251. . . ."

7 SHELBY, LON R. "Medieval Masons' Templates." <u>Journal of the Society of Architectural Historians</u> 30:140-54.

Shelby notes (p. 144) that "Several pages of Villard's <u>Sketchbook</u> contain evidence of the important place of templates in the work of mediaeval masons" and discusses the templates on fol. 32, stressing that Villard proves in his inscription that thirteenth-century masons had a technical vocabulary for referring to moldings and templates for moldings. Shelby notes (p. 145) that Villard used identifying marks on his template drawings, as well as on his drawings of the building of Reims itself, to indicate their specific features and the locations for which the templates were employed and that Villard's templates record the "work already accomplished at Reims by another master mason." He briefly discusses Master II's hints (fol. 20v) about how templates are designed, noting that for the spire two templates were involved, one large (for the actual spire) and one small (for individual stones to be employed in construction of the spire). Shelby concludes (pp. 145-46) by noting that Master II refers to templates (<u>molles</u>) only, but seems to have indicated marking gauges as well, although he apparently had no exact technical term for this device.

Shelby again (see 1970.7 and 1975.2) challenges the idea that the Villard manuscript was a textbook, stating that

the drawings concerning stereometry raise more questions than they answer.
    Reproduces details of fols. 20v, 21, 31v, and 32 after Willis.

8    WITTKOWER, RUDOLF.  Architectural Principles in the Age of Humanism.  rev. ed.  New York:  W.W. Norton & Co.
    In this edition only in Appendix II Wittkower gives (p. 159) what might be termed the "standard" humanistic view of Villard's treatment of the human figure as distinct from that of the Renaissance, "The contrast between Villard de Honnecourt's and Leonardo [da Vinci]'s proportioning of figures is a typical one:  the mediaeval artist tends to project a pre-established geometrical norm into his imagery, while the Renaissance artist tends to extend a metrical norm from the natural phenomena that surround him."

1972

1    ACLAND, JAMES H.  Medieval Structure:  The Gothic Vault.
    Toronto:  Toronto University Press.
    Under the heading "Medieval Masons" Acland makes (p. 78) a brief mention of Villard's manuscript, which he terms a "sketchbook" or "textbook" and which he says "indicates the range and complexity of the Gothic architect's training."  Acland claims that Villard made the drawings "to demonstrate his competence as an architectural teacher," following Frankl's thesis (1960.6) without, however, any reference to Frankl.

2    BUCHER, FRANÇOIS.  "Medieval Architectural Design Methods, 800-1500."  Gesta 11, no. 2:37-51.
    Discusses briefly (p. 38) Villard's use of square schematism in his plan for a Cistercian church (fol. 14v); the author relates the plan to that of Morimond.  Bucher claims that Villard's caption with this plan is "condescending," but it is unclear why he believes so.
    He appears to suggest (p. 40) that Villard learned the design principle of quadrature during his career or in the process of making his drawings:  Villard clearly misunderstood it when he drew the Lausanne rose (fol. 16v).  According to Bucher, "Only someone still not totally imbued with the rotational precepts could have so thoroughly botched up an obvious design"; but he used it in a playful manner in his drawing of "rotating masons" (fol. 19v).  Bucher discusses the Master II quadrature drawings (fol. 20) without noting that these are not by Villard.
    Reproduces fol. 19v and a detail from fol. 20.

3 FRIEDLÄNDER, RENATE. "Eine Zeichnung des Villard de
  Honnecourt und ihr Vorbild." <u>Wallraf-Richartz Jahrbuch</u>
  34:349-52.
  Discusses the unusual iconography of Villard's drawing
  (fol. 13v) of the lion and the ox of the tetramorph in
  which the animals hold scrolls rather than codices. The
  author claims (p. 349) that the general source for this
  drawing is found in metalwork rather than stonework and
  (p. 350) that the specific source is the <u>Evangelary of</u>
  <u>Saint-Médard de Soissons</u> (Paris, Bibliothèque nationale,
  MS. lat. 8850), a Carolingian manuscript which shows
  (fol. 12) the lion and the ox holding scrolls. Friedländer
  points out similarities of pose and details, for example,
  the tail of each animal wrapped around its advanced leg.
  She also notes (p. 352 n. 15) that Villard must have
  been in Soissons because he is known to have worked in the
  region of Soissons and his <u>Descent from the Cross</u> on the
  same folio relates to an ivory known to have been in the
  treasury of the cathedral at Soissons.
  Reproduces fol. 13v.

4 HAHNLOSER, HANS ROBERT. See "The Facsimile Editions," F.IV,
  2d ed.

5 MARCONI, PAOLO. "Il problema della forma della città nei
  teorici di architettura del Rinascimento." <u>Palladio</u>,
  n.s. 22:49-88.
  In a long discussion of the importance of the pentagon
  in Renaissance fortification and town planning, Villard is
  cited (p. 69) as a medieval example of the survival of this
  magical and astrological geometric form from antiquity.
  Marconi claims that Villard employed it (fol. 18v) as a
  useful design mechanism.

6 SHELBY, LON R. "The Geometrical Knowledge of Mediaeval Master
  Masons." <u>Speculum</u> 47:395-421.
  Poses and answers two fundamental questions about geome-
  try for masons as seen in the Villard manuscript:  what
  kind of geometry did Villard and Master II employ (p. 398)
  and what was the source for this geometry (pp. 408-9)?
  Shelby's answer to the first question is that medieval
  masons in general, including Villard and Master II, knew
  and employed "constructive geometry," not the "theoretical
  geometry" taught in the universities as part of the quad-
  rivium. The latter required theorems and a knowledge of
  mathematics; the former was intended to produce practical
  results and required neither complex proofs nor any knowl-
  edge of mathematics.

His answer to the second question is that neither
Villard nor Master II copied the examples of "constructive
geometry" (fols. 20, 20v, and 21) from then extant trea-
tises on geometry, although he acknowledges the existence
of a Picard geometrical treatise, Practike de Geometrie,
dated ca. 1275 (see Mortet, 1910.1). Moreover, he suggests
(p. 407) that Villard and Master II show no indication of
familiarity with the latest theories and instruments
(astrolabe or surveyor's quadrant).

Shelby's summary of the manuscript and its stereometric
geometry is that (p. 408), ". . . there is not a whit of
evidence for the existence at this time of other shop-
manuals of the masons' craft, let alone a continuing tradi-
tion of such books of which Villard's is the only sur-
vival . . . [therefore] let us assume that the Sketchbook
is what it appears to be, namely, an exceptional literary
record of some of the oral traditions of the masons'
craft."

Reproduces details of fols. 20 and 20v after Hahnloser.

7   VON SIMSON, OTTO. Das Mittelalter. Vol. 2, Das Hoch Mittel-
    alter. Propyläen Kunstgeschichte, vol. 6. Berlin:
    Propyläen Verlag.

    Contains a number of brief discussions concerning
    Villard and his manuscript (pp. 25-26, 43-44, 69, 81, 412),
    mainly a summary of Hahnloser's and Frankl's (1960.6) in-
    terpretations. Villard is called (p. 25) "a respected
    master architect . . . highly educated, with secure
    judgment," and throughout the text the manuscript is called
    a Bauhüttenbuch or a Musterbuch. Von Simpson stresses that
    architects such as Villard were also responsible for sculp-
    ture and painting and that the basis of their work was
    geometry, termed the "secret of the masons."

    His most important observations appear (p. 412) in an
    explanation of the discrepancies between Villard's drawing
    of the interior and exterior elevations of a Reims nave bay
    (fol. 31v) and the actual Reims nave. Von Simpson says
    that, leaving aside hastiness and carelessness on Villard's
    part, the difference is either the result of Villard's
    seeking to improve or modernize the design, altering its
    proportions to resemble those of Amiens, or of his copying
    at Reims a drawing which was later discarded or not fol-
    lowed. He also says one will never know which was the case
    since Villard's visit to Reims cannot be dated (although he
    gives the date "um 1230") and the chronology of construc-
    tion at Reims has not been precisely determined.

    Reproduces the Cistercian church plan on fol. 14v and
    fol. 31v.

1973

8    WIXOM, WILLIAM D.  "Twelve Additions to the Medieval Treasury
     [of the Cleveland Museum of Art]."  Cleveland Museum of Art
     Bulletin 59:89-92.
         Discusses a bronze figure of the mourning Virgin Mary
     from an early thirteenth-century Crucifixion group
     (Cleveland Museum of Art, 70.351) in the style of the Mosan
     goldsmith Master Gérard.  Wixom says (p. 89) "The Mary in
     Villard's drawing [fol. 8, dated between ca. 1220/1230 and
     ca. 1250] is so similar to the Cleveland figure in pose--in
     the disposition of the arms, hands, and drapery folds--that
     we might even wonder, despite the few discrepancies, whether
     the [Villard] drawing actually depicts our bronze and the
     ensemble from which it comes."
         Reproduces fol. 8 after Hahnloser.

                              1973

1    BRANNER, ROBERT.  "Books:  Gothic Architecture."  Journal of
     the Society of Architectural Historians 32:327-33.
         A "state of the question" essay on recent studies of
     various aspects of Gothic architecture in which Branner
     asked (p. 331) a question in passing which stimulated re-
     newed interest in Villard and may in time change the tradi-
     tional view of his career:  "Despite his [Villard's] fame
     and undoubted interest, the question that has always
     bothered me has been:  Was Villard in fact an architect or
     only a lodge clerk with a flair for drawing?"

2    DEUCHLER, FLORENS.  Gothic Art.  Universe History of Art.  New
     York:  Universe Books.
         Terms (p. 30) Villard a master mason and dates his draw-
     ings ca. 1220/1230.  Deuchler's emphasis is on Villard's
     drawings as models for stone sculpture.  He notes (p. 55)
     this specifically for the two figures on fol. 28 and claims
     (p. 81) that "the technique of cutting stone is illustrated
     in the architect Villard de Honnecourt's sketches."
     Deuchler's best summary (p. 116) is as follows:  "The fact
     that the Muldenfaltenstil appears in such a pronounced
     fashion in, of all places, the sketchbook of a master
     builder, suggests that the looped folds may in fact repre-
     sent a series of ciphers for a sculptor's guidance; they
     may have been intended to show him where the hollows of the
     folds were to go.  The drawing thus served an instructive
     function--a graphic, two-dimensional device to help the
     stone mason achieve a three-dimensional result."
         Reproduces, redrawn (from Lassus?), fols. 14, 28, 31,
     31v, 32, and 32v.

1973

3   ROBB, DAVID M.   The Art of the Illuminated Manuscript.   South
     Brunswick and New York:   A.S. Barnes & Co.
        Compares (pp. 215-16) Villard's drawing style with that
     found in contemporary north French Bible moralisée manu-
     scripts, claiming that both are related to monumental stone
     sculpture such as the Visitation group at Reims.
        Robb describes Villard as "an itinerant architect of the
     early thirteenth century" and calls the manuscript a
     sketchbook.
        Reproduces Villard's Ecclesia (fol. 4v).

4   SAMARAN, CHARLES.   "Le Carnet de croquis et de voyage d'un
     architecte française du XIIIe siècle (Villard de Honne-
     court)."   Journal des savants, pp. 241-56.
        Excellent summary (pp. 241-46) of the early literature
     on Villard, followed by a review of the 1972 edition of
     Hahnloser with detailed analysis of the differences between
     it and the 1935 edition.   Samaran accepts the view that
     Villard was an architect but denies that he was the "French
     Vitruvius" or that his manuscript was a systematic attempt
     to create a shop manual.   Samaran characterizes (p. 242) it
     as "une sorte de répertoire illustré des notions variées
     pouvant servir à une constructeur."
        Appendix A (pp. 250-54) identifies the Alessio Fellibien
     (i.e., Félibien) mentioned on fol. 1 of the manuscript as
     the Seigneur de Tuilerie near Chartres who translated a
     part of Vasari's Vite into French after 1550 (Paris,
     Bibliothèque nationale, nouv. acq. fr. 1229), noting that
     the inscription mentioning him cannot be as early as the
     1482 date it contains.   Appendix B (pp. 254-56) identifies
     Mongoguie (?) on fol. 23v as Montgaunier, a farm near
     Chartres.   See also Samaran, 1946.2.

5   SENÉ, A[LAIN].   "Quelques Instruments des architectes et des
     tailleurs de pierre au moyen âge:   Hypothèses sur leur
     utilisation."   In La Construction au moyen âge.   Actes du
     congrès de la Société des historiens médiévalistes de
     l'enseignement supérieur public, pp. 39-58.
        Discusses the nature and use of the mason's square in
     medieval construction, employing the illustration of this
     tool from fol. 20v (top row, second figure from the left)
     of the Villard manuscript.   Sené refers consistently to
     Villard and nowhere indicates that he realizes that the
     drawing in question is by Master II and not by Villard.
     He also discusses the problem of the quadrature and con-
     cludes that Lassus explained incorrectly Villard's
     (Master II's) understanding of this principle of design.

He refers to Branner (1957.1, 1957.2) and Shelby
(1965.2, 1970.7, 1971.7) for more accurate assessment of
this question.
Reproduces fol. 20v after Lassus.

## 1974

1   GEREVICH, LÁSZLÓ. "Tendenze artistiche nell'Ungheria
angioina." Accademia nazionale dei Lincei 210:121-[?].
One of the papers delivered at a colloquium held in
Rome, 23-24 March 1972, on the subject "Gli Angioini di
Napoli e di Ungheria." Gerevich cites (p. 123) Villard de
Honnecourt as the probable sculptor of the destroyed tomb
of Gertrude de Meran (d. 1213) found during the excavations
at Pilis. See Gerevich, 1971.3 and 1977.3.

2   RAGUIN, VIRGINIA CHIEFFO. "The Genesis Workshop of the
Cathedral of Auxerre and its Parisian Inspiration." Gesta
13, no. 1:27-38.
Makes (p. 30) a convincing comparison between the
drapery of a Majestas figure from a window formerly in the
church at Gercy (now in Paris, Musée de Cluny) and that
found in Villard's figures, noting that they both depend on
Parisian Muldenfaltenstil origins.
Reproduces fol. 3v, detail of Humilitas.

## 1975

1   GRANDJEAN, MARCEL, and CASSINA, GAËTAN. The Cathedral of
Lausanne. Guides to Swiss Monuments. Basel: Société
d'histoire de l'art en Suisse.
Dates (p. 27) the Lausanne rose between 1217 and 1235,
attributing the design to Pierre d'Arras. The authors
claim (p. 26) that Villard's drawing of the rose (fol. 16),
made about 1235, proves that the window has been noteworthy
from the time of its creation.

2   SHELBY, LON R. Review of Hahnloser facsimile. Speculum 50:
496-500.
Stresses the significance of the first edition of
Hahnloser in Villard studies since 1935, then lists in de-
tail the differences between the first and second editions.
Shelby provides an analysis of the contents of the
Villard manuscript which leads him to reject Hahnloser's
contention that it was a Bauhüttenbuch or that it was based
on academic treatises (see Shelby, 1972.6). He proposes

the counter hypothesis that Villard was a master craftsman,
but not an architect, and that the manuscript was origi-
nally a "private sketchbook" which, for unspecified reasons,
Villard decided to make public to an unspecified audience.

Shelby also rejects the claim of Hahnloser that Master
II and Master III were pupils of Villard.

3    TOMA, KATHY.  "La Tête de feuilles gothique."  L'Information
     d'histoire de l'art 20:180-91.
         Discussion of the origin and meaning of the leaf-face
     motif in medieval art, concluding that the motif can be
     found in Severan Roman monuments but that its association
     with Silvanus, deity of forests, is yet older.  Toma claims
     the motif was used in medieval Europe in two not always
     distinct contexts, funerary and geometric.
         It is in this second context that Villard appears, with
     the author suggesting (p. 180) that the Gothic period was
     the âge d'or for the motif and that the Villard manuscript
     returned it to a place of honor.  Toma suggests (p. 181)
     Gallo-Roman provincial works as the ancestors of Villard's
     leaf-face drawings (fols. 5v and 22) but offers no specific
     sources or models.
         Tomas refers to her thesis on this subject (Université
     de Paris, n.d.), which may discuss Villard's connection
     with the leaf-face motif in greater detail.
         Reproduces the leaf-face details of fols. 5v and 22
     after Hahnloser.

4    WIRTH, KARL-AUGUST.  Review of Hahnloser facsimile.  Pantheon
     33:79-80.
         Praises the publication of the revised edition of
     Hahnloser because the first edition had become unavailable
     and it was Hahnloser who had determined the way Villard is
     currently studied.  Wirth reviews only the additions to the
     first edition and faults these on several counts:   that
     Hahnloser unduly expanded and concentrated on some points
     which interested him personally while ignoring others of
     more general interest; that he missed a number of pertinent
     studies on Villard which had appeared after 1935 while un-
     critically accepting others of questionable merit.  He also
     states that certain of Hahnloser's proposed models for
     Villard's drawings are unacceptable because they are later
     in date than the manuscript and represent iconographic
     types unknown in the thirteenth century.

5    ZARNECKI, GEORGE.  Art of the Medieval World, Library of Art
     History.  Englewood Cliffs:  Prentice-Hall; New York:
     Harry N. Abrams.
        Discusses (pp. 379-80) Villard as a Picard architect but
     emphasizes that the manuscript, dated ca. 1220-1235, proves
     that craftsmen of the period were "masters of many trades."
     Villard is said to have done his figures, meaning the
     drapery of his figures, in a style which was "a very close
     imitation of the Muldenstil [sic] of Nicholas of Verdun,
     and this he must have absorbed in his youth, presumably by
     studying original works of the Mosan artist."
        Zarnecki assigns no specific buildings to Villard but
     claims that he "clearly headed" a mason's lodge for which
     he compiled the manuscript, termed a sketchbook.
        Reproduces fols. 10v and 16v.

### 1976

1    BUCHER, FRANÇOIS.  "Micro-Architecture as the 'Idea' of Gothic
     Theory and Style."  Gesta 15, nos. 1-2:71-89.
        Claims (pp. 72-73) that Villard's interest in non-
     structural elements (choirstalls, clock towers, lecterns,
     etc.) used in conjunction with architecture proves the
     desire of Gothic architects "to control all phases of
     design," a practice the author says is represented in our
     own time by such architects as Frank Lloyd Wright, Le
     Corbusier, Mies van der Rohe, and others.  Bucher also
     notes (p. 85 n. 12) that Villard's fascination with me-
     chanical gadgets of various types is not atypical of early
     thirteenth-century interests, citing as an example the gift
     of a hydraulic automaton to Frederick II by Saladin in
     1232.

2    GIMPEL, JEAN.  "Villard de Honnecourt:  Architect and Engi-
     neer."  In The Medieval Machine:  The Industrial Revolution
     of the Middle Ages.  New York:  Holt, Rinehart, & Winston,
     pp. 114-16.
        General summary of the traditional treatment of Villard
     as an architect associated with Cambrai and possibly with
     Saint-Quentin, seen against the prevalent background for
     training master masons in the thirteenth century.  Gimpel
     sees Villard's sketchbook as "astonishingly similar to
     Leonardo's famous notebooks" (p. 142), stressing that both
     men were practitioners of the mechanical arts, not human-
     ists, in terms of classical education.  Gimpel claims that
     Villard knew Vitruvius's De Architectura and was attempting
     to create a parallel to it.

1976

       This study by Gimpel (see also 1958.3 and 1970.1) contains some of the better English translations of Villard's inscriptions.

       Reproduces various details of Villard's drawings and fols. 5, 10, 18v, and 20.

3   GRODECKI, LOUIS. <u>Gothic Architecture</u>. History of World Architecture, no. 6. New York: Harry N. Abrams.

       Given the use of Villard's fol. 30v on the dust jacket and the beautifully reproduced illustrations of fols. 30v, 31, and 32 in the text, Grodecki has very little to say about Villard. He claims (p. 14) that Hahnloser's study of Villard was an attempt to prove that "the quest for geometric proportions was indeed a constant preoccupation in the Middle Ages." He notes (p. 58) that Villard drew the Laon towers [sic] in 1230 and "judged them to be without peer."

       Grodecki dates (p. 34) the Villard manuscript to the second quarter of the thirteenth century and terms it a book or a notebook containing models and instructions.

4   LASSUS, JEAN-BATISTE-ANTOINE. See "The Facsimile Editions," F.I, 2d ed.

5   PIERCE, JAMES SMITH. "The Sketchbook of Villard de Honnecourt." <u>New Lugano Review</u> 8-9:28-36.

       An attempt to define the aesthetic basis of Villard's drawings, regardless of their intended purpose. Pierce claims (p. 28) that the common characteristic of all of Villard's drawings is their "quality of linear movement." Noting that it has long been realized that dynamic linearism is one of the principles of Gothic architecture, he employs several expressions from Jacob Burckhardt as key concepts: "sheer rhythm of movement," "sprouting forces . . . individually expressed."

       Pierce then analyzes a number of Villard's drawings, demonstrating that he was interested not merely in movement, for example, the "ceaseless rotation" of the four masons on fol. 19v, but (p. 32) in visual ambiguity and the creation of restless visual tension, as in the four masons based on a swastika design who between them have four, not eight, legs or the three fish bodies (fol. 19v) which share a common head.

       Pierce claims (pp. 29-30) that Villard's geometry (fols. 18, 18v, 19, and 19v) may have been used to establish proportions or "as convenient devices for enlarging preparatory studies," but that this geometry was also employed to "animate the figures by establishing [oblique]

axes of action." He cites (p. 32) Villard's leaf-faces
(fols. 5v and 22) and his foliate voussoir (fol. 5v) as
obvious examples of "sprouting forces," both ambiguous
since the former can be seen as leaves-with-faces or as
faces-with-leaves, while the latter contains foliate motifs
which can be read as addorsed or confronting C-shapes.

Pierce argues (pp. 32-36) that Villard gave his archi-
tectural drawings the same sense of dynamic linear visual
ambiguity, for example, in altering the Chartres rose
(fol. 15v) "by shifting the columns from the static align-
ment with the centers of the [outer] circles to an align-
ment with new perforations between the circles . . . [so
that there] is now no dominant set of axes along the spokes
of the wheel." He notes (p. 35) that Villard stressed the
linearism of the Reims chapel interior (fol. 30v), as well
as the "sprouting forces" of its architectural members, by
inking in the spaces between the colonnettes so that they
are emphasized.

He also offers (pp. 35-36) a novel explanation for
Villard's omitting the vaults of the Reims chapel and nave
(fol. 31v): that this was Villard's method of emphasizing
the three-dimensionality of the web and its ribs because he
could not have done so had he drawn these in detail.

Reproduces a number of Villard's more dynamic figures
and fols. 5v, 18v, 30v, and 31v, after Lassus or Willis.

6   THIEBAUT, JACQUES. "L'Iconographie de la cathédrale disparue
    de Cambrai." Revue du Nord 58:407-33.
    Considers (p. 411) the traditional attribution of
    Cambrai to Villard and categorically denies the possibil-
    ity, noting that the details, especially the piers, in his
    plan (fol. 14v) are incorrect. Thiebaut dates Villard's
    visit to Cambrai ca. 1230 and states that his plan is im-
    portant for suggesting the state of construction of the
    Cambrai choir at that time.

                          1977

1   BRANNER, ROBERT. Manuscript Painting in Paris during the
    Reign of Saint Louis. Berkeley: University of California
    Press.
    Passing mention (p. 22) of Villard as a north French
    artist working in the Muldenfaltenstil, dating his manu-
    script, termed a notebook, ca. 1240.

1977

2   BUCHER, FRANÇOIS.  "A Rediscovered Tracing by Villard de
    Honnecourt."  Art Bulletin 59:315-19.
        Announces the rediscovery of a tracing (épure), in the
    first chapel on the north side of the ambulatory of Saint-
    Quentin, of a rose window similar in style to but differing
    in detail from the Chartres west rose on fol. 15v of the
    Villard manuscript.  See Bénard, 1864.1.  This design, dated
    1220/1235 and attributed to Villard, provides the basis for
    Bucher's conclusion (p. 319) that "I must stipulate
    Villard's presence in Saint-Quentin during the vital plan-
    ning phase of the choir in the 1220s."
        Bucher also notes that the tile patterns in the pavement
    of the chapel of Saint Martin in the axial western tower of
    Saint-Quentin are related to the pattern of a Hungarian
    paving tile drawn by Villard (fol. 15v), hence Villard's
    trip to Hungary is dated earlier here than it is in most
    scholarship.

3   GEREVICH, LÁSZLÓ.  "Pilis Abbey:  A Cultural Center."  Acta
    Archaeologica Academiae Hungaricae 29:155-98.
        Restates Gerevich's earlier (1971.3, 1974.1) views on
    Villard's association with Pilis, especially as master
    sculptor of the tomb of Gertrude de Meran (d. 1213).
    Gerevich here suggests (p. 185) that Villard had previously
    been one of the sculptors of the south arm reliefs and
    statues of Chartres.  Emphasizes Villard's drawings (fol.
    15v) of a Hungarian church pavement the model of which was
    probably in the south arm at Pilis:  one of Villard's five
    patterns (bottom left) is identical to an unusual pattern
    Gerevich excavated at Pilis.
        Reproduces a number of details from the Villard manu-
    script juxtaposed with likely sources and contains an
    extensive bibliography concerning Villard's visit to
    Hungary.

4   KIMPEL, DIETER.  "Le Développement de la taille en série dans
    l'architecture médiévale et son rôle dans l'histoire éco-
    nomique."  Bulletin monumental 135:195-222.
        Focuses on the use of templates for prefabrication of
    stone decorative and structural elements in thirteenth-
    century French architecture, especially at Reims and at
    Amiens.  Villard's fol. 32 is cited (p. 199) as proof that
    templates were used at Reims and (p. 201) as proof that the
    decorative moldings of the windows were additions to the
    original construction.
        Kimpel insists (p. 202) that Villard "s'est maintes fois
    trompé en ce qui concerne les détails de la cathédrale de
    de Reims," and he specifies these errors on p. 219 n. 27.

He also notes that Villard's pier plan on fol. 15v is most improbable as an example of actual construction. Villard is cited on p. 214 as proving, in his fols. 22v and 23, the technological resolution which accompanied prefabrication of architectural elements. Kimpel nowhere actually refers to Villard as an architect or mason.
Reproduces fols. 22v, 23, 31v, and 32 after Hahnloser.

6   KOSTOF, SPIRO, ed. "The Architect in the Middle Ages, East and West." In The Architect:  Chapters in the History of the Profession. New York:  Oxford University Press, pp. 59-95.
Passing mention (pp. 89-90) only of Villard, terming him "a master mason of Picardy," and claiming that his manuscript is a pattern book based on lodge tradition and was not intended to circulate outside the trade, that is, that Villard participated in the "secret of the medieval masons."
Reproduces fols. 14v and 23.

6   ROSENAU, HELEN.  "Notes on some Qualities of Architectural Seals during the Middle Ages." Gazette des beaux-arts, 6th ser. 90:77-84.
Terms (p. 77) Villard a thirteenth-century "architect, designer, and theorist" and claims that "His influence is to be recognized in the head sprouting with leaves on the plinth of the famous statue of a rider in Bamberg Cathedral."  Rosenau appears to credit (p. 78) Villard with the design of a canopy now over a statue of the Virgin at Bamberg when she says that it "resembles closely, not only the towers of Laon Cathedral, but also a fairly accurate drawing [fol. 10] of one of those towers in the design book by Villard de Honnecourt."
Reproduces fol. 10.

7   SHELBY, LON R.  Gothic Design Techniques:  The Fifteenth-Century Design Booklets of Mathes Roriczer and Hanns Schmuttermayer.  Carbondale and Edwardsville:  Southern Illinois University Press.
Terms (p. 4) Villard's sketchbook the "lone literary example of a thirteenth-century master mason's ideas and sketches [which] has survived."  But on p. 153 n. 5 he restates Branner's question (1973.1) about whether Villard may have been only a lodge clerk with a flair for drawing, noting that if someone could prove that view, most of the traditional scholarship concerning Villard would be "upset."

1978

1   BARNES, CARL F., Jr.  Letter to the Editor.  Art Bulletin 60:
    393-94.
        Refutes Bucher's claim (1977.2) that the drawing at
    Saint Quentin is by Villard, suggesting it may be a fake by
    Bénard (1864.1) made in order to associate Villard with
    that church.  Barnes questions whether the drawing was ever
    lost and raises the point that it requires a "stupefying
    series of interrelated coincidences" to make Bucher's the-
    sis operable.

2   BINDING, GUNTHER, and NUSSBAUM, NORBERT.  Der mittelalterliche
    Baubetrieb nordlich der Alpen in zeichenossischen Darstel-
    lung.  Darmstadt: Wissenshaftliche Buchgesellschaft,
    pp. 1-21.
        A general overview of the state-of-the-question of
    Villard and his manuscript, based on and adopting the the-
    ses of Hahnloser and Frankl (1960.6).  The authors date
    (p. 3) Villard's activities, including his trip to Hungary,
    mainly in the 1230s and state (p. 5) that it is possible he
    worked on the tomb of Gertrude de Meran at Pilis (see
    Gerevich, 1974.1).
        The thesis of this study (p. 2) is that the Villard
    manuscript was an Arbeitsbuch or Lehrbuch, an architectural
    summa scientiae et artis intended for use in a building
    lodge (Bauhütte), and that it is typical of its type (not
    a one of which survives).
        The most useful and original part of this study is an
    analysis (pp. 12-17) of Villard's system (?) of perspective
    rendering in certain of his architectural drawings, for
    example, the Laon tower (fol. 10) and the Reims chapels
    (fol. 30v and 31).
        Reproduces a number of details and fol. 10 after Lassus
    or Willis.

3   BUCHER, FRANÇOIS.  Response to Letter to the Editor.  Art
    Bulletin 60:394.
        Defends his claim (1977.2) that the drawing at Saint-
    Quentin is an original by Villard and argues that Barnes's
    opinion (1978.1) is invalid because the latter described a
    different drawing in a different chapel.
        Bucher claims his research indicates that Villard died
    shortly after 1233 and that the drawing dates immediately
    after Villard's return from Hungary, at the latest between
    1228 and 1233.  Bucher stands by his claim that Villard was
    an architect but denies attributing to him the choir of
    Saint-Quentin, having proposed only that he was there

during construction and offered advice, specifically, that
he "contributed to its design; neither more nor less."
However, see Bucher, F.VII.

4   LAGERLÖF, ERLAND. "En Uppmätningsritning från Medeltiden."
    In Gotsland Fornsal (Särtryck ur Gotländskt Arkiv 1978),
    pp. 33-42.
        Survey of medieval architectural engravings emphasizing
    an engraving of ca. 1300 for a retable from the crypt at
    Lojsta, Gotland. Passing reference is made (p. 41 n. 1) to
    Villard as "arkitekt" in quotation marks, suggesting that
    Lagerlöf questions this identification.
        In Swedish. Short summary in German (p. 42).

5   MURRAY, STEPHEN. "The Gothic Facade Drawings in the 'Reims
    Palimpsest.'" Gesta 17, no. 2:51-55.
        Discusses the differences in technique and execution of
    the two facade drawings in the Reims palimpsest (Reims,
    Archives de la Marne, MS. G.661). He concludes that one
    ("A") is an original, experimental design whereas the other
    ("B") is a copy of an older design, where there are few
    corrections and many pinprick guides which enabled the
    copyist to capture the details of the original.
        Murray notes (p. 54) that Villard's drawings provide a
    reasonably contemporary parallel to these Reims drawings
    and that Villard's technique of lightly incised preliminary
    leadpoint lines, frequent corrections, and infrequent use
    of pinprick guides agrees with the technique of Reims "A."
    The conclusion from this, not actually stated by Murray,
    would seem to be that Villard's architectural drawings were
    not literal copies or tracings.

6   SCHÖLLER, WOLFGANG. "Eine Bermerkung zur Wiedergabe der Ab-
    teikirche von Vaucelles durch Villard de Honnecourt."
    Zeitschrift für Kunstgeschichte 41:317-22.
        Discusses (pp. 317-19) the history of construction of
    the Gothic church at Vaucelles, dating the crossing and
    transept 1192-1216 and the choir 1216-1235. Schöller
    claims (pp. 320-21) that while the Villard and Pierre de
    Corbie plan (fol. 15) related to Vaucelles reveals numerous
    corrections under ultraviolet light, Villard's plan of the
    Vaucelles choir (fol. 17) shows no corrections, "wie nach
    einem Vorbild kopiert." He also notes that Villard drew
    the Vaucelles crossing and north arm of the transept, which
    he later erased. Villard attempted two different vaulting
    schemes, neither of which is satisfactory and neither of
    which probably reflects this part of the actual building.

1978

Schöller speculates (p. 322) that the difference in
accuracy between this area and the choir is explained by
the fact that Villard copied a plan of the choir but ex-
perimented with this area. He also proposes, less con-
vincingly, that Villard later erased this part of his
drawing not because of his errors but because, having
worked out his experiment on parchment, he no longer
required the drawing.
    Reproduces fols. 15 and 17 redrawn to show the original
lines subsequently rejected or erased.

### 1979

1   BUCHER, FRANÇOIS. See "The Facsimile Editions," F.VII.

2   BUCHTHAL, HUGO. The "Musterbuch" of Wolfenbüttel and Its
    Position in the Art of the Thirteenth Century. Byzantina
    Vindobonensia, no. 12. Vienna: Verlag der Österreich-
    ischen Akademie der Wissenschaften.
        This item is included for what it does not say. In his
    extensive analysis of the Wolfenbüttel Musterbuch (Wolfen-
    büttel, Herzog August-Bibliothek, Codex Guelf 62, 2 Aug.),
    which Buchthal attributes (p. 68) to a Venetian artist
    copying from an earlier Venetian Musterbuch, the Villard
    manuscript is thoroughly ignored. Only on p. 15 does
    Buchthal even mention it, summarily dismissing it as "a
    collection of drawings."

3   CALKINS, ROBERT G. Monuments of Medieval Art. New York:
    E.P. Dutton.
        General commentary on Villard, called a French draftsman,
    active ca. 1225-1250, who produced a notebook. Calkins
    appears (p. 268) to question the habit of terming Villard
    an architect: "whether Villard was an architect as many
    scholars believe, or merely an artist, he is representative
    of a large number of medieval artisans who emerged from
    relative anonymity with the building of the High Gothic
    cathedrals."
        Emphasis is on Villard as an example of the medieval
    artist who insisted on an "assertion of [his] individual-
    ity" rather than on an analysis of his drawings.
        Reproduces fol. 6v.

4   OST, HANS.  "Eine Architekturzeichnung des 13. Jahrhunderts
     mit einem Exkurs zur Baugeschichte der Marienkirche in
     Reutlingen."  Zeitschrift für Kunstgeschichte 42:15-30.
          Announces the 'rediscovery' of an architectural engrav-
     ing on the wall of the Sudsakristei of the former Cister-
     cian church in Reutlingen, first published in 1903 as the
     plan of a Gothic church with a polygonal choir.
          Ost interprets (pp. 16-17) this engraving as the plan
     for a flat terminal Cistercian church and dates (p. 19) the
     drawing ca. 1250-1270.  He believes (p. 20) that the
     Reutlingen engraving is very much like that (fol. 14v) in
     the Bauhüttenbuch of Villard ("wichtigstes Beispiel der
     Architekturzeichnung des 13. Jahrhunderts"), which he dates
     before 1235.
          Ost does not propose that the Villard plan is the model
     or source for the Reutlingen engraving, or that Villard was
     responsible for it, merely that both are examples of the
     ideal plan of a Cistercian church.  He proposes (p. 24)
     that if a model can be designated for the Reutlingen en-
     graving, it probably should be the plan of the Cistercian
     church at Bebenhausen, consecrated in 1238.
          Reproduces a detail of the Cistercian plan on fol. 14v.

1   ANON.  Review of Bucher facsimile.  Journal of the American
     Institute of Architects (June):63.
          More an announcement than a review, where the unknown
     author misspells Bucher as "Boucher," and briefly summa-
     rizes the contents of Architector, vol. 1.
          Reproduces fols. 31 and 32, possibly after Bucher.

2   BOULEAU, CHARLES.  The Painter's Secret Geometry:  A Study of
     Composition in Art.  New York:  Hacker Art Books.
          Briefly summarizes (p. 60) Villard's use of geometrical
     figures in the design of the human figure as "simple and
     unpretentious, and their triangulation is quite arbitrary."
     Bouleau comments that Villard provides a clear example of
     the conflicting demands on the Gothic artist, that of
     drawing correctly from nature and that of employing pre-
     determined and arbitrary geometric figures for drawings
     (cf. Huyghe, 1958.4).
          Bouleau states (p. 60), "Villard de Honnecourt was an
     architect, architecture was the leading art of his time,
     and it is patently clear that the geometry which governed
     decorative art and 'portraiture' governed architecture as
     well."

1980

> Reproduces a detail of a standing figure from fol. 18
> (said to be a photograph from the Bibliothèque nationale
> but in fact a drawing after a photograph) compared with a
> figure of a devil from the Psalter of Blanche of Castile
> (Paris, Bibliothèque de l'Arsenal, MS. 1186) employing a
> comparable geometric schemata.

3   BUCHER, FRANÇOIS. "Les Bâtisseurs du moyen-âge: L'architec-
    ture vernaculaire ou l'empreinte des particularisme lo-
    caux." Dossiers histoire et archéologie 47:66-82.
    Discusses the responsibilities and pride of the "petits
    architectes du peuple" of the Middle Ages, in which cate-
    gory Bucher places Villard. Bucher stresses that these
    architect-contractors could not specialize exclusively in
    masonry projects but were responsible for a variety of
    tasks: building bridges, cisterns, fortifications, houses,
    and the design and construction of practical mechanical
    devices including weapons. In this latter connection
    Bucher discusses (pp. 68, 70) Villard's automatic saw
    (fol. 22v) and catapult (fol. 30), providing a drawing
    reconstructing each.
    Bucher insists that these versatile individuals were,
    while not as famous as the masters of significant eccle-
    siastical building projects, quite proud of their abilities
    and accomplishments. He cites (p. 82) Villard's pride
    (fols. 10v and 15v) in his trip to Hungary as proof of
    this claim.
    Reproduces fol. 30.

## 1981

1   BARNES, CARL F., Jr. "The Drapery-Rendering Technique of
    Villard de Honnecourt." Gesta 20, no. 1:199-206.
    On the basis of an examination of the manuscript, claims
    that six separate steps can be seen in Villard's rendering
    of finished drapery: (i) leadpoint contour sketch, (ii)
    leadpoint drapery-fold sketch, (iii) lightly inked deter-
    mination of contour, (iv) heavier inking of contour,
    (v) inking of drapery-fold contours, (vi) leadpoint in-
    filling of drapery folds.
    Barnes argues that these steps parallel exactly those in
    metalworking, especially niello work, and reveal that
    Villard's professional training, and possibly his profes-
    sion, was that of a metalworker rather than that of an
    architect.
    Reproduces fols. 11, 13, 25, and 25v and details of
    fols. 3v and 16v.

2 _____. Review of Bucher facsimile. Speculum 56:595-98.
   Contains a summary version of the analysis given here
   under "The Facsimile Editions," F.VII.

3 KIDSON, PETER. Review of Bucher facsimile. Journal of the
   Society of Architectural Historians 40:329-31.
      An essay-review in which Kidson picks up the theme of
   Barnes (1978.1, 1980.1, 1981.1), Branner (1973.1), Recht
   (1981.4), and Shelby (1975.2) to question extensively and
   eloquently the traditional thesis that Villard was a Gothic
   architect-mason. Kidson poses penetrating questions to
   challenge this thesis, especially as articulated by Bucher,
   and by a series of carefully crafted points systematically
   destroys Bucher's various claims. Kidson's own view is
   expressed (p. 330) as "But anyone who wishes to insist that
   Villard really did know what every genuine medieval archi-
   tect knew certainly has a lot of special pleading on his
   hands."
      Kidson is sharply critical of Villard as architectural
   draftsman (p. 330): "The man who drew the elevation of
   Reims [fol. 31v] knew nothing of the geometrical system
   which determined the relations between its stages. What he
   drew was nonsense--something which betrays either a garbled
   misunderstanding of else total ignorance of the ways in
   which contemporary cathedral designs were put together."
   Kidson is far more favorably impressed by other Villard
   drawings, terming him (p. 329) "a superb exponent of the
   Mulden[falten]stil."
      This review does contain minor factual errors. Kidson
   misattributes to Bénard (1864.1) the attribution of the
   choir of Cambrai to Villard. Bénard in fact rejected this
   attribution (first made by Quicherat, 1849.1) and attrib-
   uted Saint-Quentin to Villard.

4 RECHT, ROLAND. "Sur le dessin d'architecture gothique." In
   Études d'art médiéval offertes à Louis Grodecki. Edited by
   André Chastel et al. Paris: Éditions Ophrys, [1981],
   233-50.
      Discusses several aspects of Villard's drawings and
   Villard's use of terms referring to his drawings. Regard-
   ing the latter, Recht concludes (pp. 234-35) that Villard
   possessed no technical vocabulary and employed portraiture
   only in the general sense of "representation." Recht
   claims that to Villard esligement simply mean "level," not
   "plan"; and that montee meant "view," not "elevation."
   Recht also claims that Villard's expression al vif only
   meant (fols. 24 and 24v) that he drew his lion from a

specific model, not as a creative, invented image, and he had not seen an actual lion.

Recht takes Villard to task as an architectural draftsman. Noting (p. 235) that Villard employed three types of architectural drawings (plans, geometric elevations, and cavalier views), Recht claims that Villard's chief difficulty was his inconsistency: "Ce qui est le plus frappant chez Villard, c'est l'inégalité avec laquel il aborde à différentes occasions une même problématique." He also states (pp. 235-36) that Villard is inconsistent, claiming to have understood quadrature but unable to recognize it in use when he drew the Lausanne rose (fol. 16). It is Recht's opinion that Villard's drawings would have been totally useless to masons, and that only later in the thirteenth century did architectural drawings (e.g., Reims Palimpsest, Strasbourg facade drawings) have sufficient detail and consistent geometrically-controlled perspective to have been useful to masons.

Recht gives Villard very little credit as an original, creative talent. He posits (pp. 234-35) that Villard copied his drawings from a Musterbuch without imposing his personal style or styles on what he copied.

Considering the fundamental question of Villard's career, Recht begins by contesting (p. 234) Hahnloser's contention that Villard was an architect and that his manuscript was a Bauhüttenbuch. Recht notes that there is no proof that the Pierre de Corbie with whom Villard collaborated on an architectural drawing (fol. 15) was an architect and that there is nothing in the manuscript that proves conclusively that Villard himself was an architect (p. 235): ". . . on serait tenté de le [Villard] considérer non plus forcement comme l'architecte, mais comme un compilateur, perméable aux caractères formels specifiques de chacune des images compilées."

Reproduces fols. 6v, 16, 24v, 30v, 31, and 31v.

# Miscellany

As best I have been able to determine, the Villard manuscript has been exhibited twice, in 1937 and in 1955, at the Bibliothèque nationale in Paris (see 1937.1 and 1955.1). It has never been loaned for exhibition elsewhere. There is a possibility that it was on display in the Bibliothèque nationale ca. 1900. In his <u>Mont-Saint-Michel and Chartres</u> (1904.1) Henry Adams states (p. 65) that "you can see [Villard's notebook] in the vitrines of the Bibliothèque nationale in the Rue Richelieu."

The Villard manuscript has been the subject of one film:

REBILLARD, GEORGES [Director], and THALER, YVES [Cameraman]. <u>Villard de Honnecourt: Builder of Cathedrals</u>, n.d.
   A 15-minute black-and-white 16mm film, said to be an International Film Festival award winner, which gives a very romantic look at Gothic architecture in general and at Villard in particular. Villard is called a thirteenth-century architect who is credited with the design of Kassa and Marburg and probably with the design of Cambrai and Vaucelles. Villard's inscriptions are very freely (and, in some instances, inaccurately) translated. The photographs of the Villard drawings are made from the Hahnloser facsimile.
   Available from the Roland Collection, 477 Roger Williams, PO Box 855, Ravinia, Highland Park, IL 60035. Purchase price [1979]: $185.00; Rental price: $18.50.

# Appendix: Churches Attributed to Villard

The following is a list of churches attributed totally or in part to
Villard, together with the earliest source making the attribution.
As indicated in the Introduction, no church or part of any church can
be attributed with absolute certainty to Villard.

1.  FRANCE
    Braine, Abbey Church of Saint-Yved (Tourneur, 1888.1)
    Cambrai, Cathedral of Notre-Dame (Quicherat, 1849.1)
    Chartres, Cathedral of Note-Dame (Crombie, 1952.1)
    Laon, Cathedral of Notre-Dame (Crombie, 1952.1)
    Meaux, Cathedral of Saint-Etienne (Paris, 1856.1[?]; Bauchal,
        1887.1)
    Meaux, Abbey Church of Saint-Faron (Coulton, 1928.1)
    Reims, Cathedral of Notre-Dame (Paris, 1856.1)
    Saint-Quentin, Collegial Church of Saint-Quentin (Bénard,
        1864.1)
    Vaucelles, Abbey Church of Notre-Dame (Wilpert, 1865.4)

2.  GERMANY
    Marburg, Collegial Church of Saint Elizabeth (Lassus, 1858.4)

3.  HUNGARY
    Eger, Cathedral of Saint Stephen (Divald, 1927.2)
    Estergom, Cathedral (?) (Aubert, 1966.1)
    Gyulafehérvár, Cathedral of Saint Stephen (Möller, 1905.3)
    Jaák, Abbey Church of Notre-Dame (Möller, 1905.3)
    Kassa (now Košice, Czechoslovakia), Cathedral of Saint
        Elizabeth (Henszlmann, 1857.1)
    Pilis, Abbey Church of Notre-Dame (Gerevich, 1971.2)
    Zsámbék, Abbey Church of Saint Benedict (Möller, 1905.1)

# Author Index

Ackerman, James S., 1953.1
Acland, James H., 1972.1
Adams, Henry Brooks, 1904.1
Adhémar, Jean, 1939.1
American Institute of Architects, 1980.1
Assier, Alexandre, 1866.1
Aubert, Marcel, 1935.1; 1947.1; 1961.1; 1966.1

Barnes, Carl F., Jr., 1960.1; 1978.1; 1981.1; 1981.2
Baron, Françoise, 1960.2
Bauchal, Charles, 1887.1
Bénard, Pierre, 1864.1; 1865.1; 1867.1; 1875.1
Bibliothèque nationale, Paris, 1937.1; 1955.1. See also Omont, Henri
Binding, Gunther, 1978.2
Bober, Harry, 1963.1
Booz, Paul, 1956.1
Bouleau, Charles, 1980.2
Bouvet, Francis, 1960.3 (F.VI)
Bowie, Theodore Robert, 1959.1 (F.V, 1st ed.); 1962.1 (F.V, 2d ed.); 1968.1 (F.V, 3d ed.)
Branner, Robert, 1955.2; 1957.1-2; 1958.1; 1959.2; 1960.4-5; 1961.2; 1963.2; 1968.2; 1973.1; 1977.1
Briggs, Martin S., 1927.1
Brunet, Jacques-Charles, 1864.2
Brutails, Elie Jean-Auguste, 1902.1

Bucher, François, 1968.3; 1969.1; 1972.2; 1976.1; 1977.2; 1978.3; 1979.1 (F.VII); 1980.3
Buchthal, Hugo, 1979.2
Bulteau, [L'abbé] Marcel-Joseph, 1881.1; 1883.1; 1888.1
Burges, William, 1858.1; 1860.1; 1887.2

Calkins, Robert G., 1979.3
Cassina, Gaëtan. See Grandjean, Marcel, 1975.1
Cerf, Charles, 1861.1
Chappuis, Françoise, 1970.4
Chevalier, Cyr Ulysse Joseph, 1905.1
Clark, [Sir] Kenneth, 1956.2
Cornell, Henrik, 1968.4
Coulton, George Gordon, 1918.1; 1928.1
Crombie, Alistair Cameron, 1952.1
Csemegi, József, 1955.3

Daniel-Rops, Henry. See Petiot, Henry Jules Charles
Degenhardt, Bernhard, 1950.1
De Lasteyrie [du Saillant], Robert Charles, 1926.1. See Quicherat, 1886.1
Demaison, Louis, 1894.1; 1902.2; 1954.2
Deuchler, Florens, 1967.1; 1973.2
Dimier, M.-Anselme, 1949.1
Diringer, David, 1958.2

# Author Index

Wormald, Francis, 1936.3
Worringer, Wilhelm, 1967.9

Zarnecki, George, 1975.5

# Subject Index

This index is intended to assist readers interested in specific aspects of Villard's life, for example, his trip to Hungary, or in specific aspects of Villard's drawings, for example, classification of their subject matter. In compiling this index, I have listed all proper names but I have omitted topics so general in nature that they would require inclusion of virtually every entry, for example, the dating of Villard's activities or references to Villard as an architect.

Three caveats are to be noted. First, the seven facsimile editions are not indexed because each of these is to some degree concerned with almost every aspect of Villard's life and manuscript. Second, the Preface and Introduction are not indexed here because, while both offer my personal interpretation of Villard and his manuscript, they derive from and cite extensively the studies analyzed in this bibliography. Third, this index is based on the entries in this bibliography, not on the studies which these entries summarize.

The entries under each heading below are listed chronologically rather than alphabetically because later studies frequently develop or refute the thesis or theses of one or more earlier studies. Inclusion of a given entry under the heading does not necessarily imply that the author of that entry endorses or supports the concept implied by the heading itself. For example, under the heading "Saint-Quentin (Church), Villard as Architect of," I do not agree that Villard was the architect of Saint-Quentin. In the entry "Textbook, Villard Manuscript as," Frankl's claim that the manuscript was a textbook is vigorously denied by Shelby.

Antiquity
-Villard's interest in
  Viollet-le-Duc, 1860.2;
  Renan, 1865.2; Hamann-
  Maclean, 1949.2; Marconi,
  1972.5
-Villard's use of models from
  Burges, 1858.1; Mérimée,
  1858.5; Renan, 1865.2;
  Vitry, 1929.4; Adhémar,
  1939.1; Hamann-Maclean,
  1949.2
Arches, geometry of
  Brutails, 1902.1; Lethaby,
  1904.2; Branner, 1960.4
Archimedes spiral, Villard's use
  of
  Viollet-le-Duc, 1863.1;
  Branner, 1960.4; Shelby,
  1969.2
Architectural drawings, Villard's
  use of other
  Garling, 1858.2; Viollet-
  le-Duc, 1859.2; Bénard,
  1864.1; Demaison, 1902.2;
  Booz, 1956.1; Jantzen,
  1957.4; Branner, 1963.2;
  Schöller, 1978.6
Astrolabe
  Shelby, 1972.6
Augustinian proportions.  See
  Pythagorian proportions

Bamberg (Cathedral), Villard's
  influence on
  Rosenau, 1977.6
Bayeux Tapestry, Villard's
  drawings compared to
  Lefebre des Noëttes,
  1912.3
Bebenhausen (Church), Villard
  drawing compared to
  Ost, 1979.4
Bible moralisée (Paris, Biblio-
  thèque nationale, MS. lat.
  11.560)
  Anon., 1955.1
Braine (Church), Villard as
  architect of
  Tourneur, 1888.2; Szabó,
  1913.1

Budapest (Royal Palace) Villard
  as architect of
  Gerevich, 1971.3
Burckhardt, Jacob
  Pierce, 1976.6
Byzantine art, Villard's use of
  as models
  Viollet-le-Duc, 1863.1;
  Renan, 1865.2; Panofsky,
  1921.1; Adhémar, 1939.1;
  Deuchler, 1967.1

Cambrai (Cathedral)
-Villard as architect of
  Quicherat, 1849.1;
  Viollet-le-Duc, 1854.1;
  Garling, 1858.2; Cerf,
  1861.1; Houdoy, 1879.1;
  Bauchal, 1887.1; Bulteau,
  1888.1; Demaison, 1894.1;
  Sturgis, 1901.2; De
  Lasteyrie, 1926.1; Briggs,
  1927.1; Coulton, 1928.1;
  Stein, 1929.3; Horváth,
  1936.1; Harvey, 1950.2;
  Pevsner, 1966.3; Marcq,
  1971.6; Gimpel, 1976.2;
  Thiebaut, 1976.7; Kidson,
  1981.3
-Villard's plan of
  Houdoy, 1879.1; Branner,
  1963.2; Reinhardt, 1963.3;
  Thiebaut, 1976.6
Carpentry, Villard's drawings of
  Salzman, 1952.2; Gimpel,
  1958.3
Chartres (Cathedral)
-mechanical angel of
  Lecocq, 1876.1
-Villard as architect of
  Crombie, 1952.1
-Villard as sculptor at
  Kidson, 1958.5; Gerevich,
  1977.3
-Villard's drawing of west rose
  of
  Bénard, 1864.1; Durand,
  1881.2; Bulteau, 1888.1;
  Adams, 1904.1; Kunze,
  1912.2

Strassbourg (Cathedral), drawing
of facade (Strasbourg, Musée
de l'Oeuvre Notre-Dame,
Dessin "A"), Villard's
drawings compared to
Recht, 1981.3
Subject Matter in the manuscript,
classification of
Quicherat, 1849.1; Burges,
1858.1; Gimpel, 1958.3

Templates, drawings of in the
Villard manuscript
Swartout, 1932.1; Shelby,
1971.7; Kimpel, 1977.4
Terence, Villard's figures
compared to
Renan, 1862.1
Tetramorph, Villard's drawing of
Friedländer, 1972.3
Textbook, Villard manuscript as
Pevsner, 1943.1; Frankl,
1960.6; Shelby, 1970.7;
Shelby, 1971.7; Binding
and Nussbaum, 1978.2
Third-Point arches. See Arches,
geometry of
Toledo (Cathedral), Villard's
influence on
Street, 1865.3; Enlart,
1895.1
Training as an architect,
Villard's
Nicq-Doutreligne, 1914.1;
Réau, 1936.2; Aubert,
1947.1; Von Simson, 1952.3
Treatise, Villard manuscript as
Viollet-le-Duc, 1863.1
Trier (Church), Villard as
architect of
Enlart, 1902.3; Eichler,
1953.3
Trough-fold style. See
Muldenfaltenstil

Vasari, Giorgio
Samaran, 1973.4
Vaucelles (Church)
-Villard as architect of
Wilpert, 1865.4; Bauchal,
1887.1; Enlart, 1895.1;

Enlart, 1902.3; Lethaby,
1904.2; Nicq-Doutreligne,
1914.1; Coulton, 1918.1;
Aubert, 1947.1; Dimier,
1949.1; Gimpel, 1958.3;
Baron, 1960.2; Héliot,
1967.3
-Villard's plan of ˙
Wilpert, 1865.4; Dimier,
1949.1; Schöller, 1978.6
Versatility of interests,
Villard's
Garling, 1858.2; Viollet-
le-Duc, 1859.2; Renan,
1862.1; Viollet-le-Duc,
1863.1; Coulton, 1928.1;
Pevsner, 1943.1;
Lefrançois Pillon, 1949.3;
Gimpel, 1958.3; Henderson,
1967.4; Gimpel, 1970.1;
Acland, 1972.1;
Zarnecki, 1975.5; Bucher,
1980.3
Villard, correct spelling of
Burges, 1858.1
Virgin Mary, bronze figure of
(Cleveland Museum of Art,
70.351), Villard's use of as
model
Wixom, 1972.8
Vitruvius, Villard compared to
Quicherat, 1849.1; Mortet,
1910.1; Lorgues, 1968.5;
Samaran, 1973.4; Gimpel,
1976.2

Wolfenbüttel Model Book
(Wolfenbüttel, Herzog August-
Bibliothek, Codex Guelf 62,
2 Aug.), Villard manuscript
compared to
Buchthal, 1979.2

Zsámbék (Church), Villard as
architect of
Gál, 1929.2; Horváth,
1936.1